NEW BLOOD TATTOO

Published in 2014 by Graffito Books Ltd.,
32 Great Sutton Street,
London EC1V 0NB
www.graffitobooks.com

© Graffito Books Ltd, 2014
ISBN 978-1909051010

Art Direction: Karen Wilks
Additional design: Tristan Baliuag

Editor: Jayney Kensington
Assistant Editor: Joanne Serrano

British Library cataloguing-in-publication data:
A catalogue record of this book is available at The British Library.

Printed in China.

NEW BLOOD TATTOO

Allan Graves

General Editor

Text by
Antoni Cadafalch

GRAFFITO

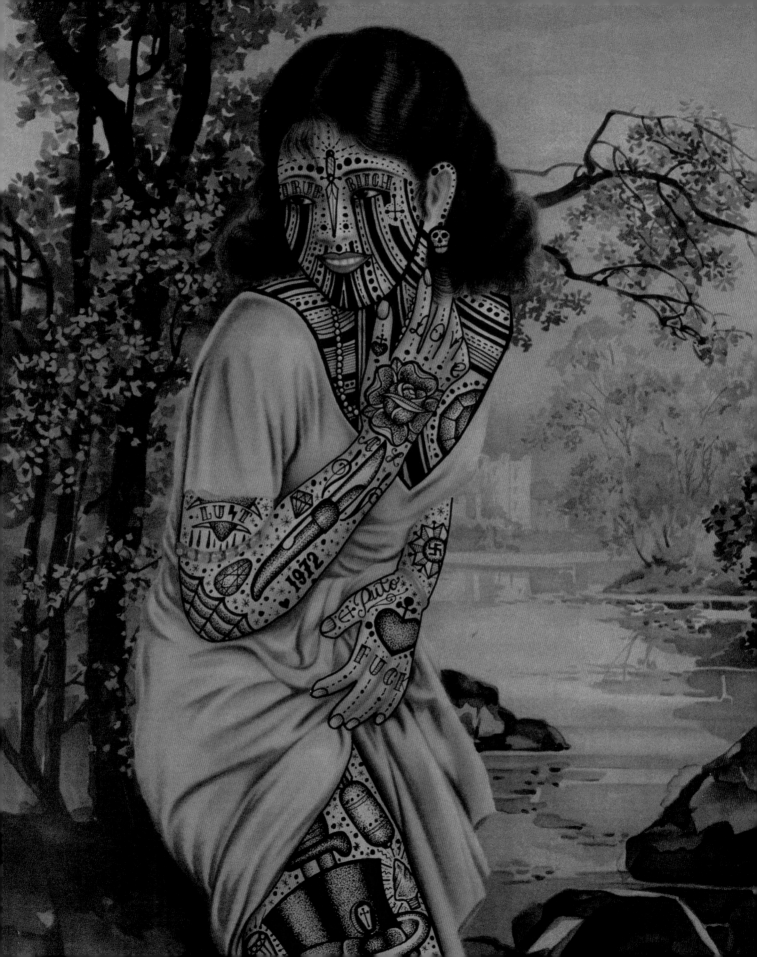

CONTENTS

LEFT: *Creepy model.*
Ramon Maiden.
Ink on paper.

FOREWORD

The overriding characteristics of the tattoo scene today are change, eclecticism, crosscurrents of influence and, not least, globalisation. Just when we think we are at the peak of the movement, when it can't get any more influential, when it seems that there are more than enough tattoo shops, we realise that, as tattoo artists, we have never been busier.

And more and more artists are entering the industry and coming into it younger, with new influences and ideas. It is the sheer variety and depth of the art of these new entrants that we wanted to capture, from all corners of the world. This is what sparked the idea for *New Blood Tattoo* – the trends which current young guns are embracing and which are likely to inform the movement for the next decade.

There was a time when, if you wanted a tattoo, you would head to your nearest tattoo studio and be happy with the result. Today, people are identifying and following individual artists, with specific and recognisable styles, and often travelling significant distances to get that perfect inking on their bodies. Getting a tattoo has become a much more considered event, a more personal choice.

It's a well-worn argument that all this is the result of the Internet, the quicker exchange of ideas, the sheer visibility of the whole tattoo scene. But at a deeper level something else has been going on. Back in the day the route to becoming a tattooist was, if you were lucky, getting an apprenticeship and slowly learning to draw on the job. Today many artists, already highly skilled at draughtsmanship, drawing and painting, are seeking out apprenticeships, seeing tattooing as one of the most interesting, exciting areas of creativity and, critically, one where they can earn a good living practising their art without having to deal with the bullshit of the art world. This is injecting massive new talent, energy and new ways of doing things into the tattoo scene. It is 'new blood' in every sense of the term.

The other significant development has been how much tattoo artists are travelling, exchanging ideas, doing spots at conventions or guest weeks at parlours thousands of miles away. For those in west coast USA wishing to get a tattoo from some esoteric London-based talent whose work they've spotted on the Internet, it's more than likely that they will get that tattoo when the tattooist, it turns out, is doing a week on Melrose in Los Angeles. And it's more than likely that that esoteric London talent is from

Argentina, came to London for a week, and somehow stayed. With the new bloods having the most time to travel, it is their new ideas that are spreading fastest – another reason we wanted to do this book.

As with any principle of selection, picking from the mass of talent out there wasn't easy.It boiled down to wanting to show as many styles, trends, movements as possible. So we have classic Old School, but with an original twist (Chazen); a highly technical illustrator who achieves dramatically detailed results (Young); the orientally-influenced Ben Cheese; the sharply contrasting Dani who brings Arabic motifs to his work; the almost art-deco elegance of Luca Font; the mystical and visceral imagery of Fernando Amador; David Hale's designs, anchored in the traditions of Native American art; the stunningly original baroque/ religious/ faded retro inspirations of Ramon Maiden; the amazing free-flowing inventions of Aaron Odell, rooted in the tradition, but with a fantastic power; the witty and girly Old School of Alessia Pedrosa; the perfectly-worked and highly original designs of Eva Schatz, created in her atelier in Salzburg. And these are just some of the artists in *New Blood* – picked at random to illustrate the simple point that the range of influences now is even wider than we can imagine.

One thing all the artists here have in common is how much they owe – as they mention in their biographies – to other artists' influence in arriving at their own individual styles. We're firmly convinced that the greater the ideas exchange, the more new styles will emerge. One of the ambitions for *New Blood* is that it should be part of that process. We chose not to show tattoos on skin – there's more than enough of that imagery out there. Rather, by selecting detailed flash and detailed art, we wanted tattooists to see the specifics of the creative processes that end up as ink on skin, so that they could see the techniques up close, get inspired and work new ideas into their own designs. For those wanting to get inked, *New Blood* is there to give an idea of the sheer range of new artists and tattoo art that's now emerging. The only downside is that it makes deciding what tattoo to have that much harder.

For me it's been an inspiring journey. As a tattooist it's given me a load of inspiration. As the General Editor, compiling this brilliant range of talents has been pure enjoyment. I hope you find it the same!

Allan Graves
London

FERNANDO AMADOR

"Ever since I can remember I had a pencil in my hand. And then I decided I liked tattoos and everything related to them. Becoming a tattoo artist was a natural progression." As an artist, he is self-taught "The type of institutionalised classes you get in school were not for me." The hardest thing, says Fernando, was finding someone to teach him. "At first I knew no one in the industry. It was just a case of walking around with my portfolio of drawings, trying to catch someone's attention." Having got his apprenticeship there was then a further blow: his teacher had to leave the country suddenly for legal reasons; "I was left in limbo for a couple of years, doing reception work and watching tattooists when I could." His breakthrough came when Xico, who he still works with (at Forevermore Tattoo in London), offered him an apprenticeship. Tattooing, says Fernando, has altered his work, making him apply less detail and creating more defined lines, "crisper, if you will." Favourite tattoo artists include Jeff Gogue, Victor Chil, Robert Hernandez and Thomas Hooper. "They all have different styles, but each transmits something unique which I can use in my own designs." His influences are medieval and pre-medieval history, horror films and H. P. Lovecraft's work and also "paganism and nature." When not tattooing, Fernando also works as a concept artist for the film production outfit, Wyldewood Productions.

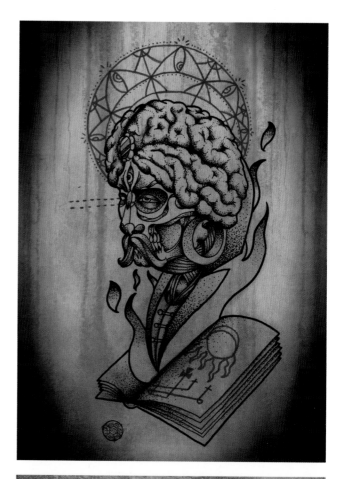

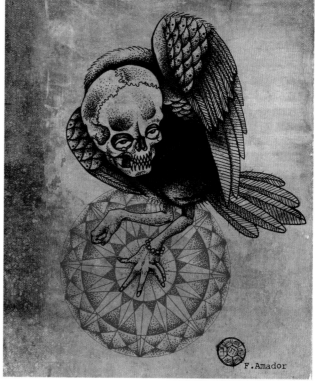

ABOVE: *Fakir*.
Ink on paper.

RIGHT: *Skull Crow*.
Ink on paper.

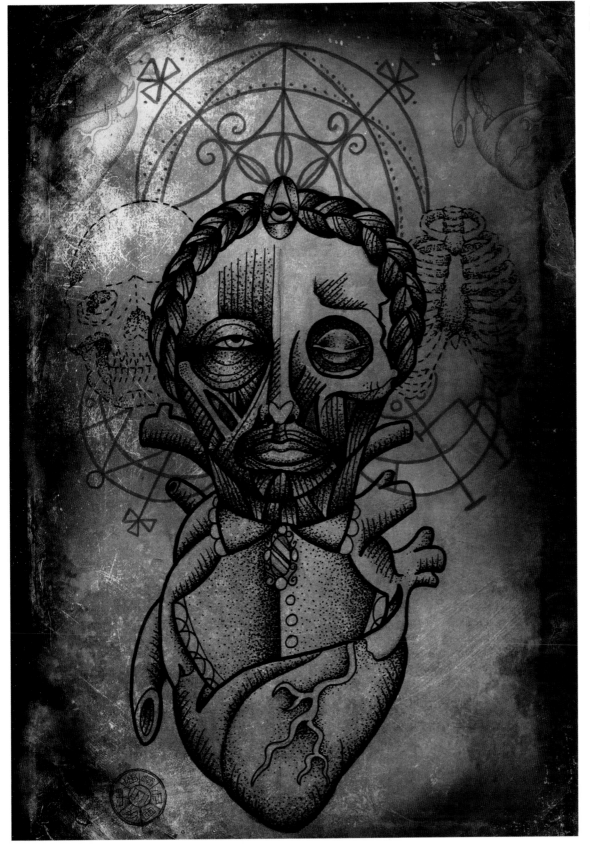

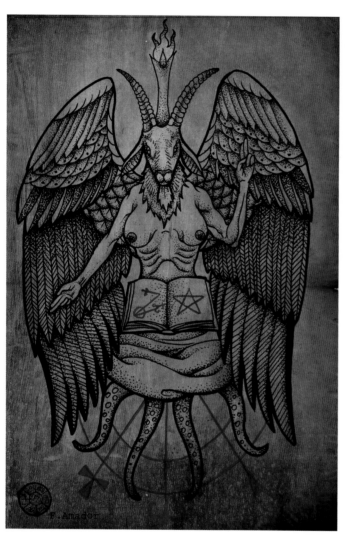

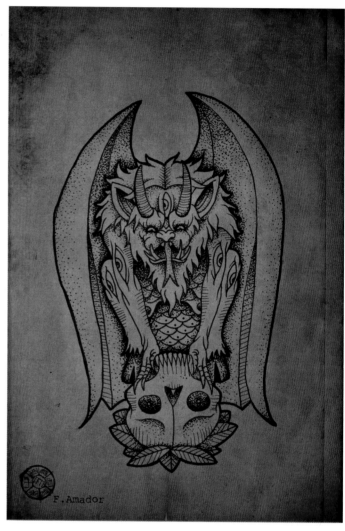

ABOVE: *Baphomet.*
Ink on paper.

ABOVE RIGHT:
Gargoyle.
Ink on paper.

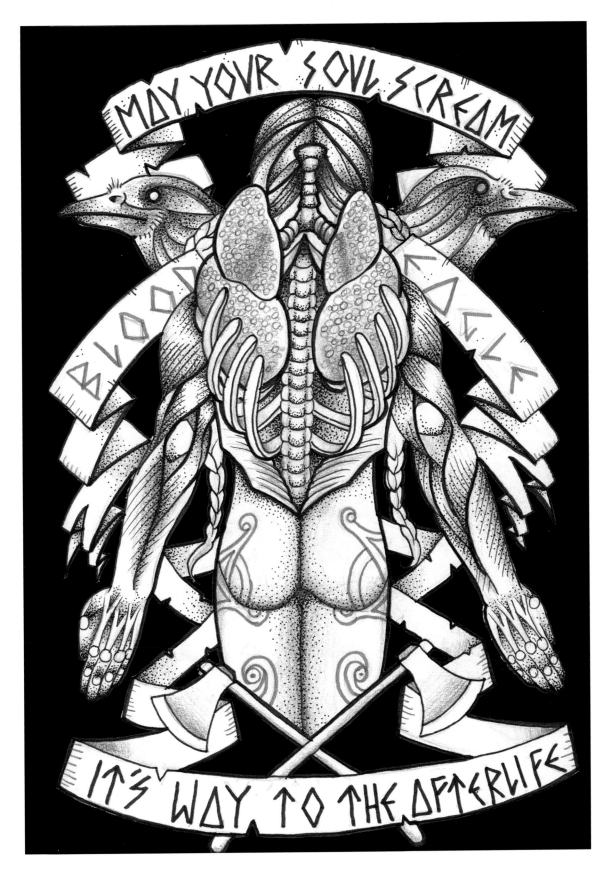

LEFT: *Blood Eagle.*
Ink on paper.

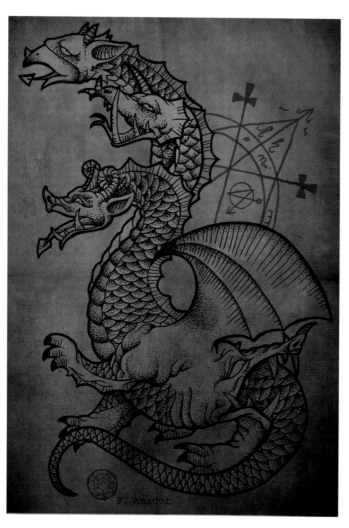

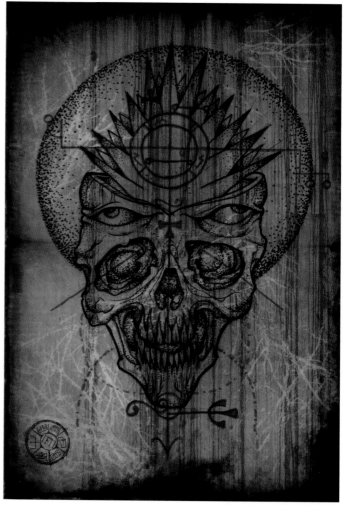

ABOVE: *Tiamat*.
Ink on paper.

ABOVE RIGHT: *Brain Storm*.
Ink on paper.

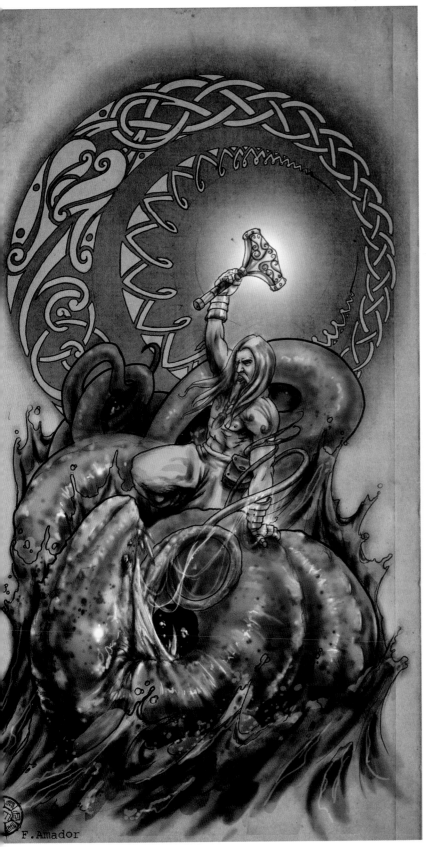

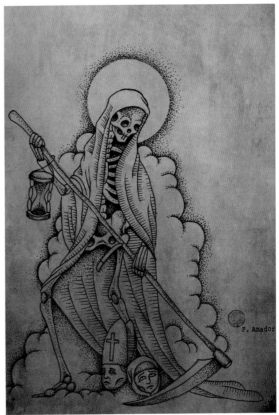

LEFT: *Thor v Jormungandr*.
Ink on paper.

ABOVE: *Death*.
Ink on paper.

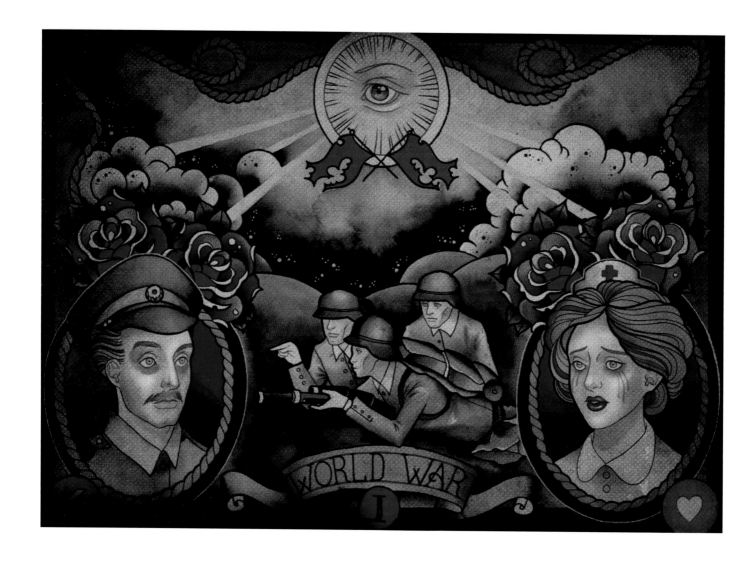

MYRA BRODSKY

When Myra was 16, she realised that she could use her considerable drawing talent to create tattoos. "My very religious parents used to force me to attend Jewish school classes. The fact that they banned tattoos there only made me keener!" The first moves were tough. "No one took me seriously when I arrived, as a rather shy girl, in Berlin." She had a few jobs, got fired three times and left of her own accord twice. That was when she decided to open her own shop, The Decay Parlour in Prenzlauer Berg, and she hasn't looked back. Her clients are broad-ranging, from professionals like academics, doctors and lawyers, to creatives and graphic designers. Myra's work has now been featured in *Vice*, *Total Tattoo Magazine* and in *Mitteschön Berlin*. When not tattooing, she is much in demand with media agencies, as an illustrator for art nouveau packaging designs. Of the scene she says "The tattoo scene is clearly moving into the art world. Where it will end up, or whether that's a good thing, who knows ? I do know however, that no one will regret getting a big aesthetic tattoo piece done."

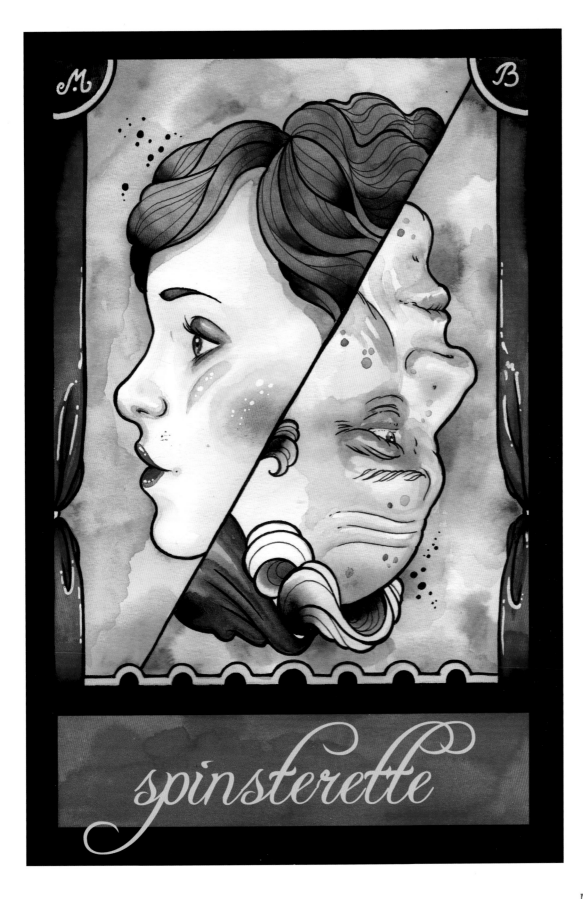

FAR LEFT: *World War I.*
Acrylic on canvas.

LEFT: *Spinster.*
Watercolour on paper.

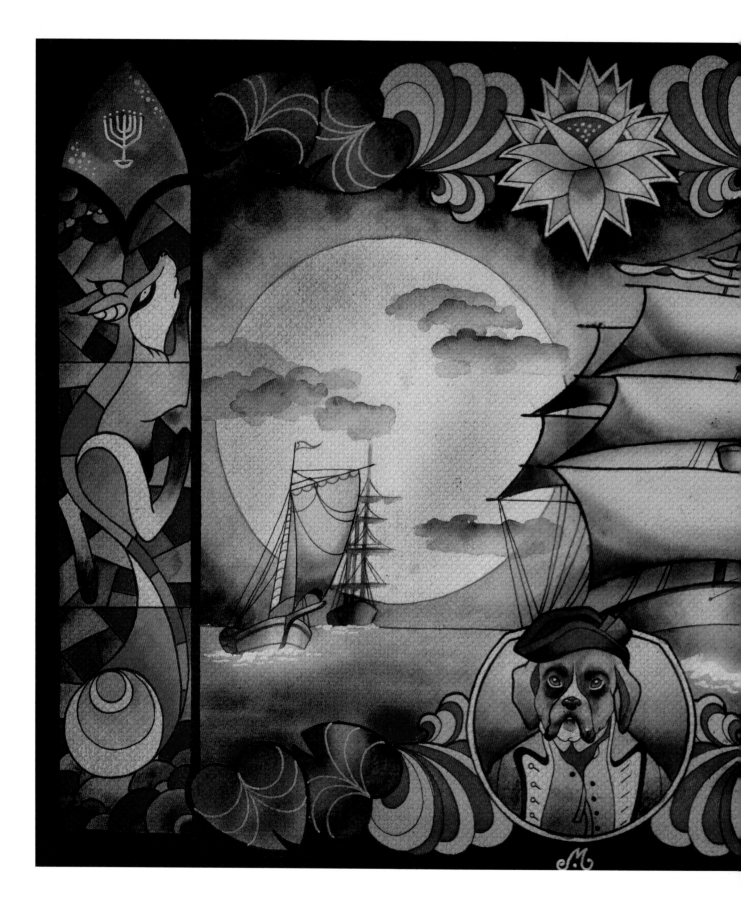

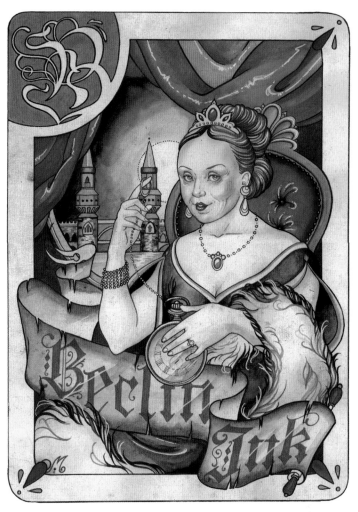

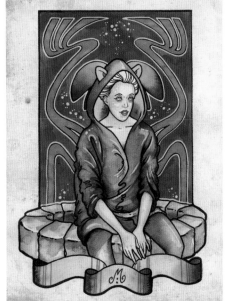

FAR LEFT: *Commodore*. Acrylic on canvas.

LEFT: *Damned Small*. Watercolour and ink on paper.

ABOVE: *Queen of Berlin*. Watercolour and ink on paper.

LEFT: *Squire.*
Acrylic on canvas.

RIGHT: *Decay Parlour.*
Acrylic on canvas.

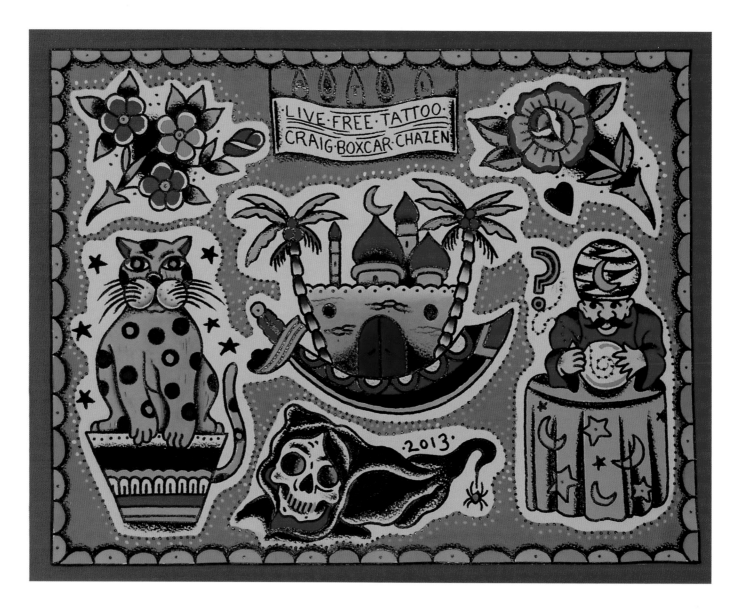

CRAIG CHAZEN

Chazen went through a time of lots of odd jobs, all of them dissatisfying. The one constant in his life was getting tattooed and "so I thought, hey, why not become a tattoo artist?" The start was tough and intimidating: walking into shops asking for apprenticeships, talking to heavily tattooed artists, "and then it turned really scary when you're holding that machine in your hand and you think 'damn, I'm about to fuck up.'" He began at Cow Pok, in Buffalo NY (whilst also working in a car assembly plant – not much time for sleep); he now works at Live Free Tattoo in Atlanta, GA. His technique is "hard and fast, American-style traditional tattooing." Amongst many influences are early Americana folk art and early advertising: "I love sifting through the past to see what can be brought to new life." Inspiration comes from so many artists and writers – "Jason Kelly, Grez, Josh Mason, Jeff Zuck, Andrew Stickler, Cap Coleman, Percy Waters, Tom Waits, Jack Kerouac, Charles Bukowski to name only a good few."

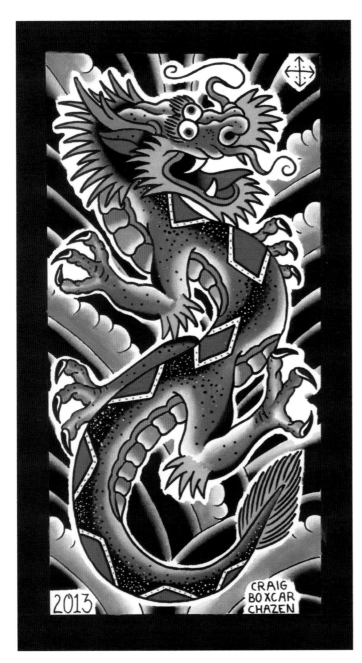

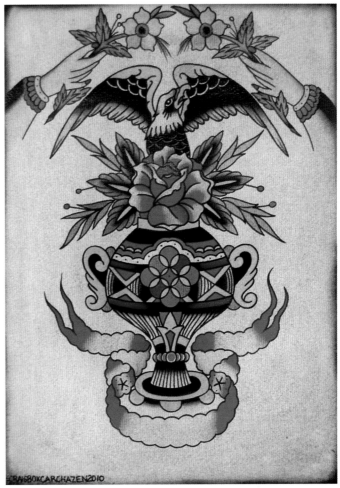

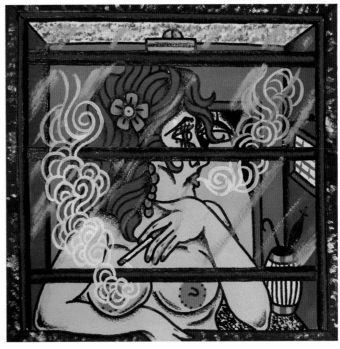

LEFT: *Live Free Tattoo.*
Acrylic on paper.

ABOVE: *Dragon.*
Acrylic on paper.

ABOVE RIGHT: *Rose and Eagle.*
Acrylic on paper.

RIGHT: *Smokin'.*
Acrylic on paper.

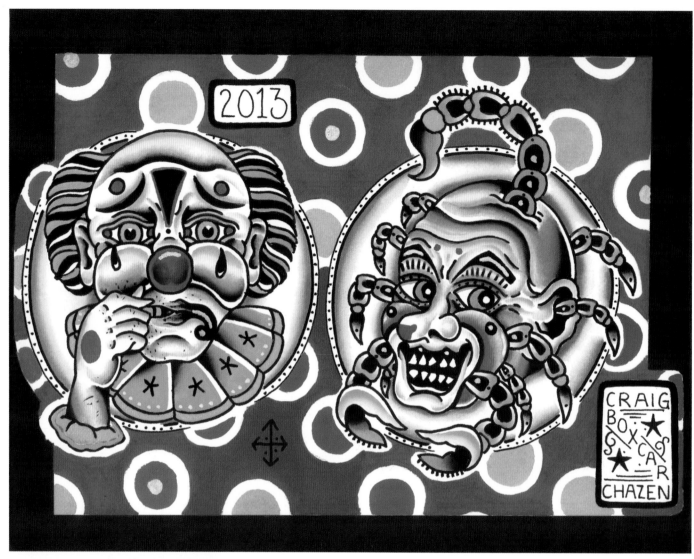

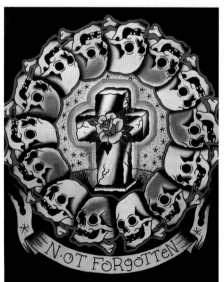

ABOVE: *Scorpion Clown.*
Acrylic on paper.

LEFT: *Not Forgotten.*
Acrylic on paper.

ABOVE RIGHT: *Tattoo Clown.*
Acrylic on paper.

RIGHT: *Live Free II.*
Acrylic on paper.

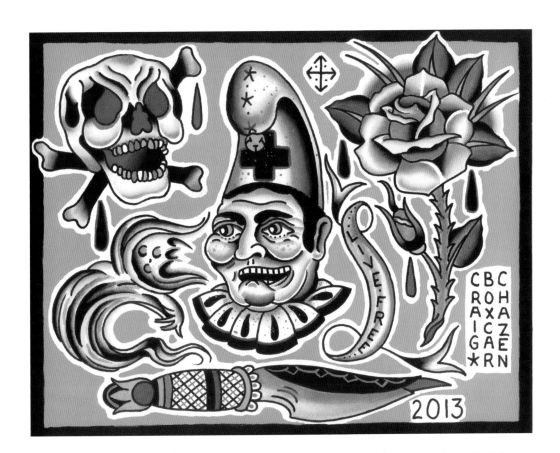

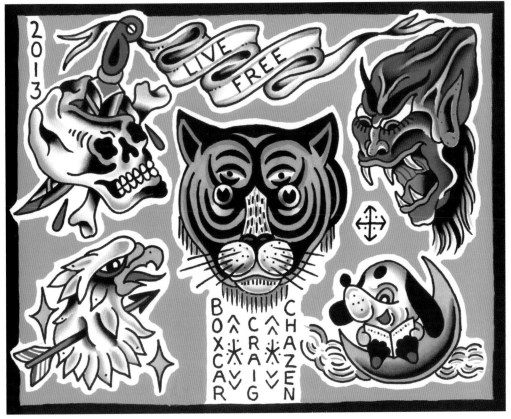

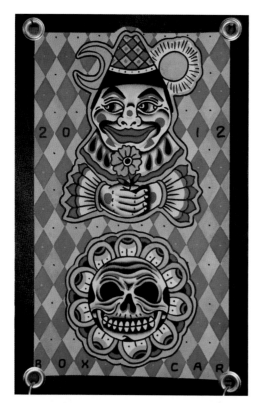

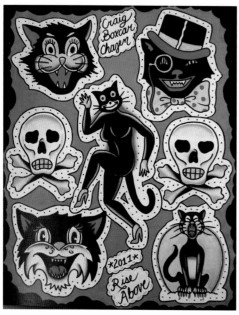

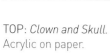

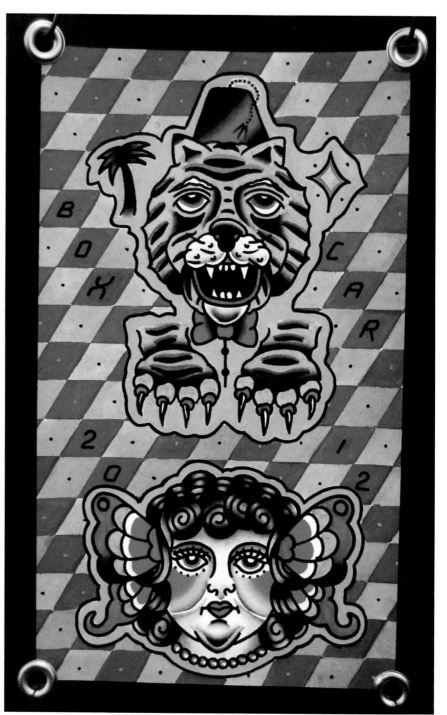

TOP: *Clown and Skull.*
Acrylic on paper.

ABOVE: *Rise Above.*
Acrylic on paper.

ABOVE: *Tiger and Butterfly Girl.*
Acrylic on paper.

RIGHT: *Rose and Skull.*
Acrylic on paper.

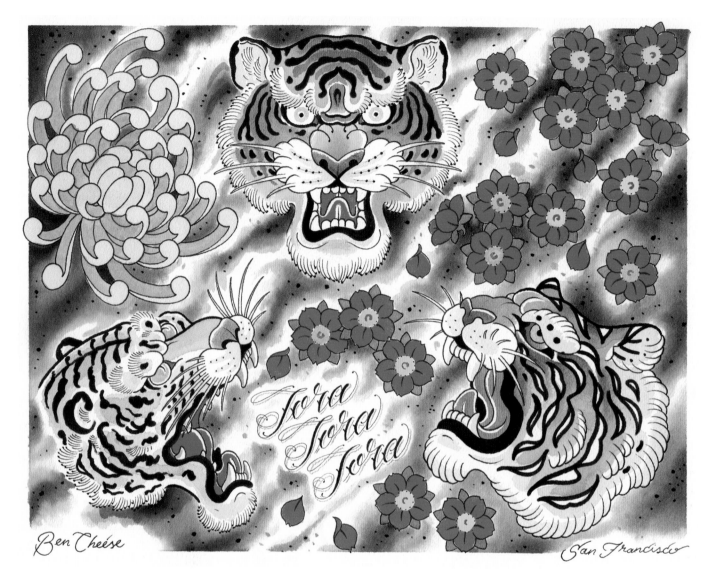

BEN CHEESE

"I was really influenced to get into tattooing by the tattoos worn by Marilyn Manson and other rock bands. My friends and I just started hanging around tattoo shops in San Luis Obispo and checking out all the amazing flash on the walls. The work of Aaron Cain and Frank Lees stuck out, for some reason," says San Francisco-based Cheese. The early years were the usual story of getting turned down for an apprenticeship by a load of tattoo shops. Cheese gave up on the idea of becoming a tattoo artist and focused on playing music. Then his chance came, at Monkeywrench Tattoo in Santa Rosa, CA. "Justin Shaw there helped me so much; I owe that man a lot." Cheese is inspired by a load of sources, but particularly admires the Japanese tradition. Amongst tattooists he cites his main influences as "Justin Shaw and Jesse Swanson (both now with Faith Tattoo), Mike Rubendal, Henning Jørgensen and Tim Lehi." Now based at Everlasting Tattoo, Cheese says "the guys there are an amazing group. They're constantly pushing me to do better and better stuff."

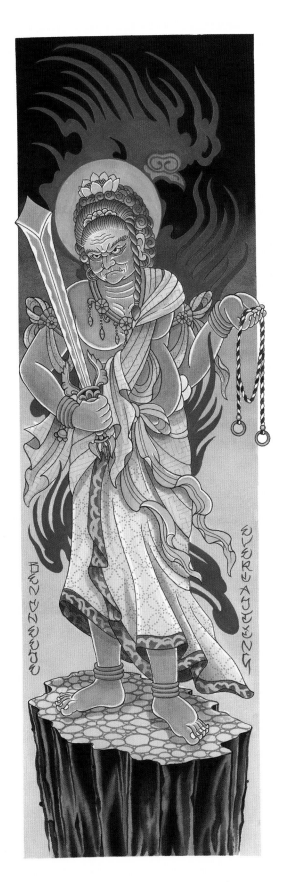

FAR LEFT: *Three Tigers*.
Watercolour and ink
on paper.

LEFT: *Fudo*.
Watercolour and ink
on paper.

BELOW: *Iron Maiden*.
Watercolour and ink
on paper.

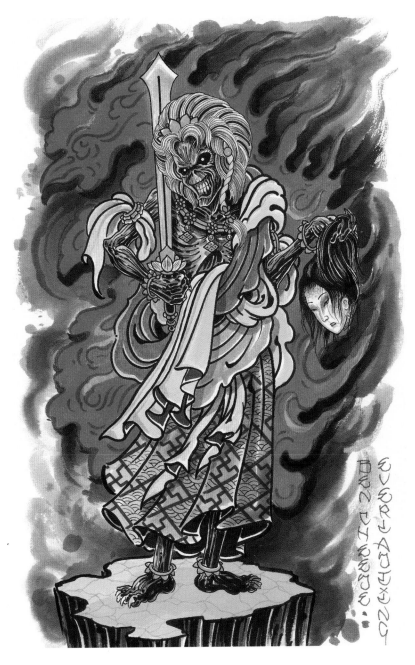

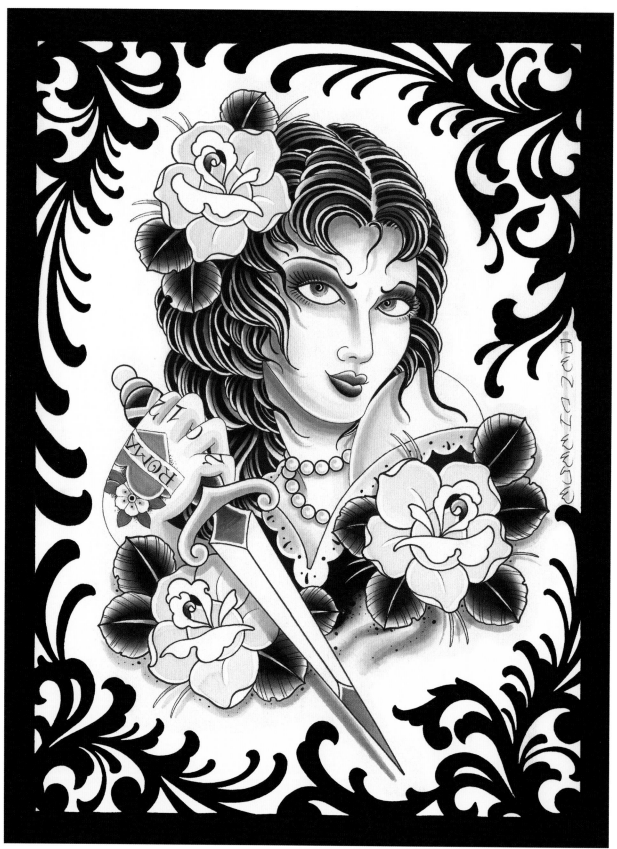

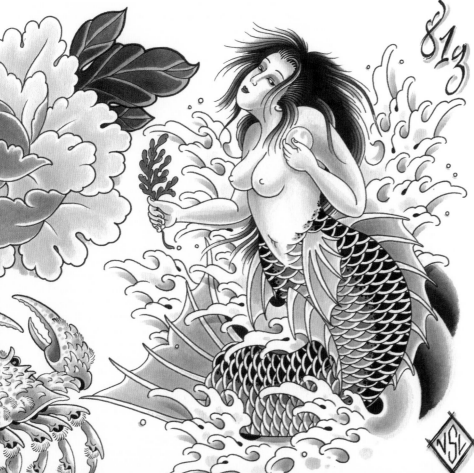

FAR LEFT: *Roma.*
Ink on paper.

ABOVE: *Everlasting
Tattoo.*
Ink on paper.

LEFT: *Mermaid.*
Ink on paper.

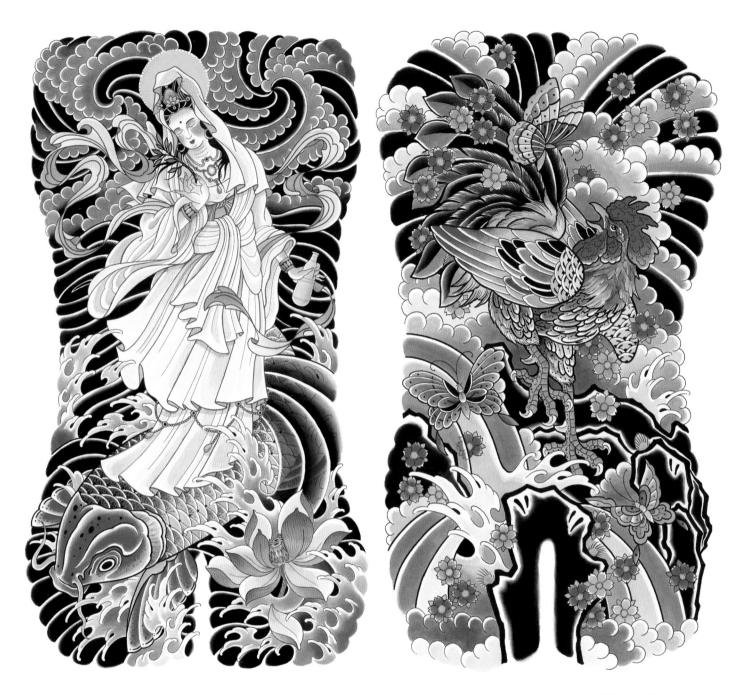

ABOVE LEFT: *Kuan Yin*.
Watercolour and ink
on paper.

ABOVE: *Rooster*.
Watercolour and ink
on paper.

RIGHT: *Chola-Geisha*.
Watercolour and ink
on paper.

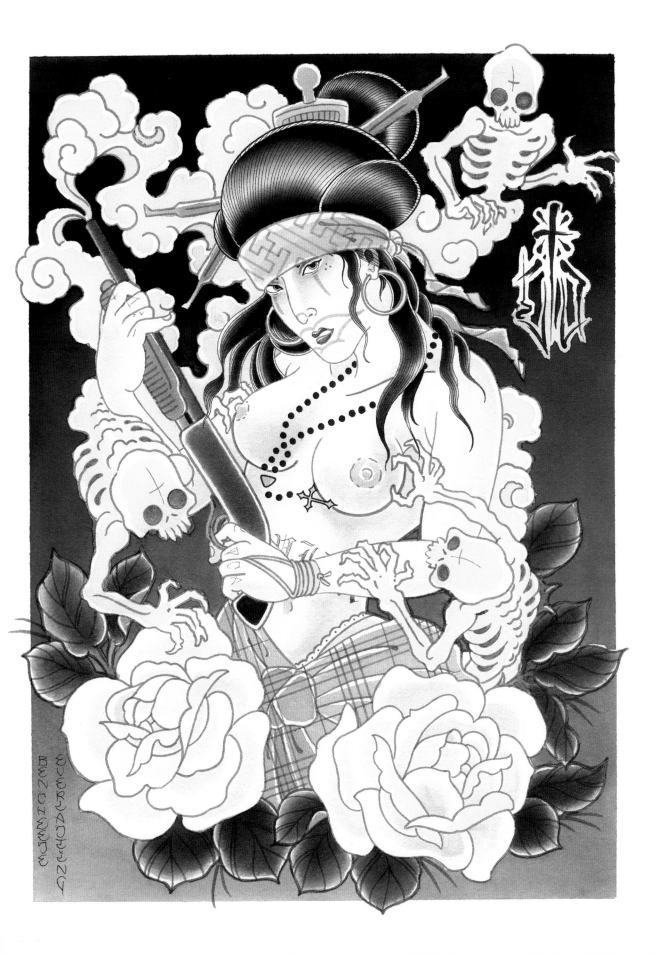

31

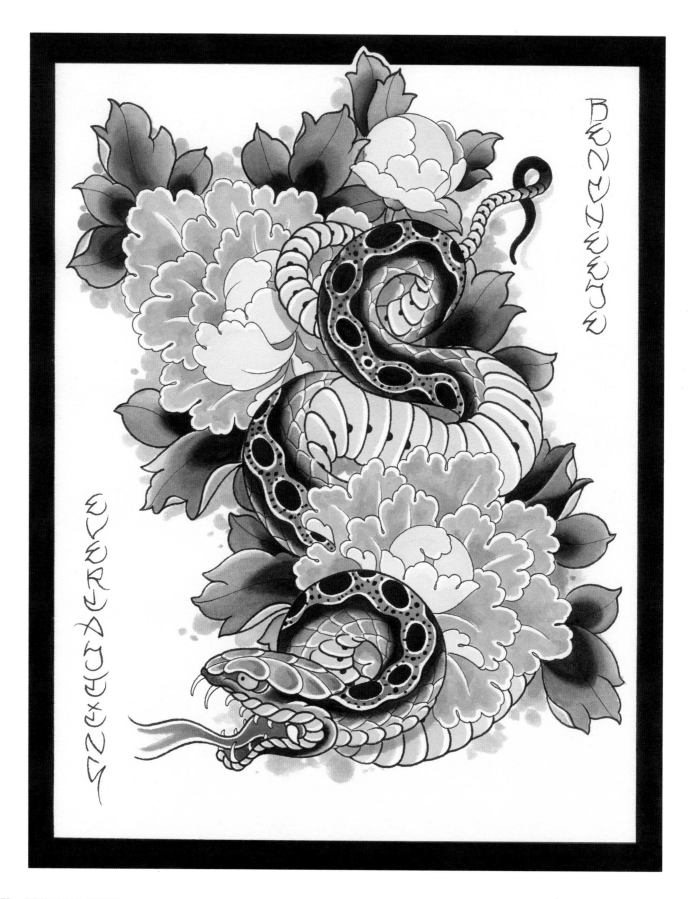

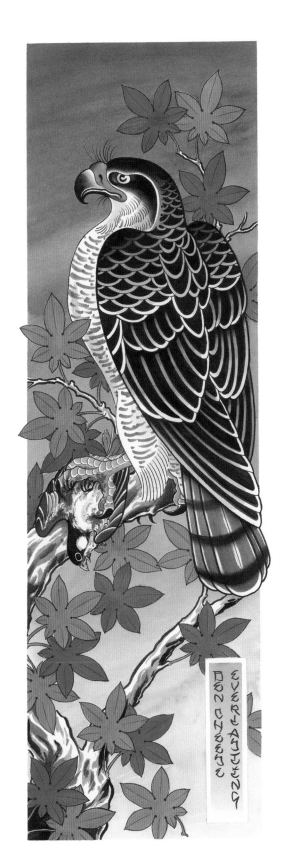

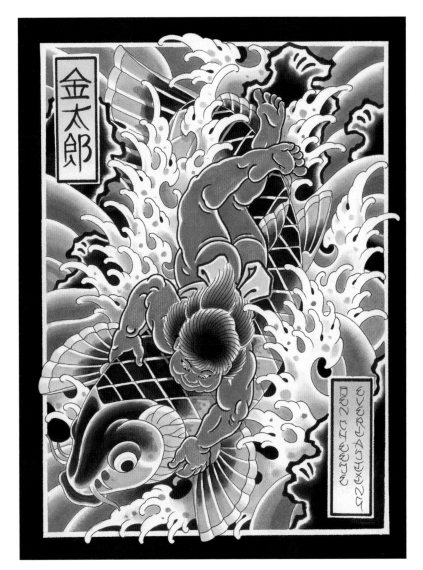

FAR LEFT: *Peonies and Snake.*
Watercolour and ink on paper.

LEFT: *Hawk.*
Watercolour and ink on paper.

ABOVE: *Kintaro.*
Watercolour and ink on paper.

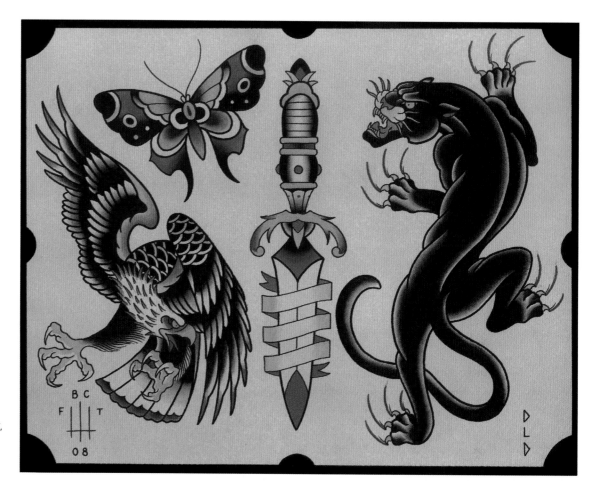

RIGHT: *Eagle, Knife and Panther*. Watercolour and ink on paper.

BELOW: *Goddess*. Watercolour and ink on paper.

BELOW RIGHT: *Heart, Eagle, Skull and Girl*. Watercolour and ink on paper.

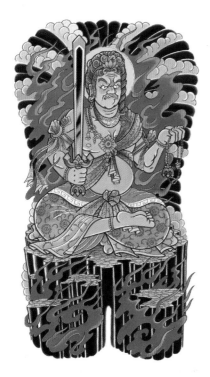

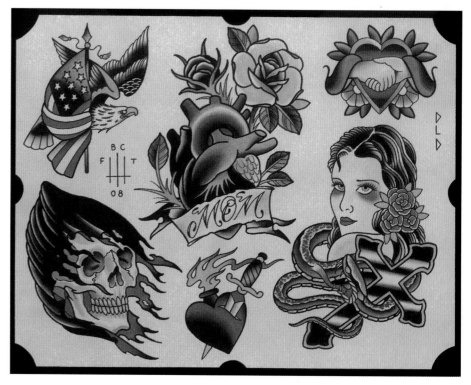

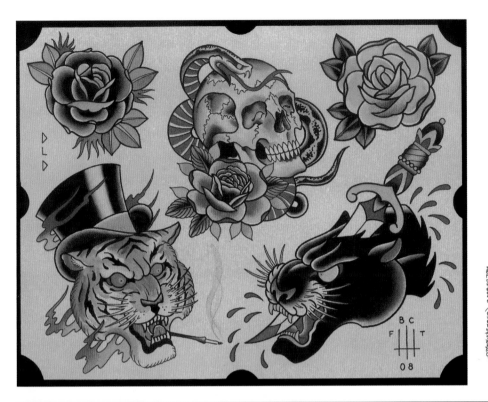

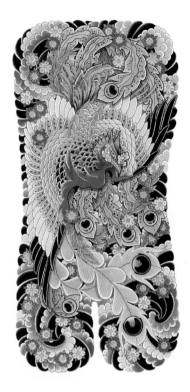

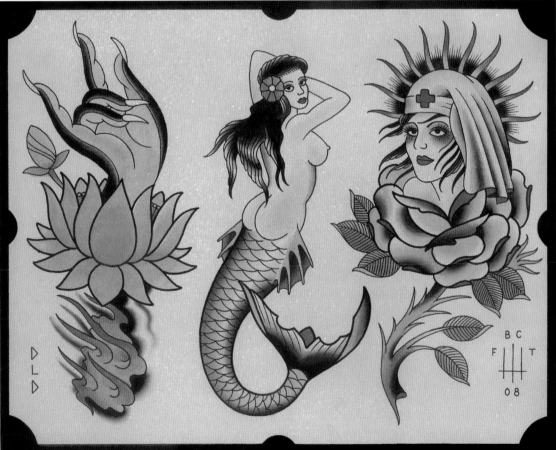

ABOVE LEFT: *Skull, Roses and Big Cats*. Watercolour and ink on paper.

LEFT: *Lotus-Hand, Mermaid and Nurse*. Watercolour and ink on paper.

ABOVE: *Phoenix*. Watercolour and ink on paper.

DANI

"I knew I didn't want a five-day-per-week
desk job and I just love creating art. Tattooing
could provide me with the sort of life I
wanted, you know; getting paid for my art
and using the creative part of my brain was
a great deal," says Dani. He was managing a
tattoo shop in Lisbon, Portugal and tattooing
at home when, on impulse, "I decided it was
now or never, I just went ahead and opened
my own shop." Three years later he went
to London to meet more artists, followed
by more travel "so I could learn and share
from other tattoo artists." Dani works with
watercolour pencils for his sketches, creating
his distinct symbolic style: "I think that's why
people come to me – they increasingly like
meaning and symbolism in their work. And,
sure, the fact that I'm quite a nice guy also
helps!" He finds everything inspiring, rock
bands in particular. As well as flash designs
for tattoos, Dani wants to create much larger
art pieces for a future gallery show. Of tattoo
in general he says, "It will go from strength
to strength. We are all part of a movement,
where all cultures and influences are
merging into one enormous global culture.
Tattoo is part of this, influencing other art
forms and getting influenced in turn."

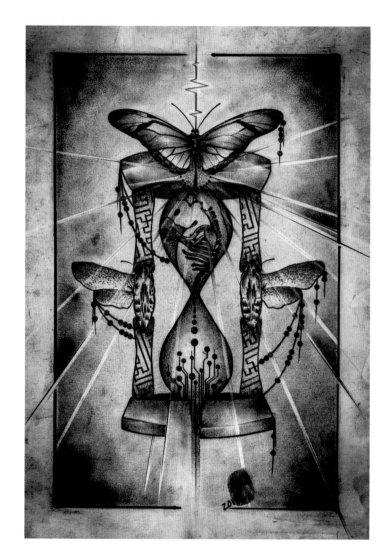

ABOVE: *Butterfly and Time.*
Watercolour pencil
on paper.

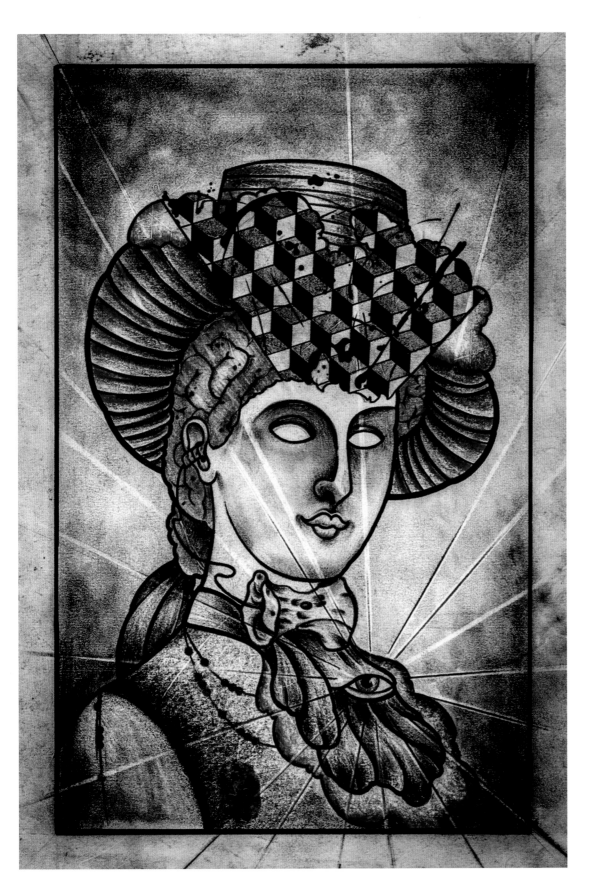

LEFT: *Consciousness*.
Watercolour pencil
on paper.

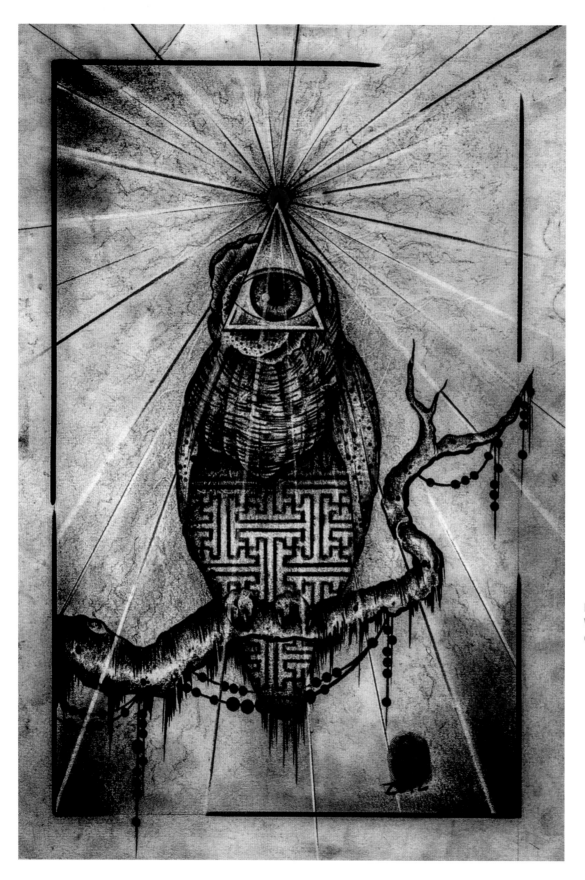

LEFT: *Owl and Eye*.
Watercolour pencil
on paper.

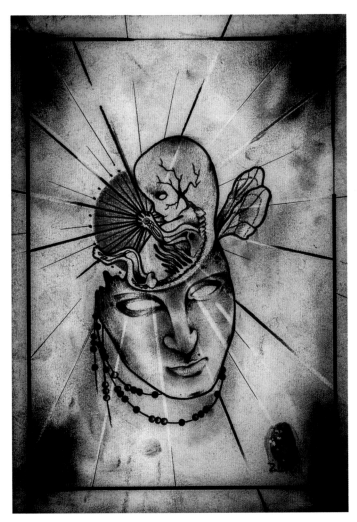

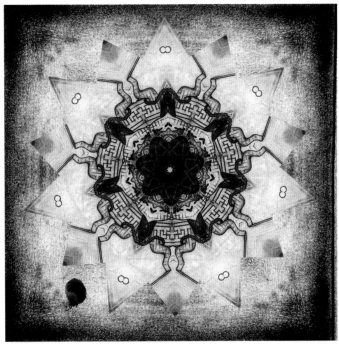

ABOVE: *Mask and Winged Foetus.* Watercolour pencil on paper.

ABOVE RIGHT: *Kaleidoscope I.* Watercolour pencil on paper.

RIGHT: *Kaleidoscope II.* Watercolour pencil on paper.

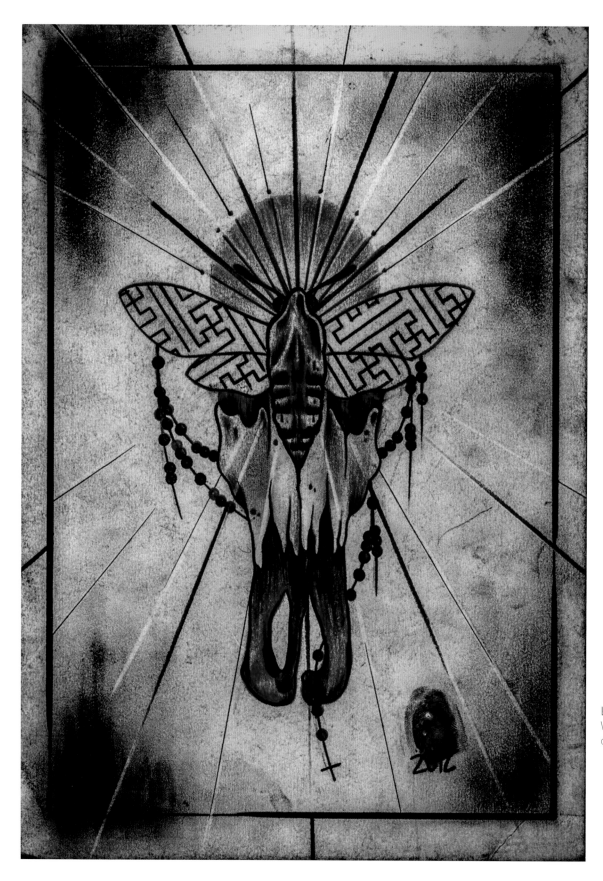

LEFT: *Moth*.
Watercolour pencil
on paper.

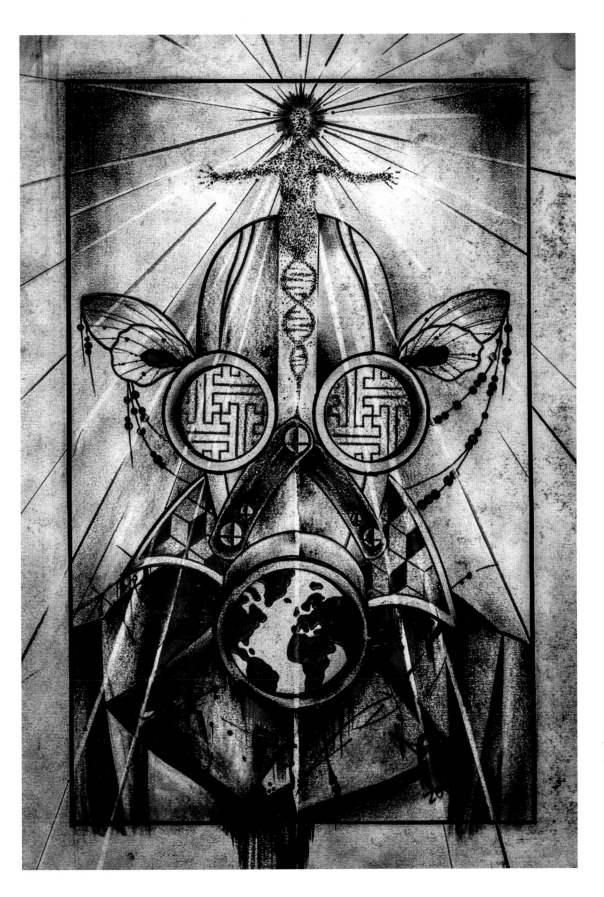

LEFT: *Chimera with Gas Mask.* Watercolour pencil on paper.

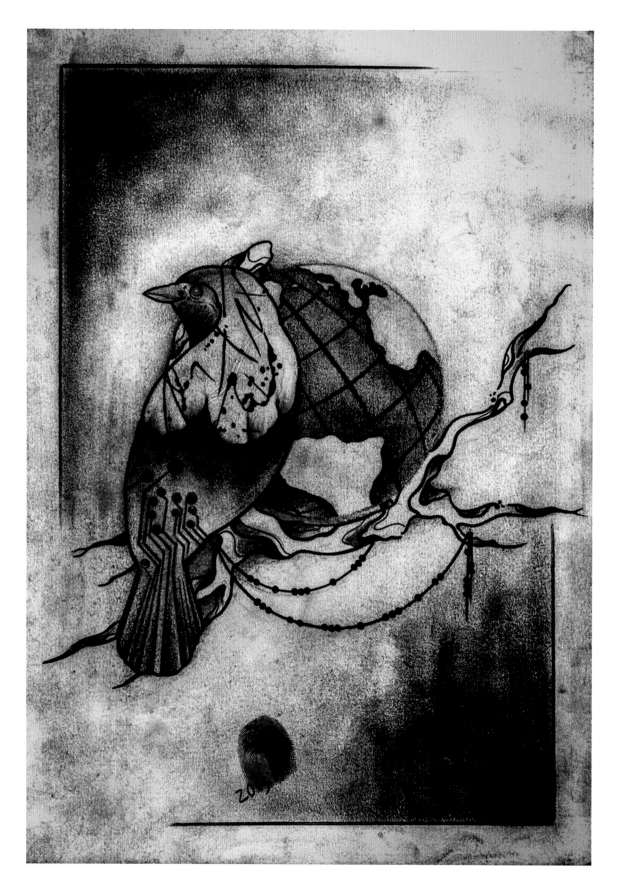

LEFT: *Black Bird.*
Watercolour pencil
on paper.

ABOVE: *Kaleidoscope III.*
Watercolour pencil
on paper.

RIGHT: *Kaleidoscope IV.*
Watercolour pencil
on paper.

LUCA FONT

"When I came across Americana tattooing I had no clue what it was, but it looked good to me, that's what got me into being tattooed" says Luca Font. Starting out was like "playing *Tony Hawk Pro Skater* until you start thinking you could do the same thing and then you realise that it's harder doing it with a board rather than a control pad... yeah, you could say it was a little frustrating at the start." Now based at Skin Fantasies in Bergamo, Italy (But with frequent trips to Buenos Aires), Luca draws mostly with ink on paper, occasionally acrylics or paint. Rather than influences specifically from tattoo culture Luca says "If it looks good, I'm into it. I collect a little bit of everything, from old books to video games, posters, flyers – my house will always be a mess and I'm glad about that." His art school was graffiti – "so many great artists" – a world he got into in his early teens. Today his clients come to him, he thinks, "maybe because they want some long-haired guy who barely speaks to them so they can sleep in the chair." As far as tattoo becoming mainstream he says "I'm sure there was a golden age which has passed, but we can't worry about that. When tattoos cease to be fashionable and then work begins drying up, then we can worry."

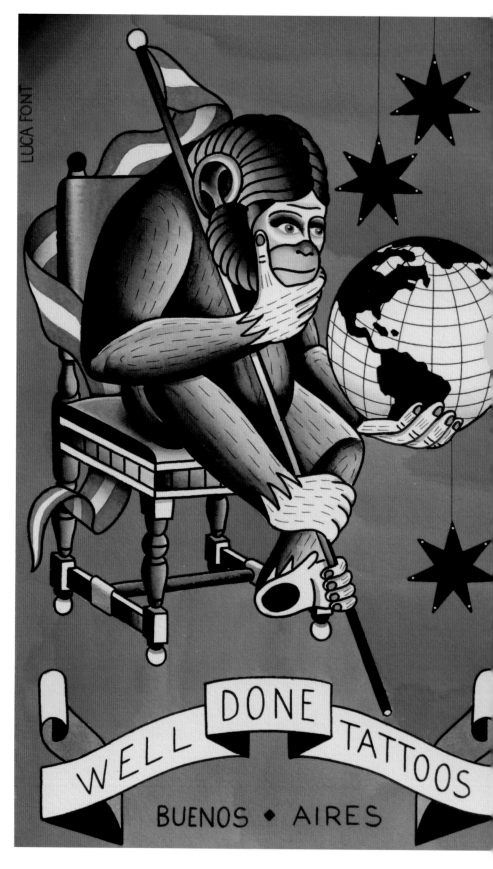

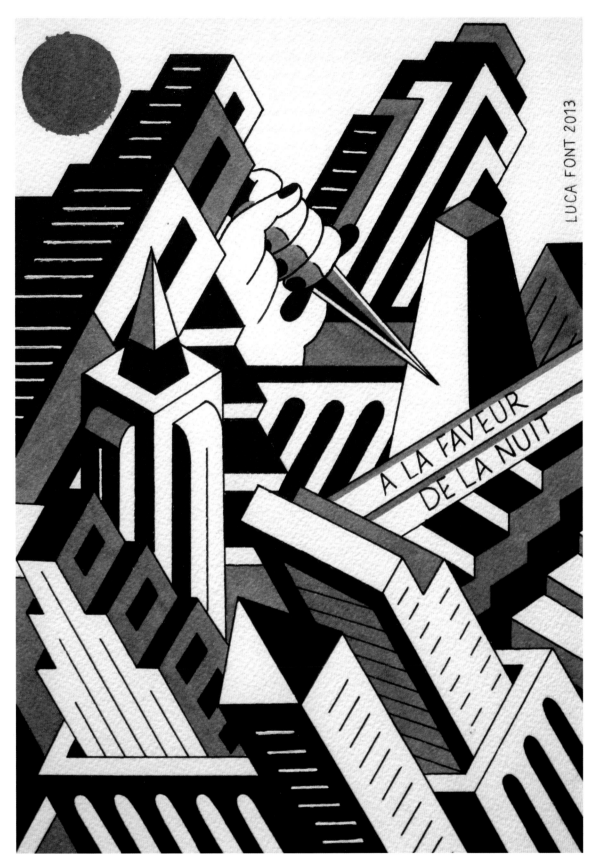

FAR LEFT: *Well Done Tattoos.*
Ink on paper.

LEFT: *A la Faveur de la Nuit.*
Ink on paper.

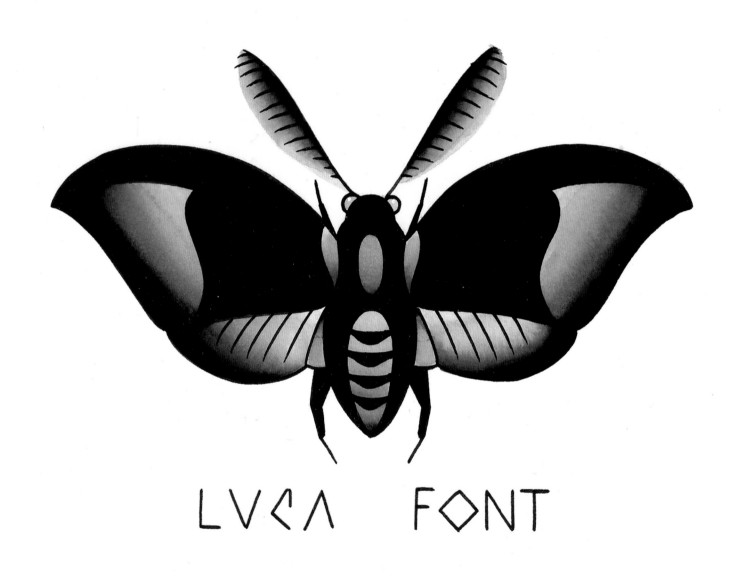

ABOVE: *Personal Logo.*
Ink on paper.

RIGHT: *Entomology.*
Ink on paper.

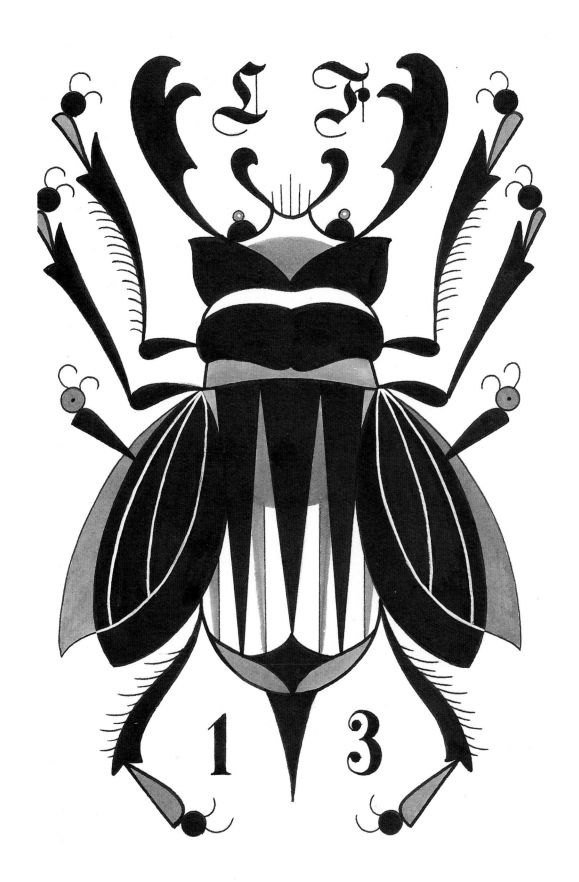

LEFT: *This World's an Accident (detail).* Ink on paper.

RIGHT: *The Clairvoyant.* Ink on paper.

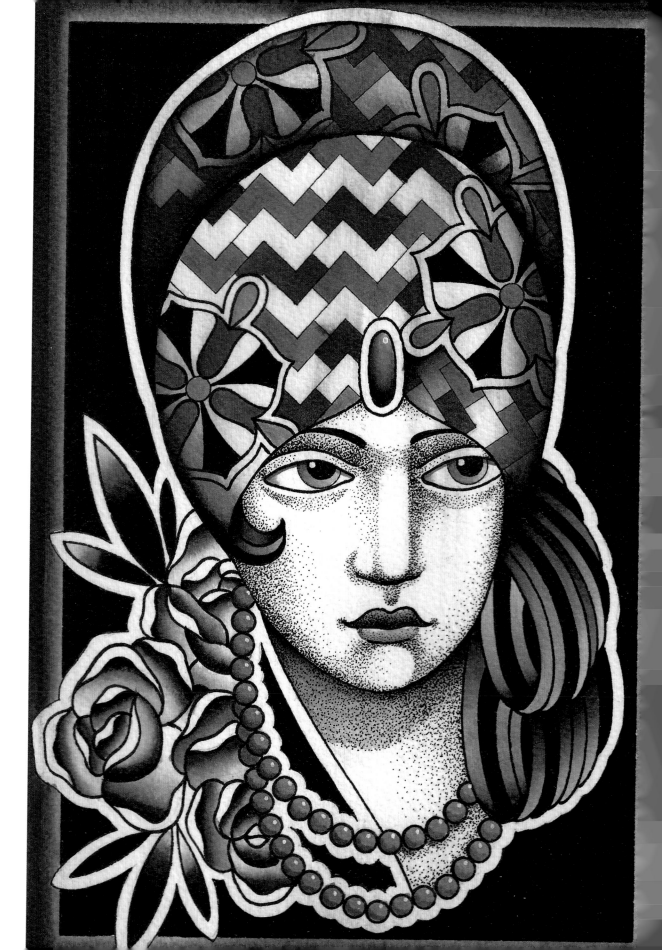

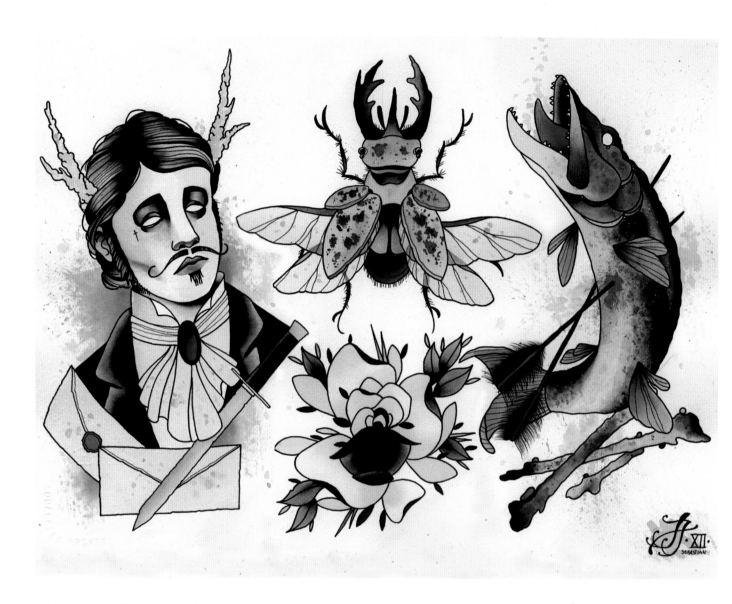

SEBASTIAN FORSBERG

"Some of my earliest memories were watching my dad paint bad ass paintings on canvas... both my parents were amazing artists, and that was formative." Sebastian knew he would have to work at something he loved, and that was tattoo. The beginning was hard. "I was super broke and super tired. I worked all day as an apprentice and spent all night drawing and painting." That was at 4-Ever Tattoo in Sweden, where he is still based. He works with ink and watercolour and tries to develop as original a style as possible. "I take inspiration from everything – including folklore and movies – except from other exciting tattoos." When working on a tattoo Sebastian says "I get super-stoked on everything; I want everything to be unique and fresh so every customer leaves with the very best tattoo I've done up to that point." Originally Sebastian was into the darker styles of artists like Derek Noble and Rachi Brains. "Now I try to dig deeper; I'm super into Japanese." Sebastian is part of the KOTH art collective. "It's great to be working with people who are in the same position as you. We keep pushing each other every day."

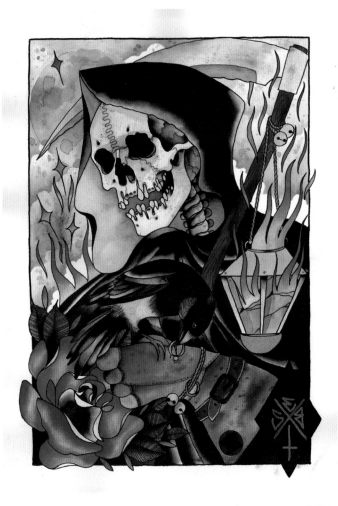

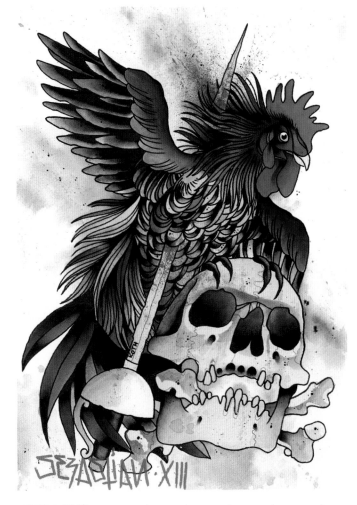

LEFT: *Scandiflash*.
Ink and acrylic on
paper.

ABOVE: *Grim Reaper*.
Ink and acrylic on
paper.

ABOVE RIGHT: *Rooster*.
Ink and acrylic on
paper.

RIGHT: *Flash*.
Ink and acrylic on
paper.

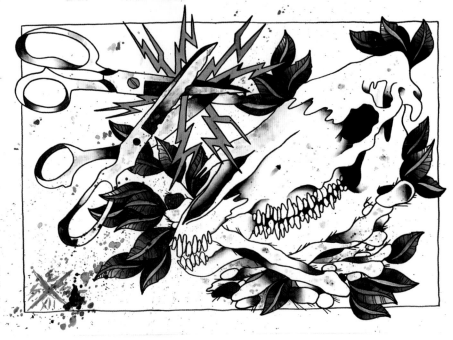

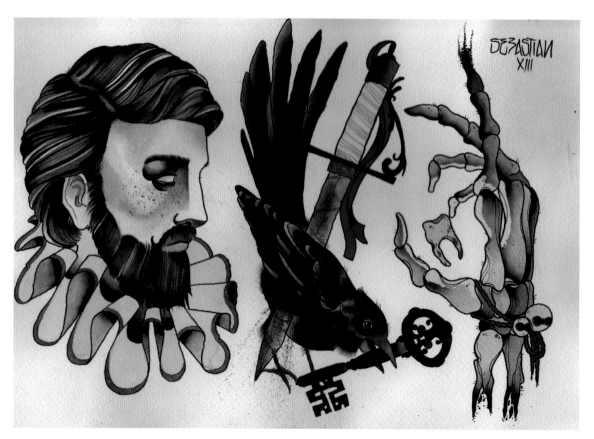

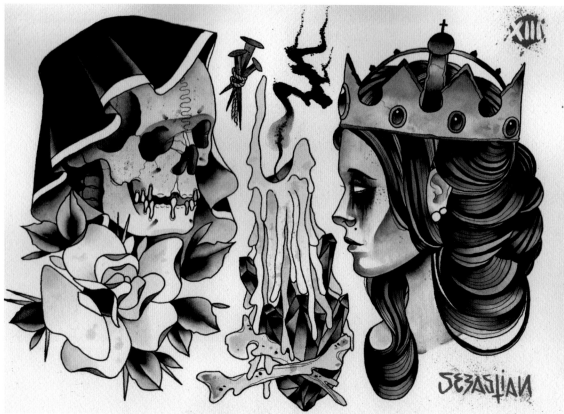

ABOVE LEFT:
Black Craft.
Ink on paper.

LEFT: *New Reaper.*
Ink on paper.

RIGHT: *Locust.*
Ink on paper.

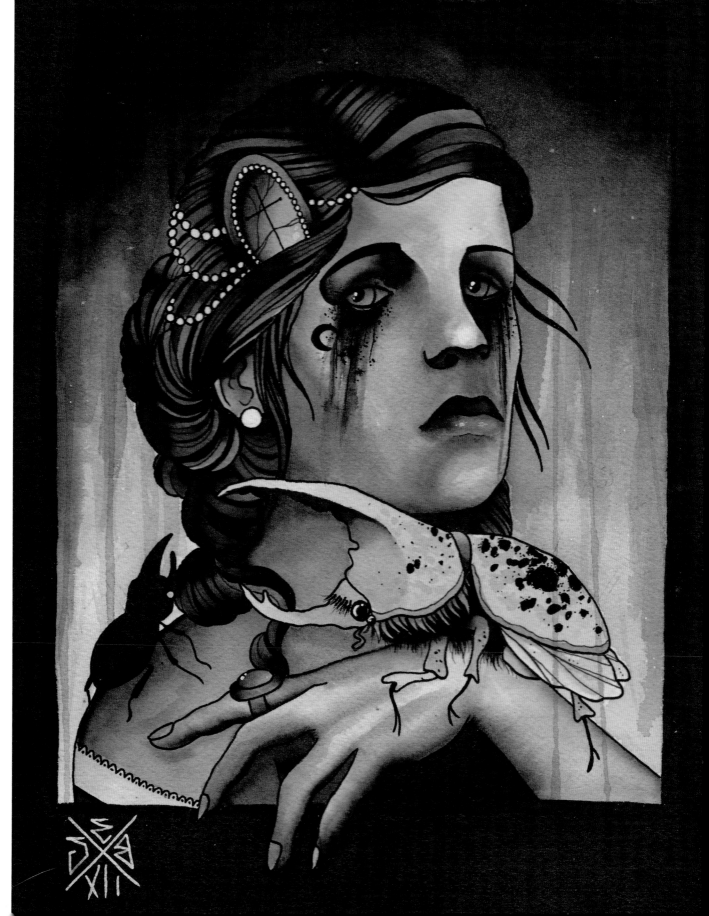

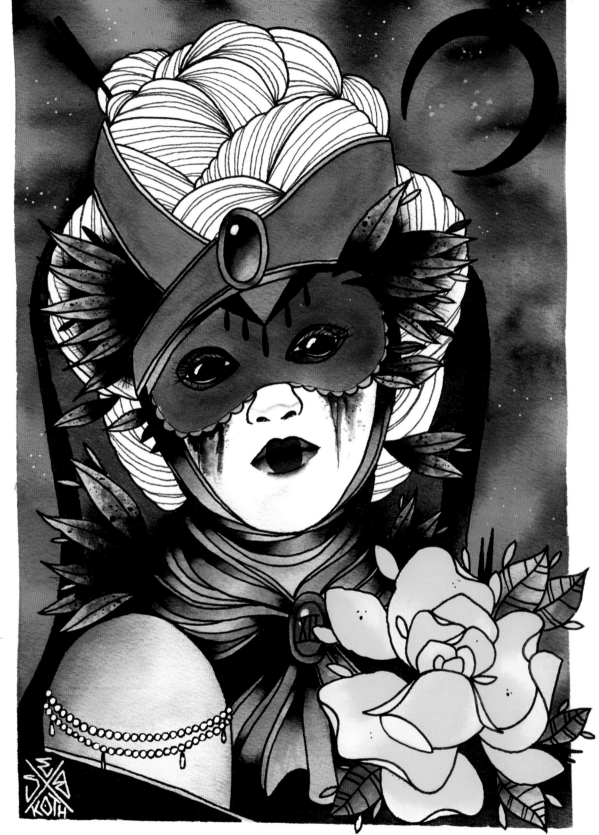

RIGHT: *Venice Ghost*.
Watercolour and ink
on paper.

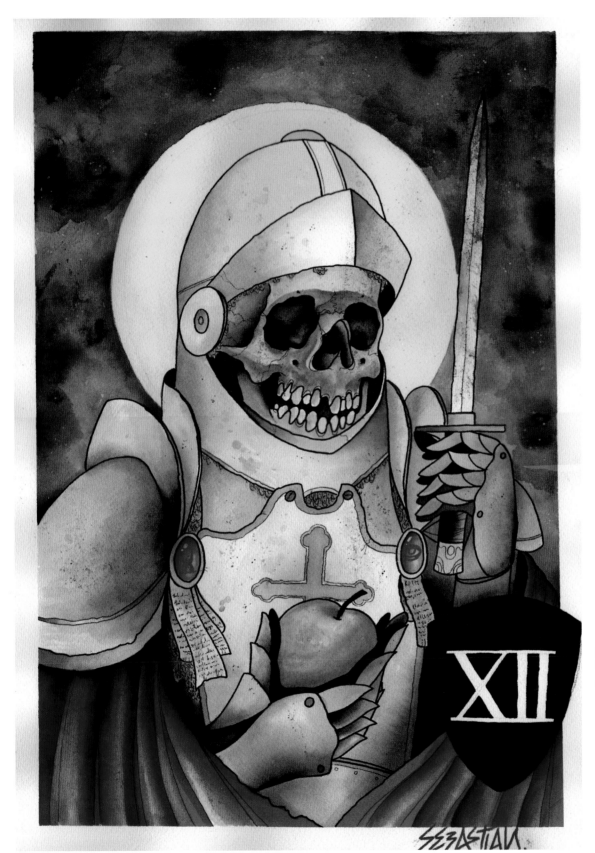

LEFT: *Death*.
Watercolour and ink
on paper.

DANI GREEN

"I grew up in a household where computers and TV were frowned upon, so drawing became my creative escape as far back as I can remember" says Dani Green. "I thought about tattoos early on, but it was only at the age of 19 that I got my first one. It was after that that I thought this world could hold more opportunities for me." She had two apprenticeships – "creating tattoos on willing guinea pigs" – before joining Love Hate Tattoo in Edinburgh. Today her customers are constantly pushing her art in new directions and now she is applying tattoo techniques to her artworks. Dani says that she doesn't want to be know for just one thing, but wants to adapt her style in multiple directions. For inspiration she taps first and foremost into her imagination. "I don't want to lose that sense of creating something which is mine. But of course I admire and am influenced by tons of artists, from Goya to Junko Mizuno. And then there are tattooing geniuses like Jason Minauro. It means a lot when he gives my work the nod. Dani did study Fine Art at university ("to appease my parents") but found the experience constraining; "it took me one year after graduating to find my creative spark again." The scene, she reflects, has exploded in recent years, and whilst that offers more opportunities for talented artists, it has also allowed amateurs "who butcher peoples' skin" into the game. "Tattooing requires integrity, passion and very hard work. It's not some X-Factor contest."

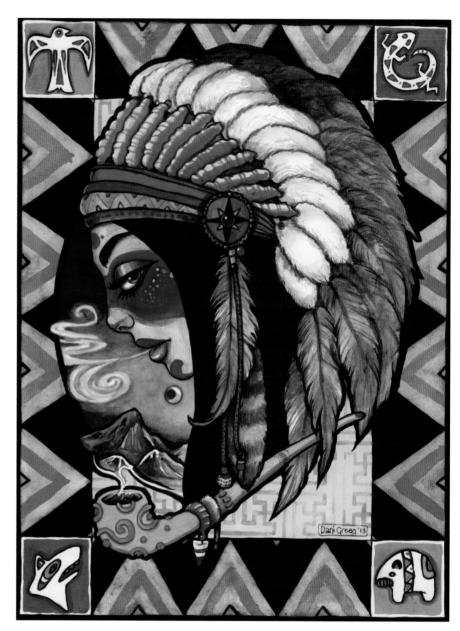

ABOVE: *Indian.*
Watercolour ink on paper.

RIGHT: *Native American.*
Watercolour ink on paper.

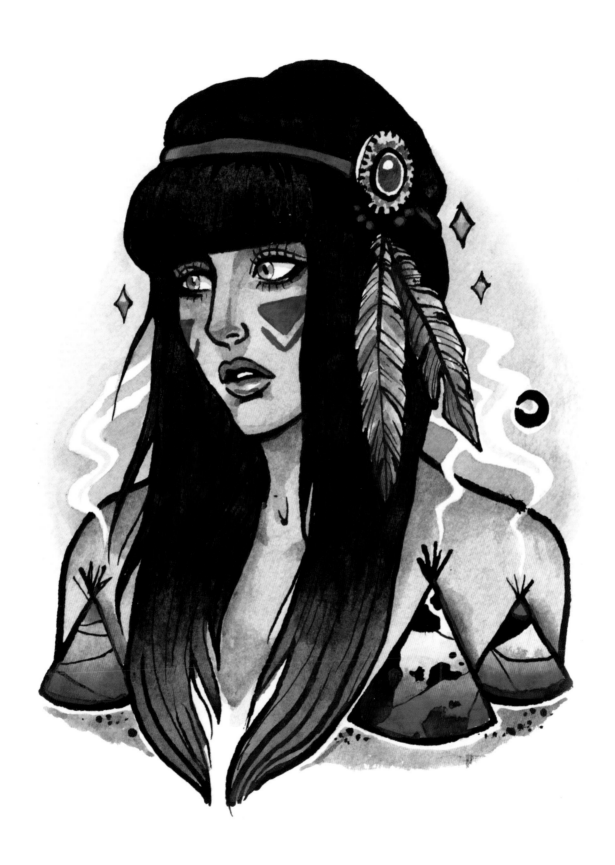

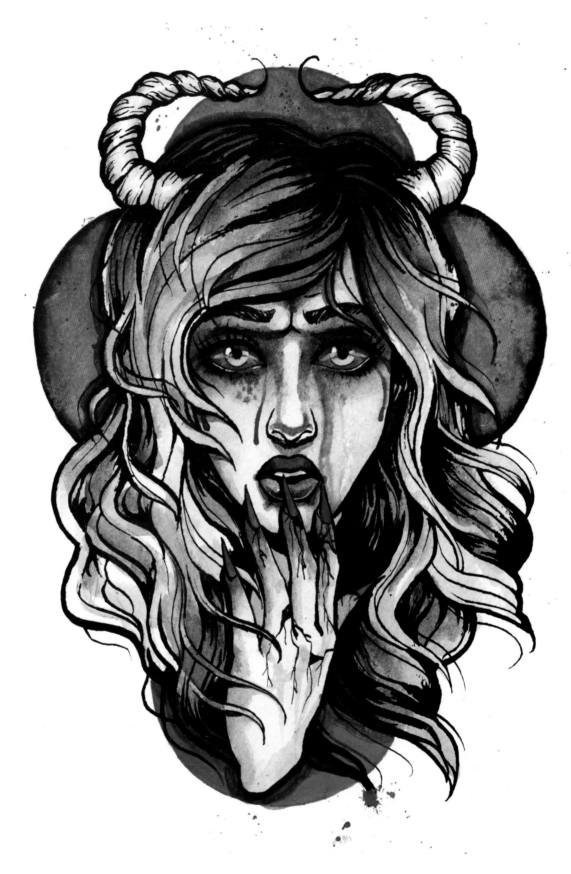

RIGHT: *Possession.*
Watercolour ink on
paper.

FAR RIGHT: *Lady Bird.*
Watercolour ink on
paper.

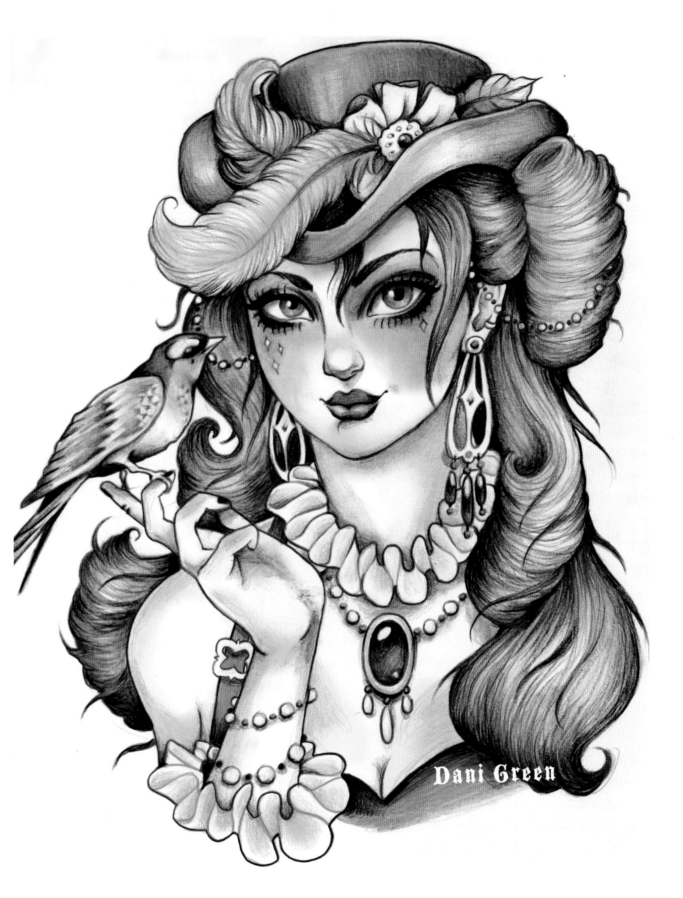

Dani Green

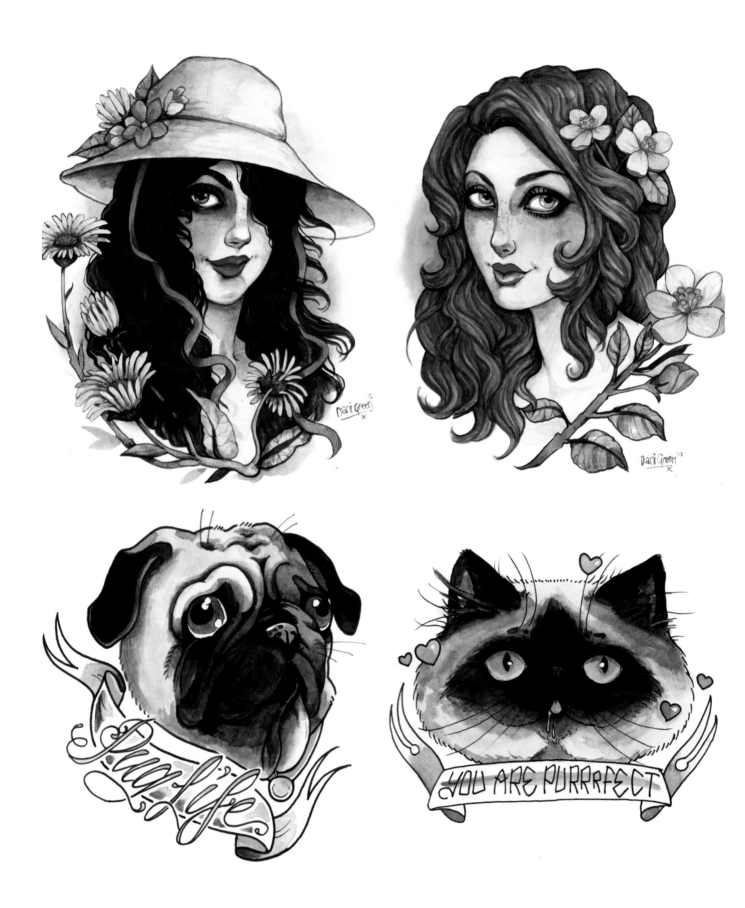

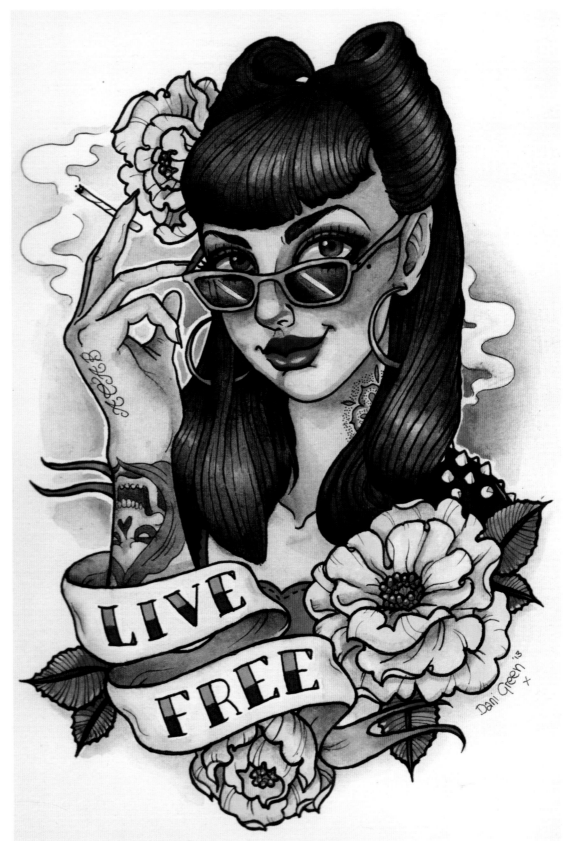

TOP LEFT: *Flower Gal 2.*
Watercolour ink on paper.

TOP RIGHT: *Flower Gal.*
Watercolour ink on paper.

BOTTOM LEFT: *Pug Life.*
Watercolour ink on paper.

BOTTOM RIGHT:
Purrrfect.
Watercolour ink on paper.

RIGHT: *Live Free.*
Watercolour ink on paper.

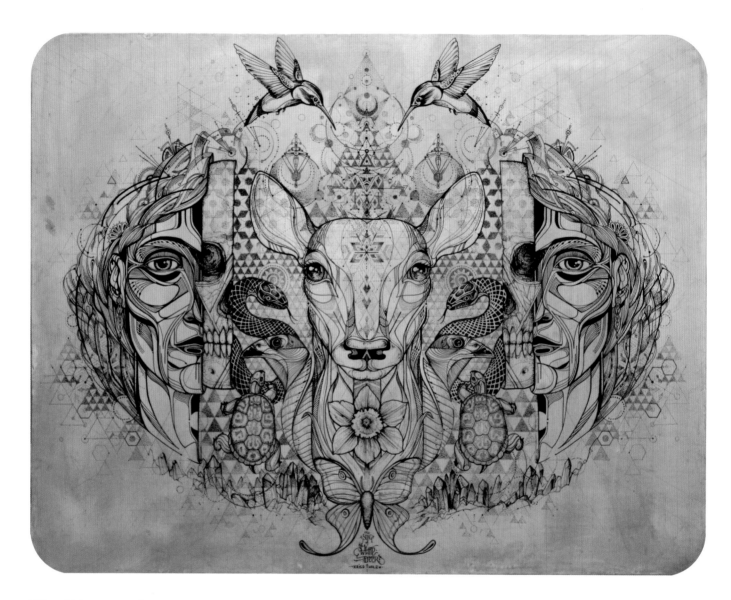

DAVID HALE

Seeing the album art for the Red Hot Chilli Peppers' *Blood Sugar Sex Magic* so enthralled Hale when he was 12, that he got hooked. "It made me realise there was a means of creating art on flesh and I knew what I had to do." After studying drawing and painting at the University of Georgia, he began his apprenticeship with Mark Longenecker in Cocoa Beach, FL (although he didn't finish). Today he has his own studio and shop: Love Hawk in Athens, GA. After trying a multitude of techniques – acrylic, oil, watercolour, aerosol, sculpture and digital – Hale has returned to pen and ink. Of tattoo he says: "It influences my entire outlook on life. I am enthralled by the ritual of it and the art that it manifests as well as the incredible people who share their skins and lives with me." The influences are too many to mention, although "my two cornerstones have been my Grand Uncle Jim Hayden and best friend Kris Davidson." Hale is enthralled by all of life: "I have a deeply-rooted spiritual and family life, which branches out into a complexity of influence, like forks in an endless river. Creation and the infinite beauty of the Light and the Dark, fills me with wonder and flows back into my art."

LEFT: *Nature.*
Ink on paper.

BELOW: *Archangel.*
Ink on paper.

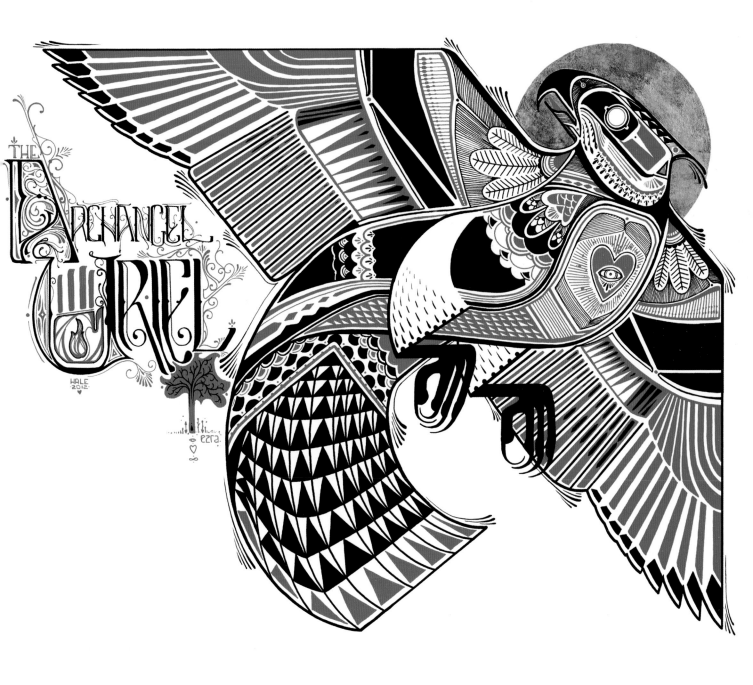

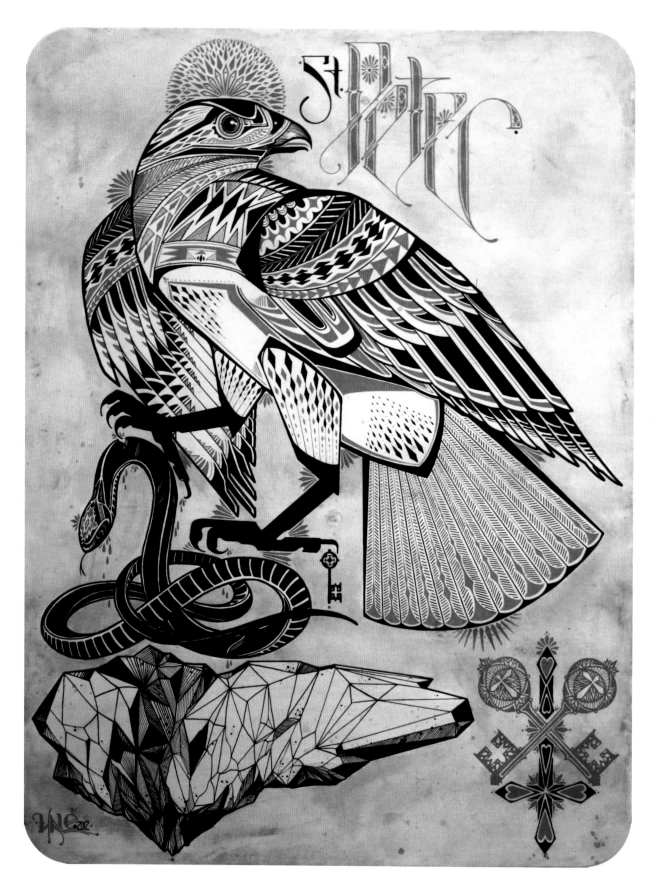

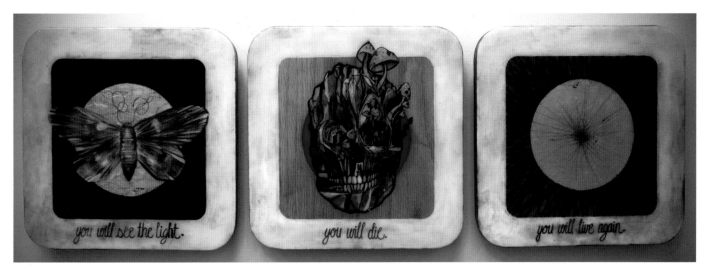

you will see the light. you will die. you will live again.

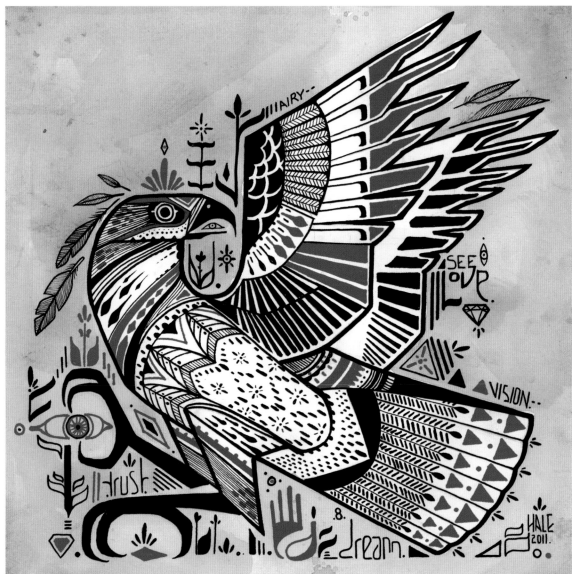

FAR LEFT: *St Peter*.
Ink on paper.

LEFT: *On the Wing*.
Ink on paper.

ABOVE: *Runes*.
Mixed media.

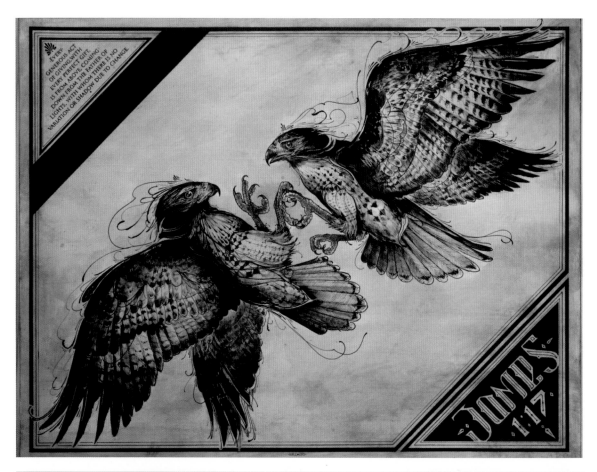

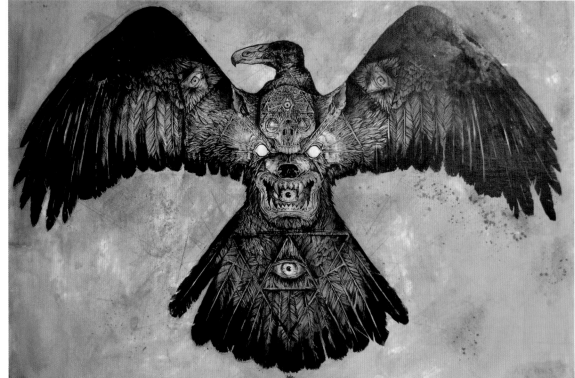

ABOVE: *Perfect Gift*.
Ink on paper.

RIGHT: *Strong Tribe*.
Ink on paper.

FAR RIGHT: *Rise*.
Ink on paper.

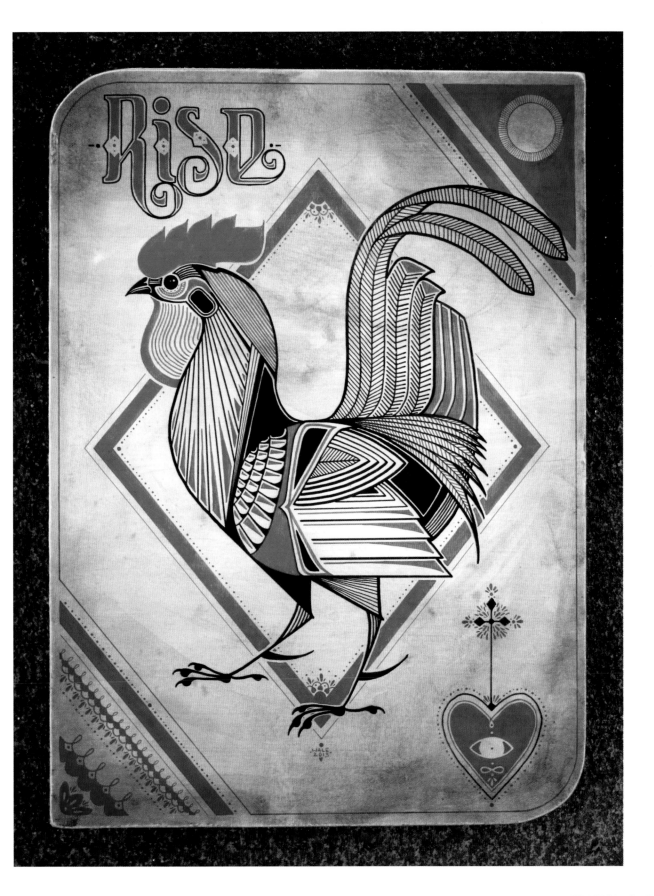

VALENTIN HIRSCH

After studying Fine Arts at the Vienna Academy, Valentin Hirsch decided to take his fascination with art on skin a stage further. "There are many different technical options available as a tattooist and that allows one to be a non-conformist" says Hirsch. He sees two sides to the art – learning how needles work on the skin (the technical bit) and developing a feeling for the machine and an individual way of doing things (the artistic bit). "There is also always a tension between the sketch on paper and the way the actual tattoo materialises on skin. It's the same with the idea – there's always a tension between that and the end result. Making a tattoo is challenging, every time." He began at Toeloop Tattoo in Berlin and today is based at AKA Berlin, AKA London and as a regular guest at NY Adorned (in both NYC and London). His big artistic influences are Albrecht Dürer, contemporary engravers and Thomas Hooper (one of the first dotwork tattooers Valentin got to know). Of his approach he says "my attitude is to stay open to new impressions... you can be inspired artistically by the most mundane things."

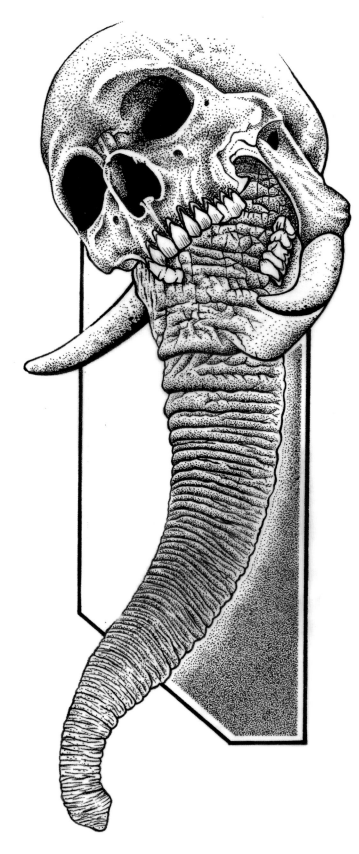

RIGHT: *Elephant Trunk.*
Ink on paper.

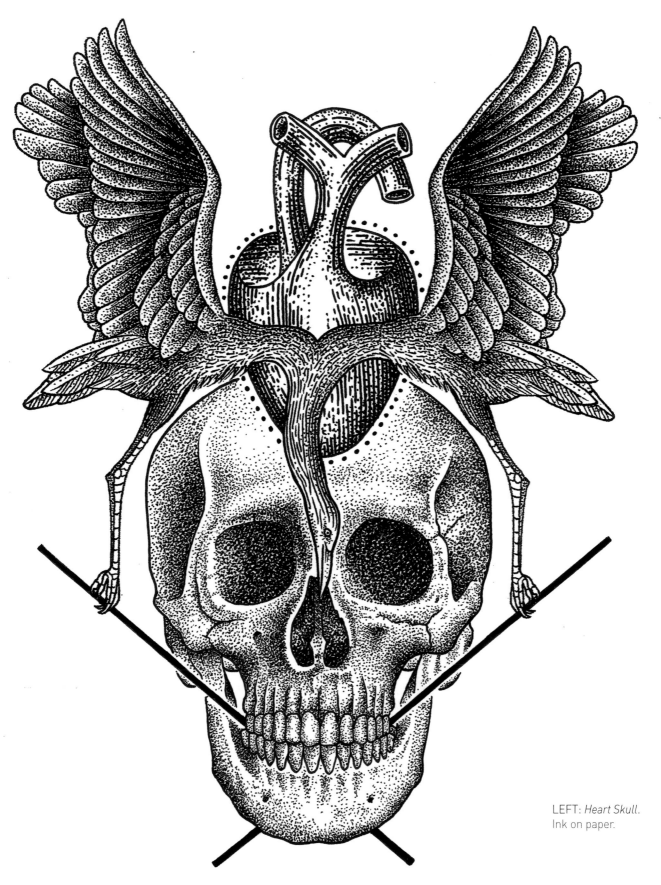

LEFT: *Heart Skull.*
Ink on paper.

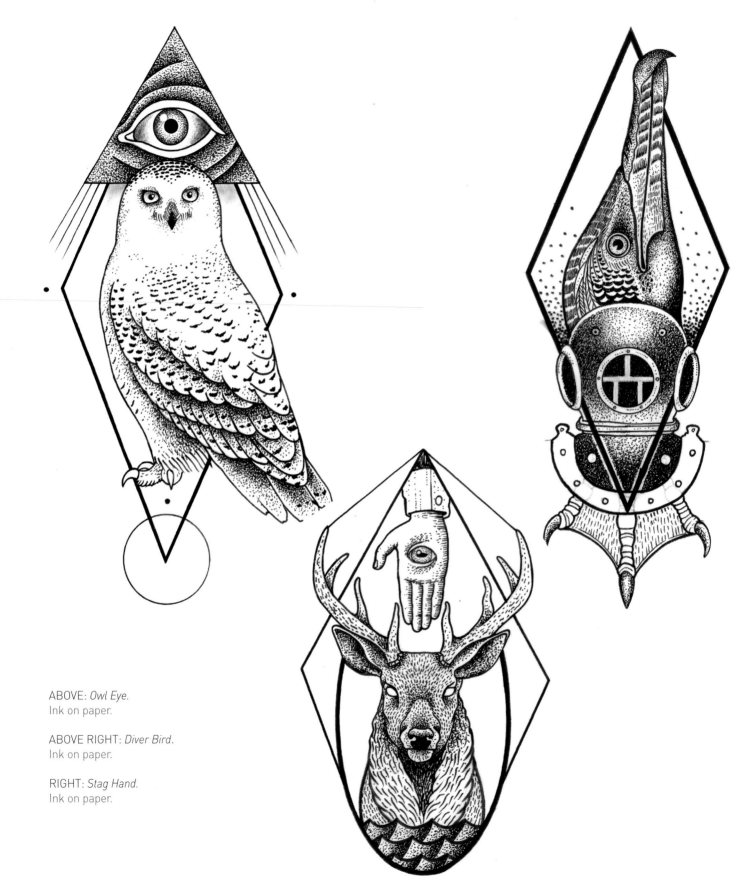

ABOVE: *Owl Eye.*
Ink on paper.

ABOVE RIGHT: *Diver Bird.*
Ink on paper.

RIGHT: *Stag Hand.*
Ink on paper.

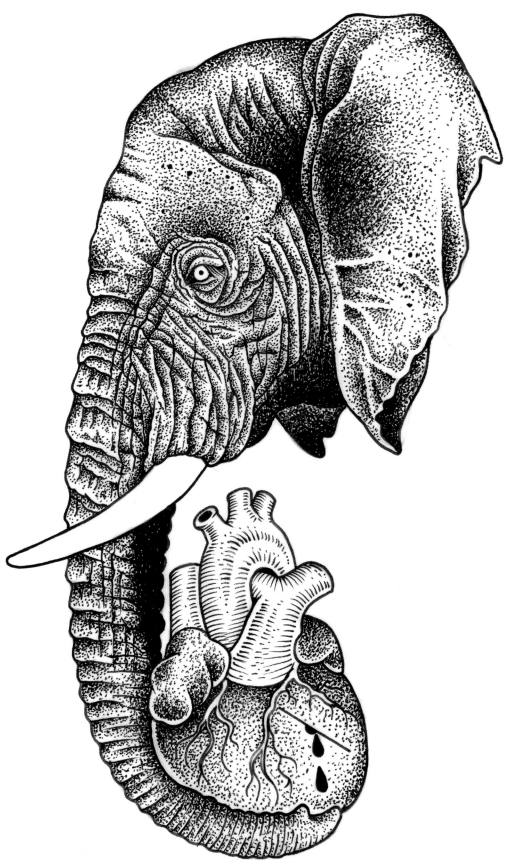

LEFT: *Elephant Heart.*
Ink on paper.

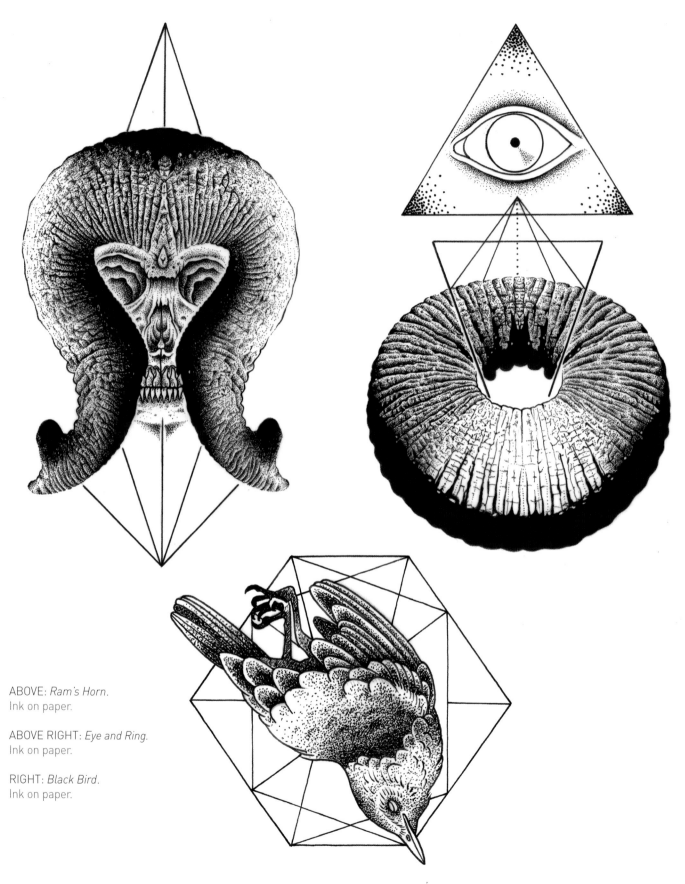

ABOVE: *Ram's Horn*.
Ink on paper.

ABOVE RIGHT: *Eye and Ring*.
Ink on paper.

RIGHT: *Black Bird*.
Ink on paper.

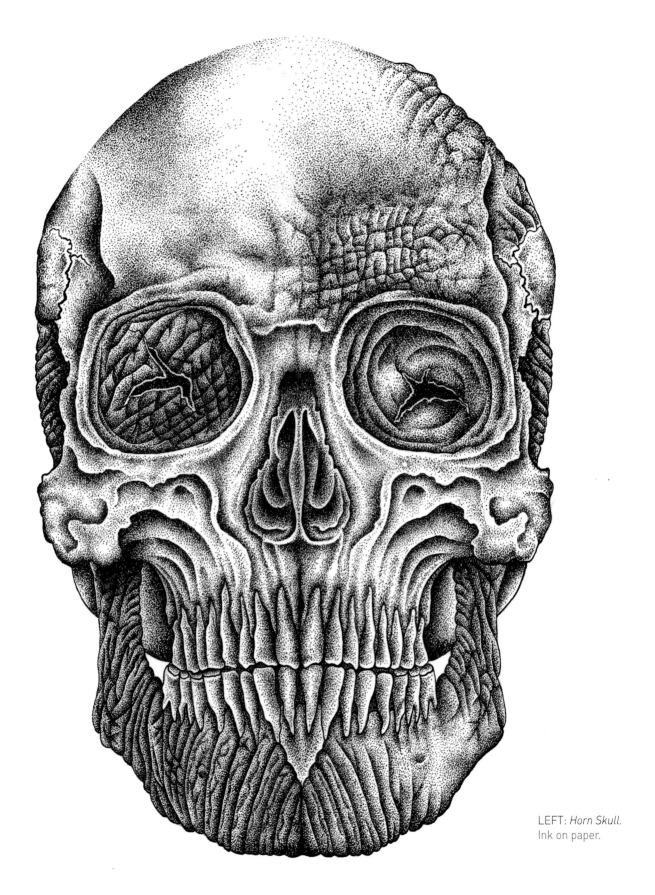

LEFT: *Horn Skull.*
Ink on paper.

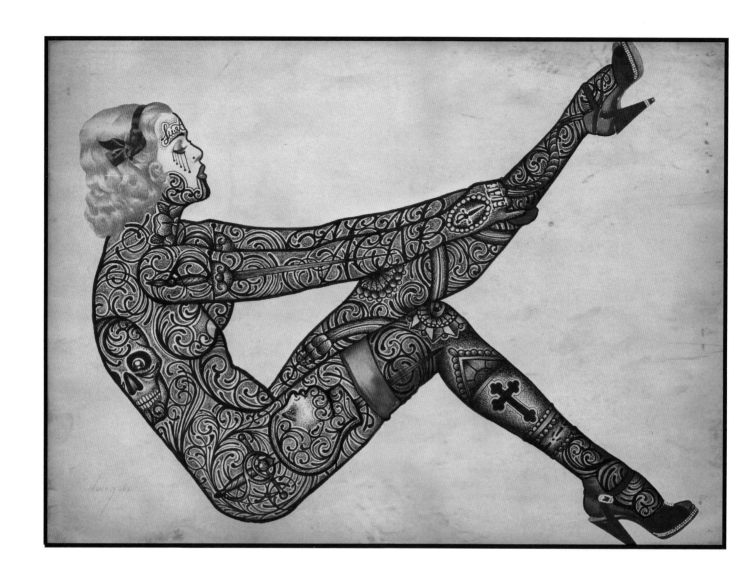

RAMON MAIDEN

"My training as a social worker, my passion for travel, my family history and my experience with visual arts are not in anyway uniform and this has allowed me to bring different creative experiences to my work," says Barcelona-born Ramon. Entirely self-taught he prefers not to focus on anything too specific, but to keep progressing by experimenting. Travel is a critical part of that – for him NYC is a second home. Tattoo is one form of artistic expression for Ramon, not an end in itself. The artists he admires (most are personal friends) are excellent tattooists, but good also at other forms of art. They include Lola Garcia, Seth Wood, Dr Lakra, Cris Cleen, Annie Frenzel, Sebastian Domaschke, Matthias Boechtter, Ryan Mason and Amina Charai, "to name a few." To us Ramon's work is instantly recognisable, yet he says "I think my style is quite changeable and I have different sources of inspiration. Historical motifs feature prominently – I love the world wars, the Victorian era, America in the 1920s – but I also like to shake contemporary consciousness and my work includes religious and political references."

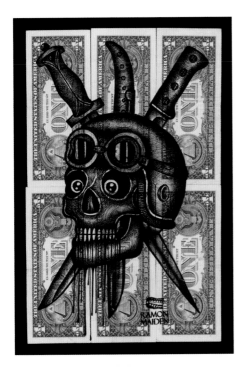

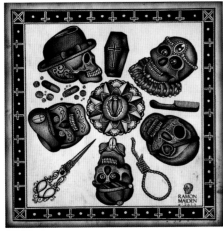

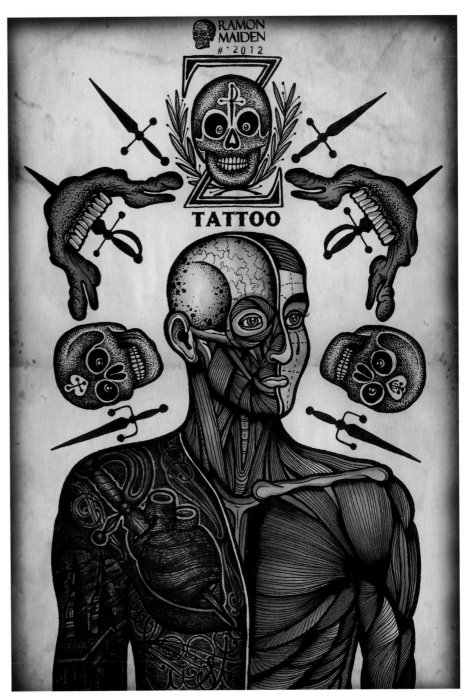

LEFT: *Punisher*.
Ink on paper.

TOP:
Money Devil II.
Ink on paper.

ABOVE: *Death I*.
Ink on paper.

RIGHT: *Z Magazine*.
Ink on paper.

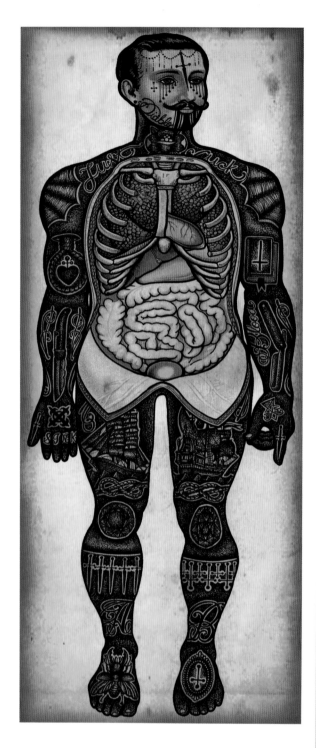

ABOVE: *Inked Anatomy*.
Ink on paper.

RIGHT: *Devil*.
Ink on paper.

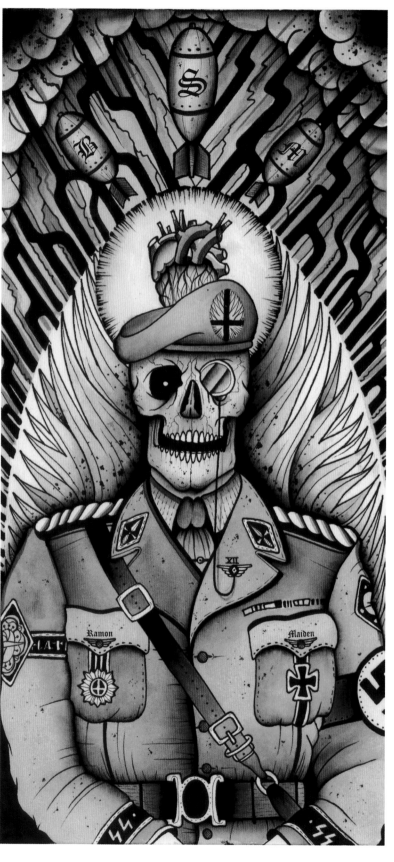

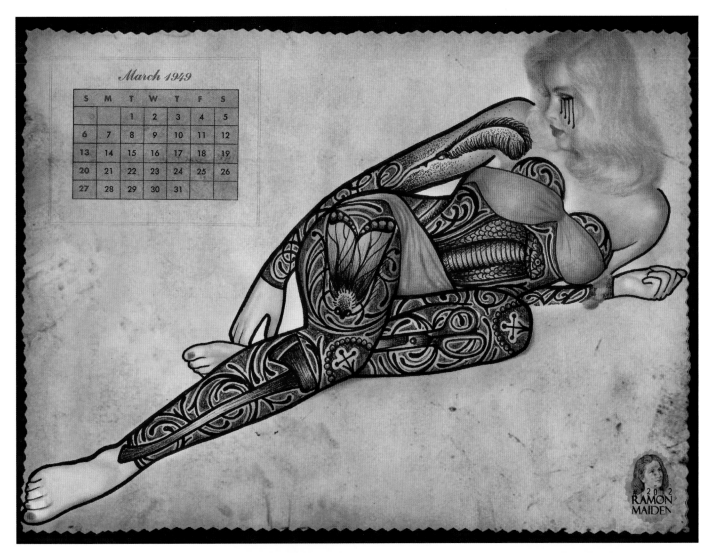

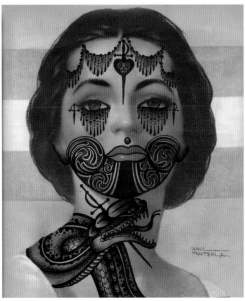

ABOVE: *Mopet*.
Ink on paper.

RIGHT: *Blue 44*.
Ink on paper.

FAR RIGHT: *Para Ti*.
Ink on paper.

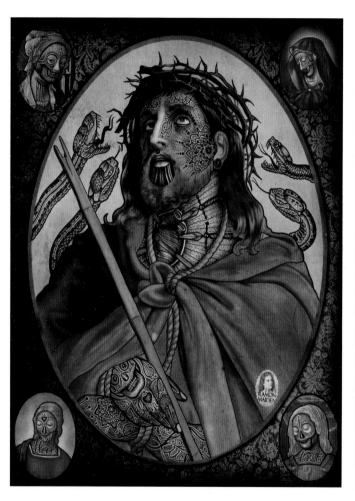

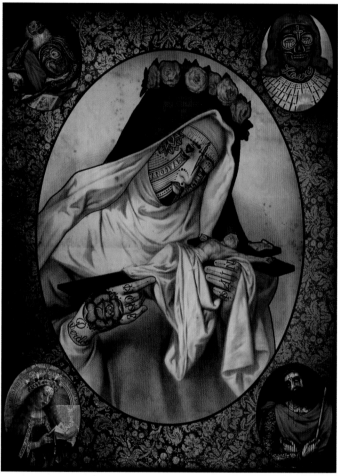

ABOVE: *Vanitas*.
Ink on paper.

ABOVE RIGHT: *Virgin*.
Ink on paper.

FAR RIGHT: *Ben*.
Ink on paper.

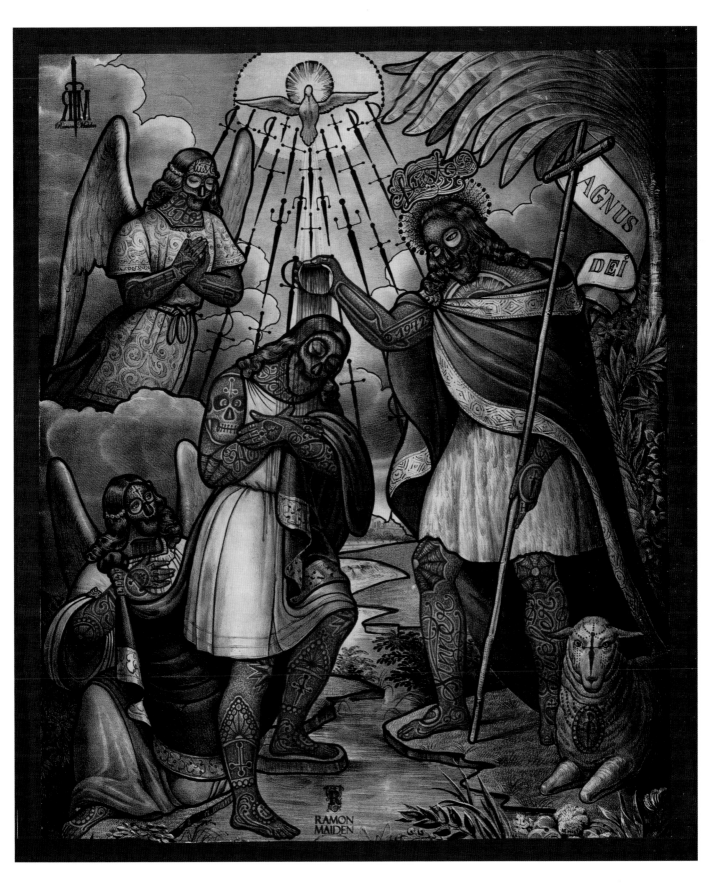

AGNUS DEI

RAMON MAIDEN

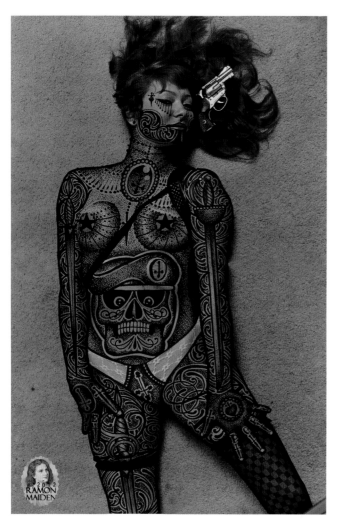

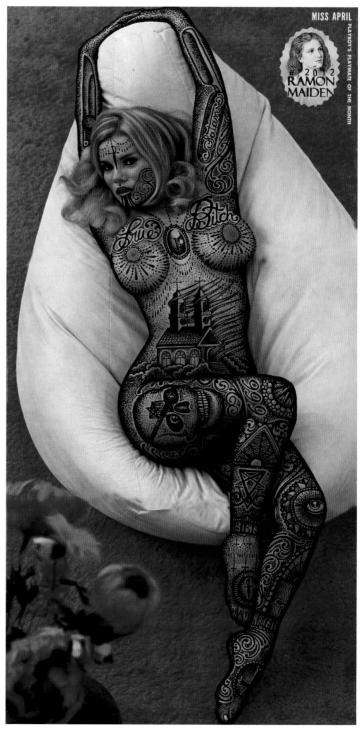

ABOVE: *Gunner I.*
Ink on paper.

RIGHT: *Zooki.*
Ink on paper.

MIDDLE: *Inked Vargas.*
Ink on paper.

FAR RIGHT, TOP:
Blue.
Ink on paper.

FAR RIGHT, BOTTOM:
Lust Masquerade.
Ink on paper.

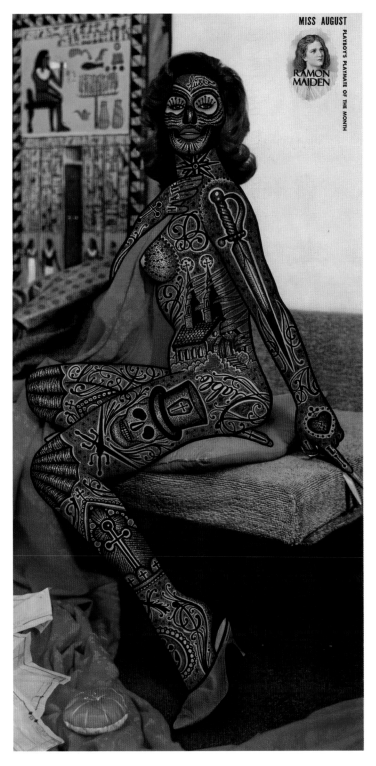

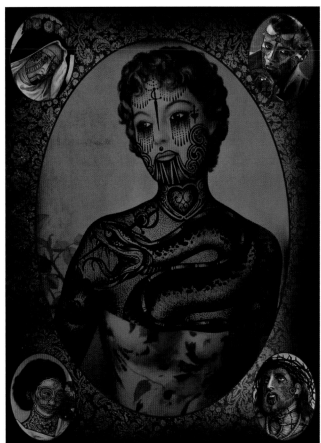

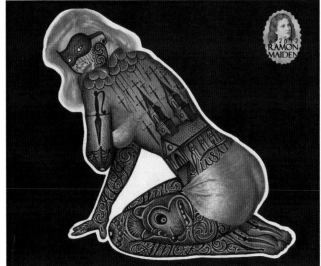

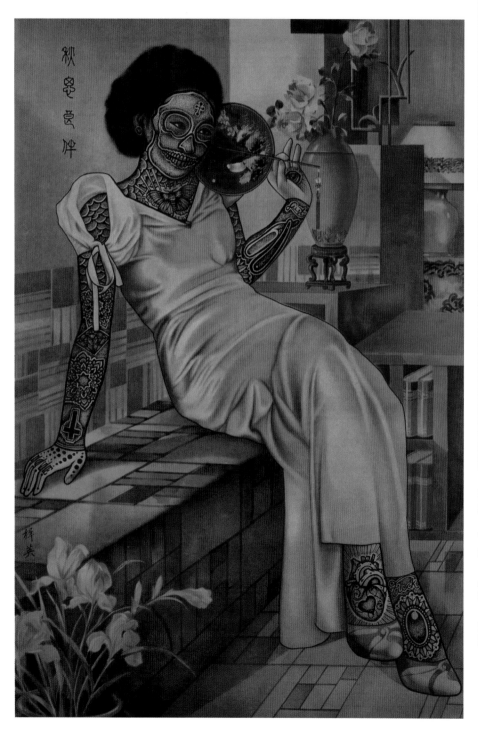

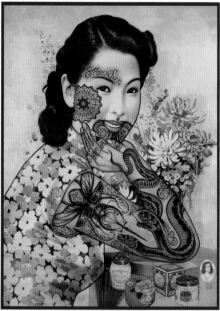

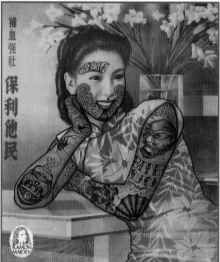

LEFT: *Asian Beauty.*
Ink on paper.

TOP: *Sinner.*
Ink on paper.

ABOVE: *Last Asian.*
Ink on paper.

RIGHT: *Sophia.*
Ink on paper.

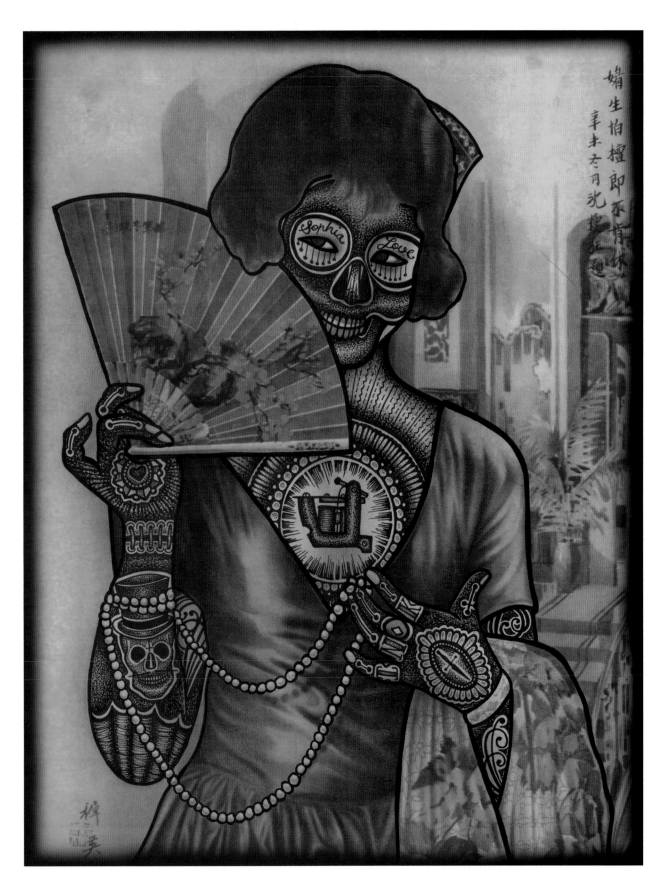

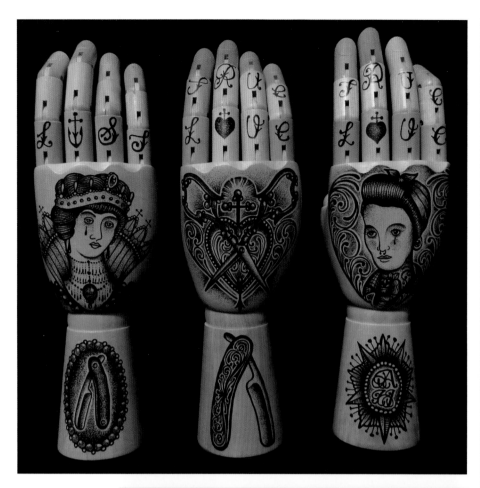

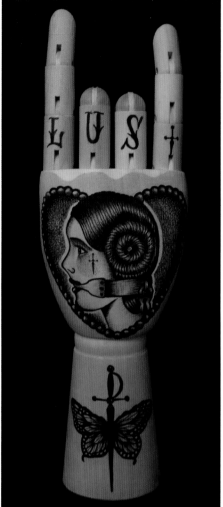

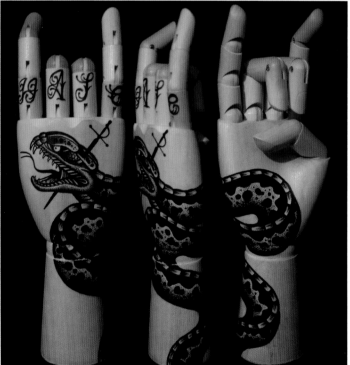

ABOVE LEFT: *Last Hands.*
Wooden mannequins.

ABOVE: *Leia.*
Wooden mannequin.

LEFT: *Snakezz.*
Wooden mannequins.

ABOVE RIGHT: *Irene.*
Ink on paper.

RIGHT: *Waisted Time.*
Ink on paper.

FAR RIGHT: *London II.*
Ink on paper.

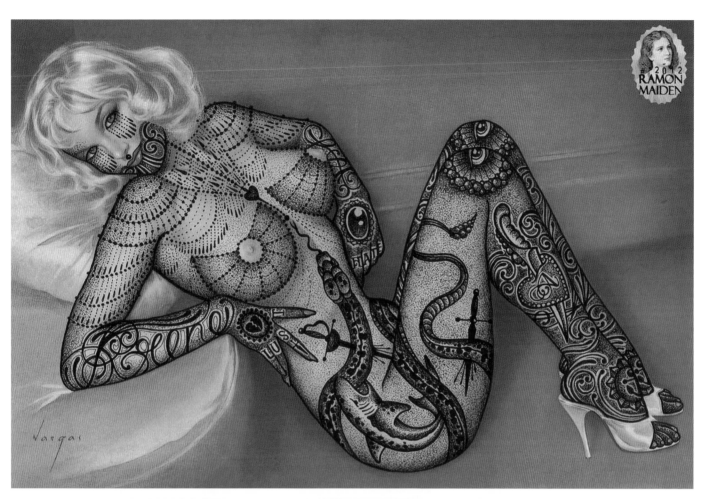

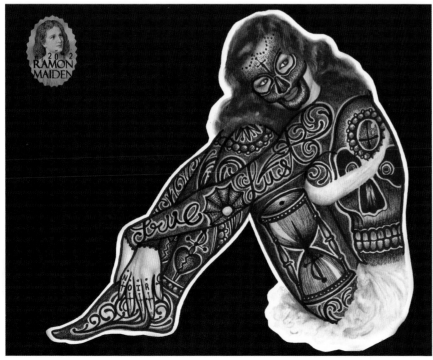

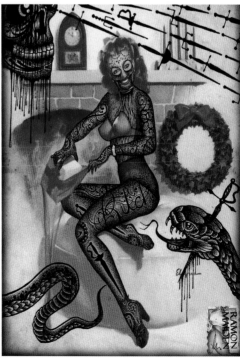

SCOTT MOVE

"I was getting tattooed for a long while before I thought about making the move into the business. I needed a push to do it, and that's what my girlfriend did." At the start Scott nearly chickened out. "I began thinking I wasn't cut out for it. There seemed to be too much danger involved. I was too much of a wimp. I then got myself a machine and started tattooing at home on myself and a few friends. I sucked. Tattooing is hard as shit and when there's no one to watch over you you learn the hard way. I started working all day and tattooing three nights a week. I wouldn't recommend this route." It was Allan Graves, of Haunted Tattoo in London, who gave Scott his break. Scott then moved on to Circle Tattoo in London's Soho. After trying many techniques and media, Scott has reverted to black pen and ink; "it's all I do now," he says. He is influenced by everything around him. "I need visual food every day. I crave it. I'm always looking for something new." Art school he says was a waste of time. "I think all I learnt was how to have my ideas crushed; or how to create a piece so it looks the same as the rest of the class? No thanks!" Artists he admires? "If I had to name three artists who inspire me daily, it would be Mike Giant, Francis Bacon and Albrecht Dürer."

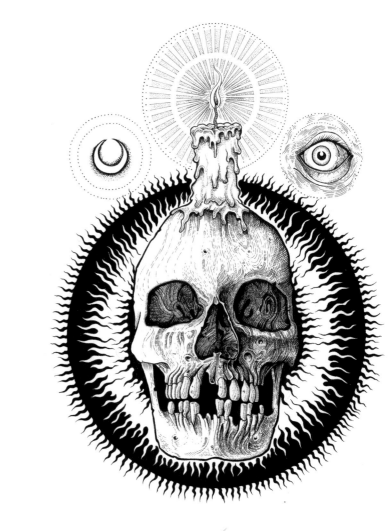

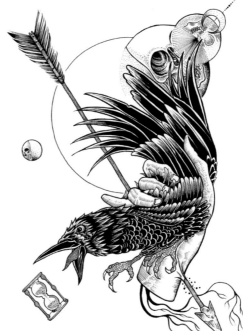

ABOVE: *Death is Awesome.*
Pen and Ink.

LEFT: *Time's Arrow.*
Pen and Ink.

RIGHT: *Darwin.*
Pen and Ink.

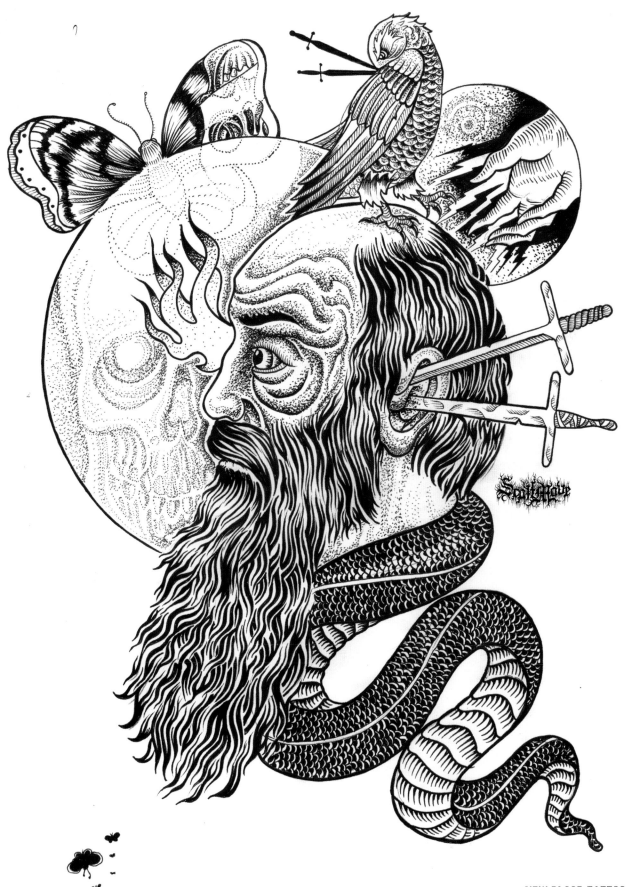

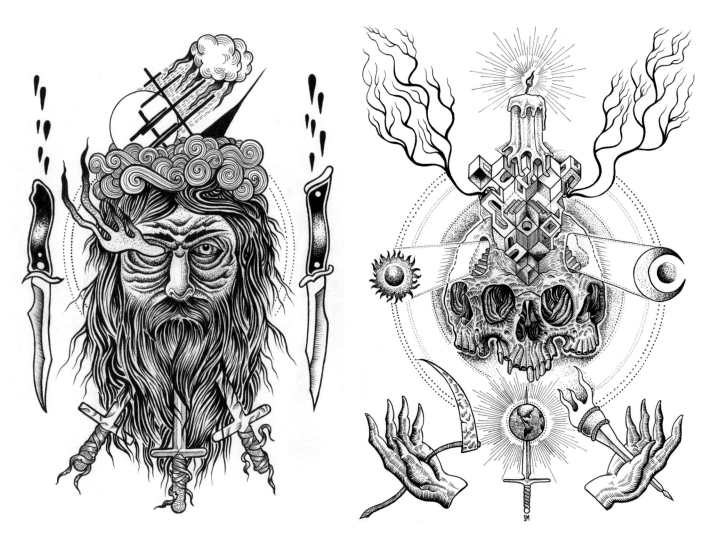

ABOVE: *Neptune.*
Pen and Ink.

ABOVE RIGHT:
Life's Short.
pen and Ink.

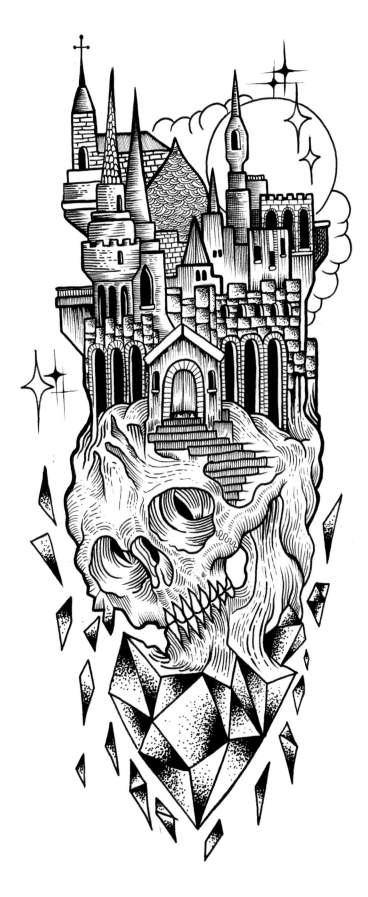

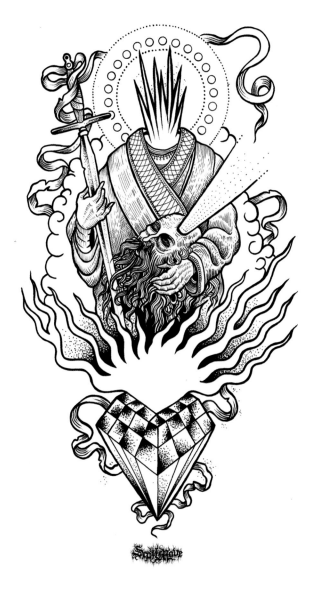

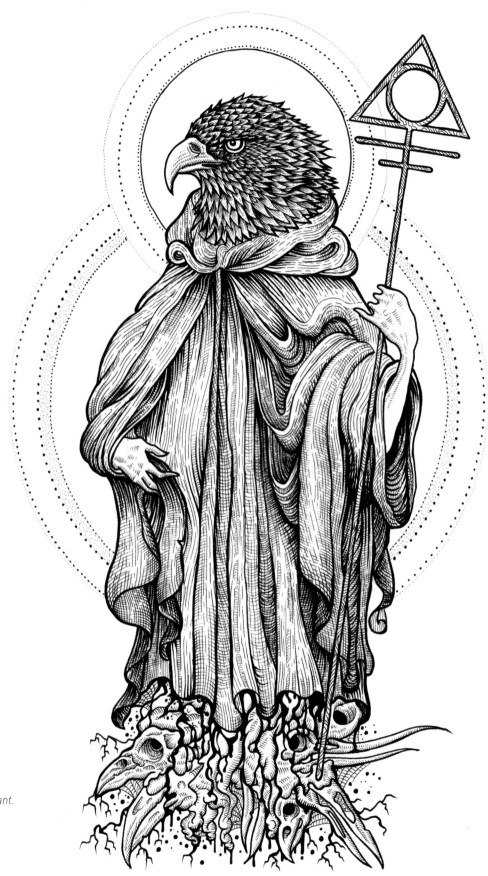

RIGHT: *Eagle.*
Pen and Ink.

FAR RIGHT: *Elephant.*
Pen and Ink.

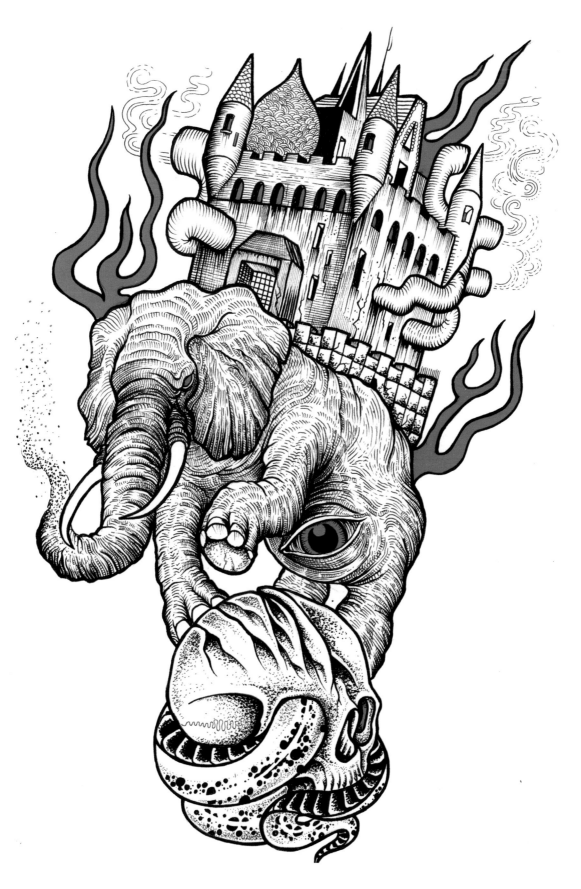

AARON ODELL

"I was, for as long as I can remember, infatuated with tattoos... particularly the way they are permanent, but age and move with the person." Drive and ambition got Aaron through the tough early stages: "I believe God blessed me with this talent and opened the right doors that have got me to where I am today." He started in a few small shops in Sacramento, CA, then moved to Reno for a while before finding his current base at Imperious Rex back in Sacramento "with an amazing group of artists." When it comes to the design of a tattoo he says "I have no rules, I paint how I feel, whether the piece calls for a traditional, realistic or heavily-textured approach." For his paintings he uses the same techniques as for his tattoos. "The process for painting in watercolours is very similar to the process for tattoos. The way I line and shade the piece is basically the same. I have had people see my paintings, buy them and then have me tattoo that image on them...a true honour for someone to like my work that much." With his sources of inspiration, Aaron likes combining opposing styles. Amongst artists, he cites Jeffery Williford, Harley Haslem and Ricket as influences. Of the scene he thinks recent changes are positive. "There are now serious collectors of tattoo artists' work. There's a strong bridge forming between the art and tattoo communities."

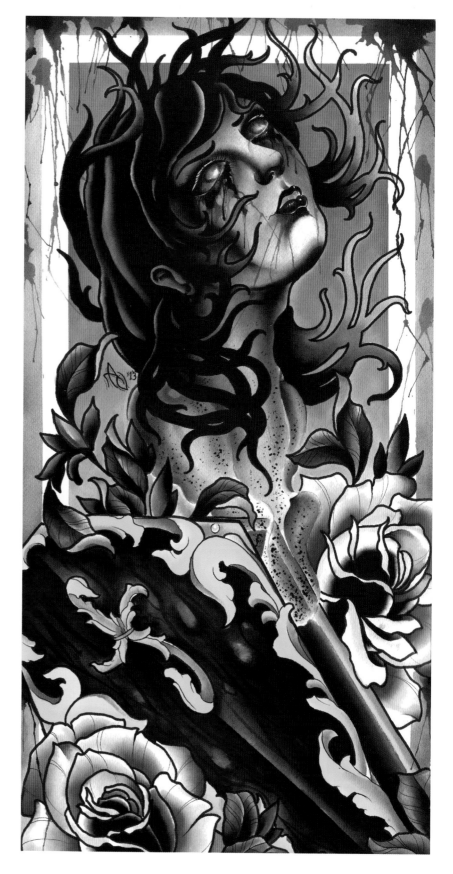

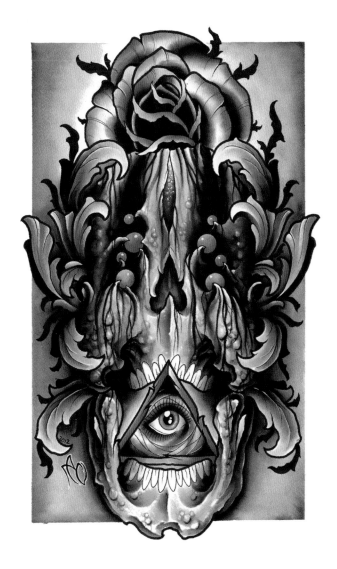

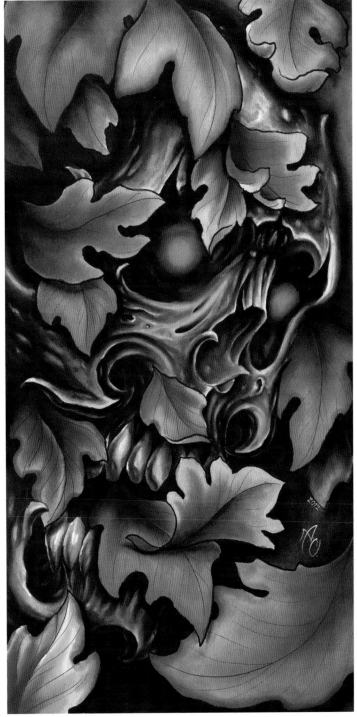

LEFT: *Rebirth from the Grave.*
Watercolour.

ABOVE: *All Seeing Eye.*
Watercolour.

RIGHT: *Skull Leaves.*
Watercolour.

BELOW: *Owl.*
Ink and watercolour.

RIGHT: *Rebirth.*
Markers, ink and
watercolour.

FAR RIGHT: *Roseye.*
Ink and watercolour.

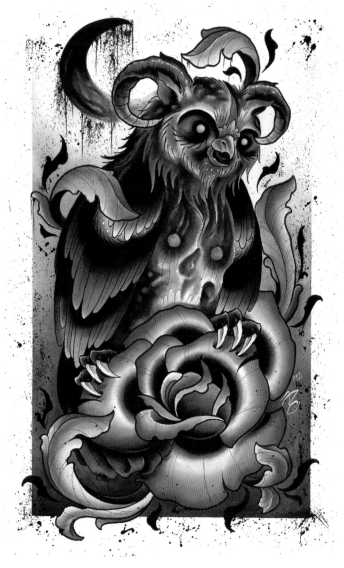

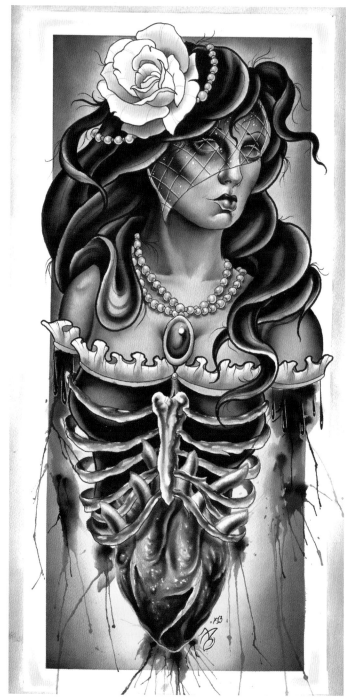

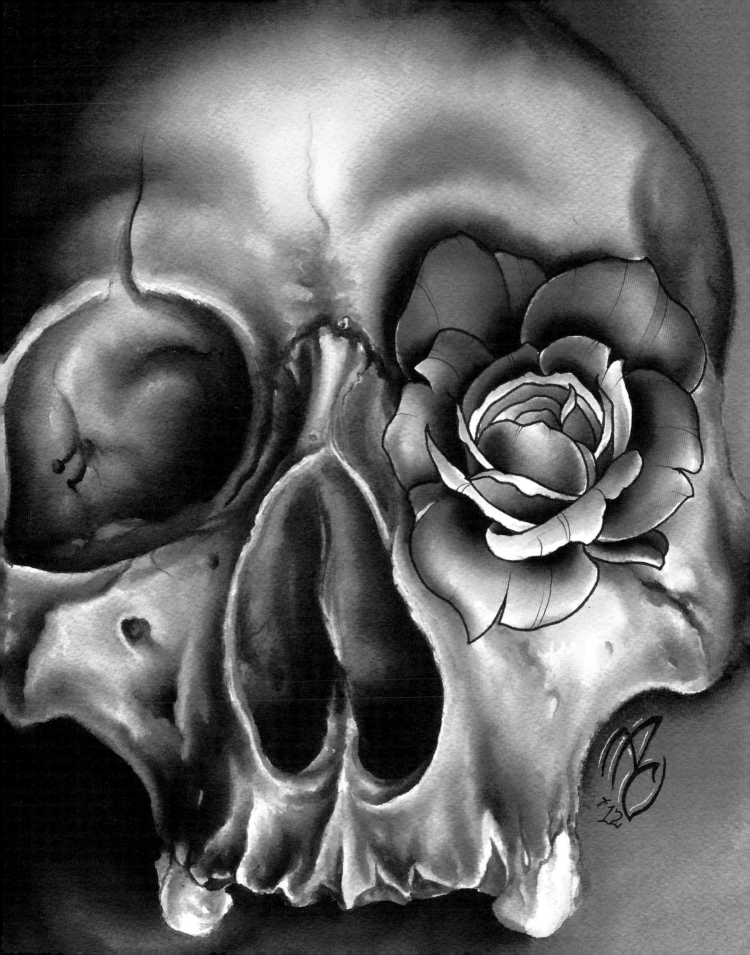

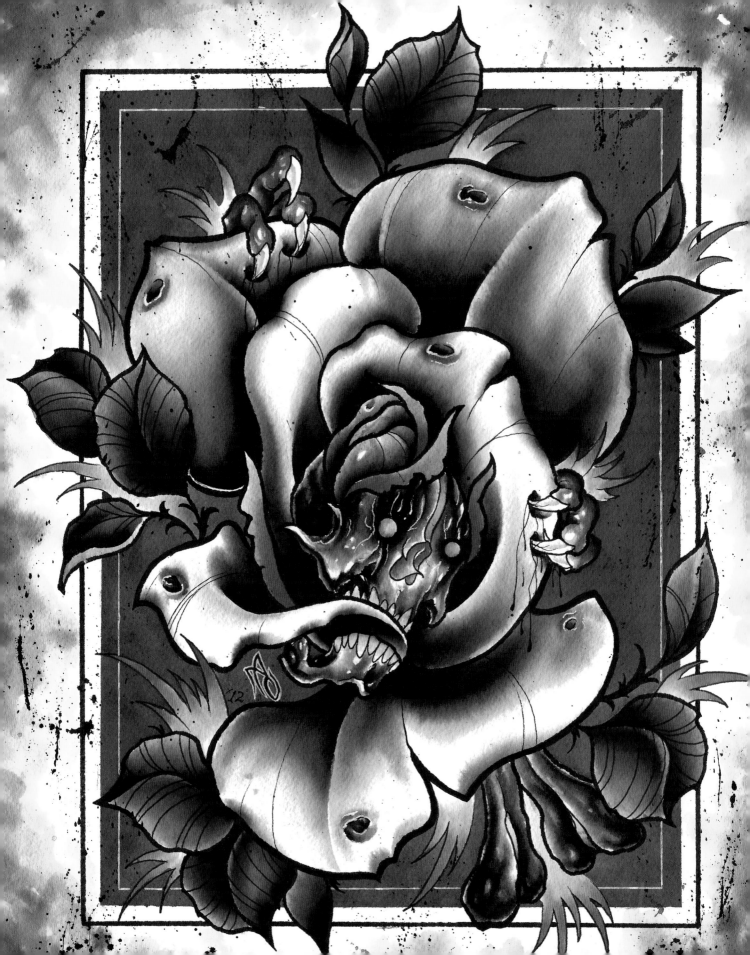

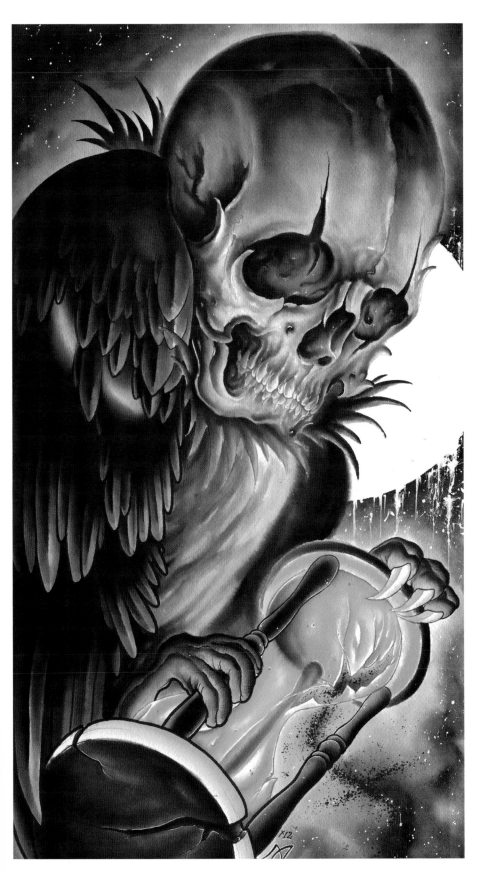

FAR LEFT: *Skull and Rose Morph.*
Markers, ink and watercolour.

LEFT: *Vulture Skull.*
Markers, ink and watercolour.

RIGHT: Two head
Sparrow.
Markers, ink and
watercolour.

FAR RIGHT:
Duality Girl.
Markers, ink and
watercolour.

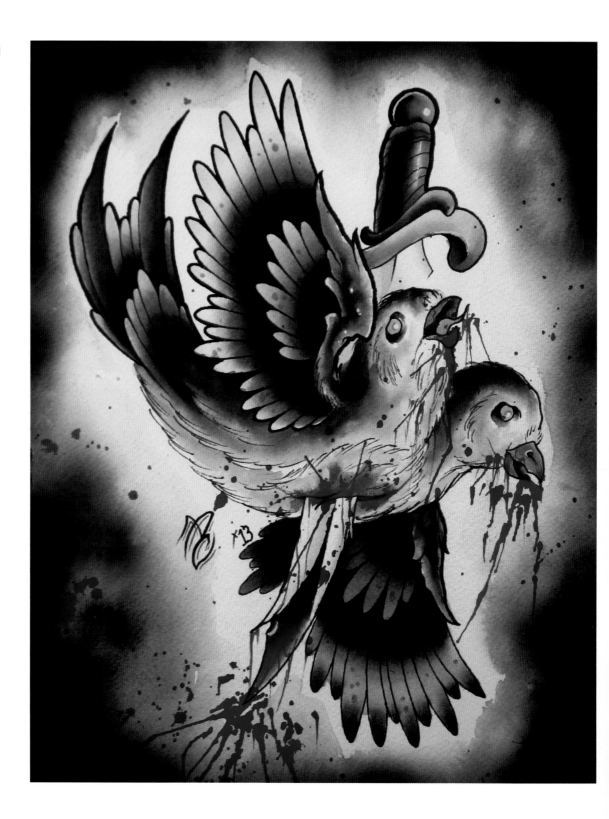

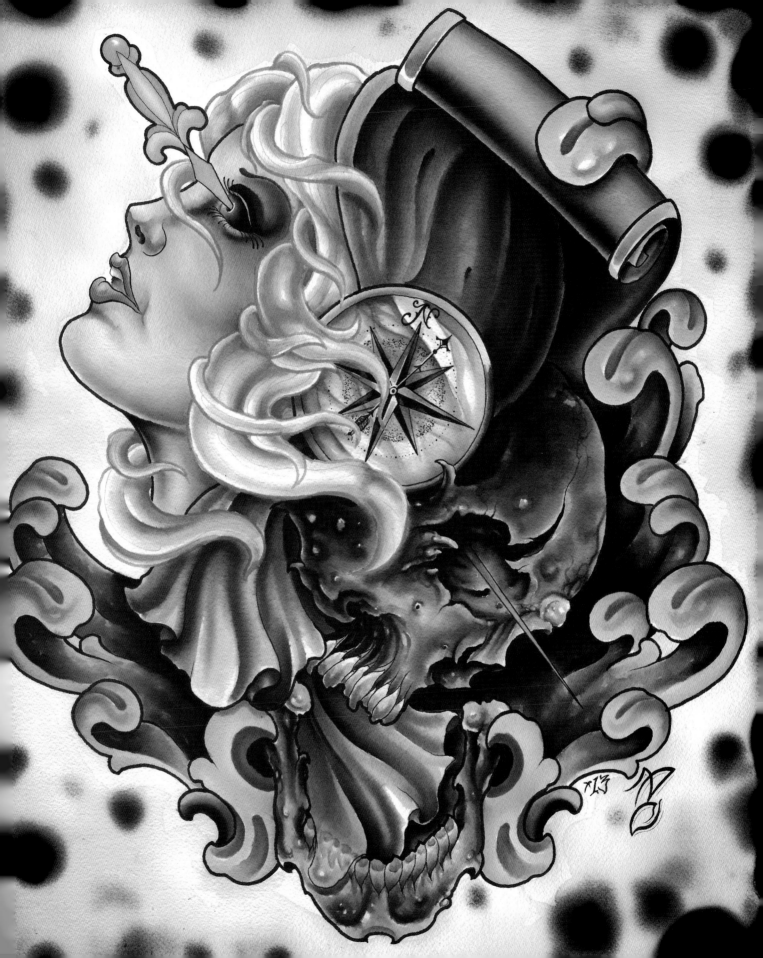

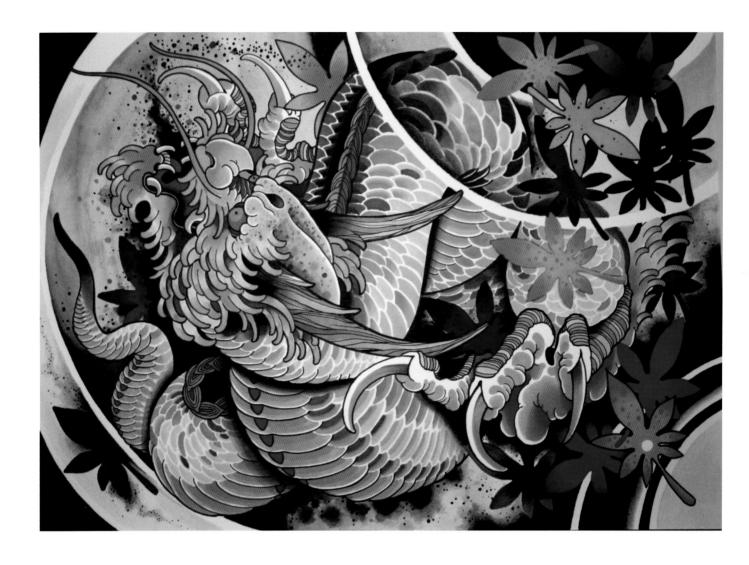

STUART PADGIN

"As a kid, my best friend's dad was heavily into tattoos and had decent coverage and I became fascinated by the imagery that surrounded them. They played a big influence, I'm sure, in me wanting to become a tattooist." Completely self-taught, Padgin apprenticed in Whitstable on the UK's Kent coast, before moving to Progression Tattoo in Adelaide, Australia. He works mostly with watercolours, using techniques picked up from others, or developed through trial and error. He draws, he says "exactly the same way I tattoo – same colours and layering. Artistic influences include Stefan Johnsson, Justin Harris, Bobby Johnson and Peter Lagergren. Inspiration comes from random thoughts and other forms of art he doesn't practice "including, unlikely though it may sound, sculpture and baroque oil paintings. Inspiration is completely random; you never know when it will hit." Of the tattoo scene he says: "It's great that it's evolving faster and faster, with amazing new artists popping up all over the place, on Instagram or on Facebook, and cranking out great pieces of work every day. I think that as tattooing becomes more and more accepted it will only get more creative. There is now definitely a greater acceptance of new thinking and experimentation."

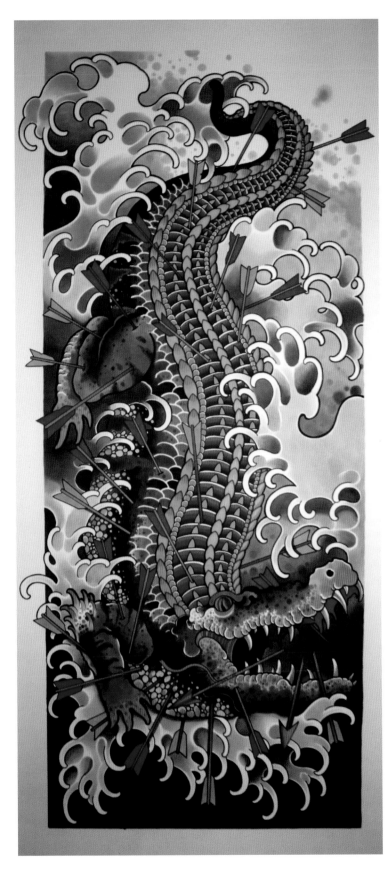

FAR LEFT: *Dragon.*
Ink on paper.

LEFT: *Croc.*
Ink on paper.

BELOW: *Tengu.*
Ink on paper.

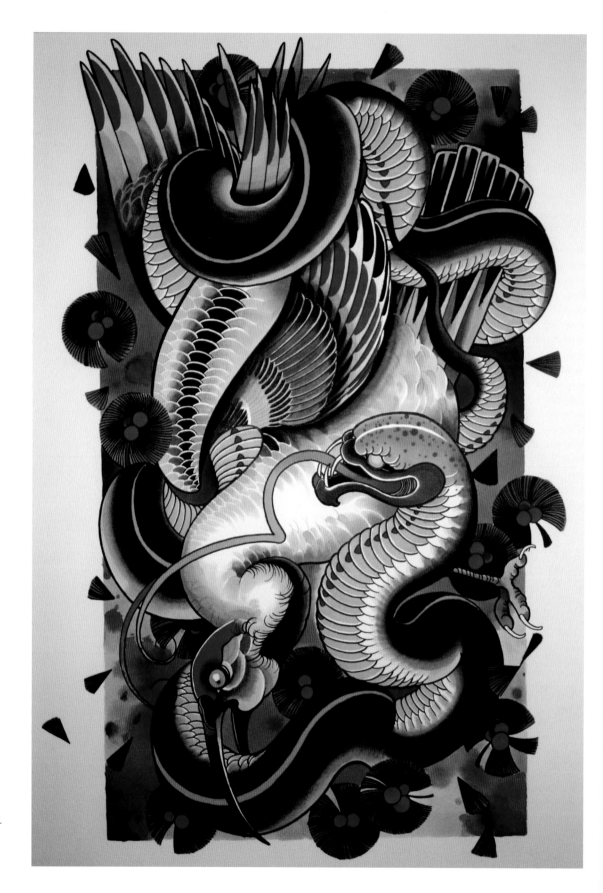

RIGHT: *Crane*.
Ink on paper.

FAR RIGHT: *Warrior*.
Ink on paper.

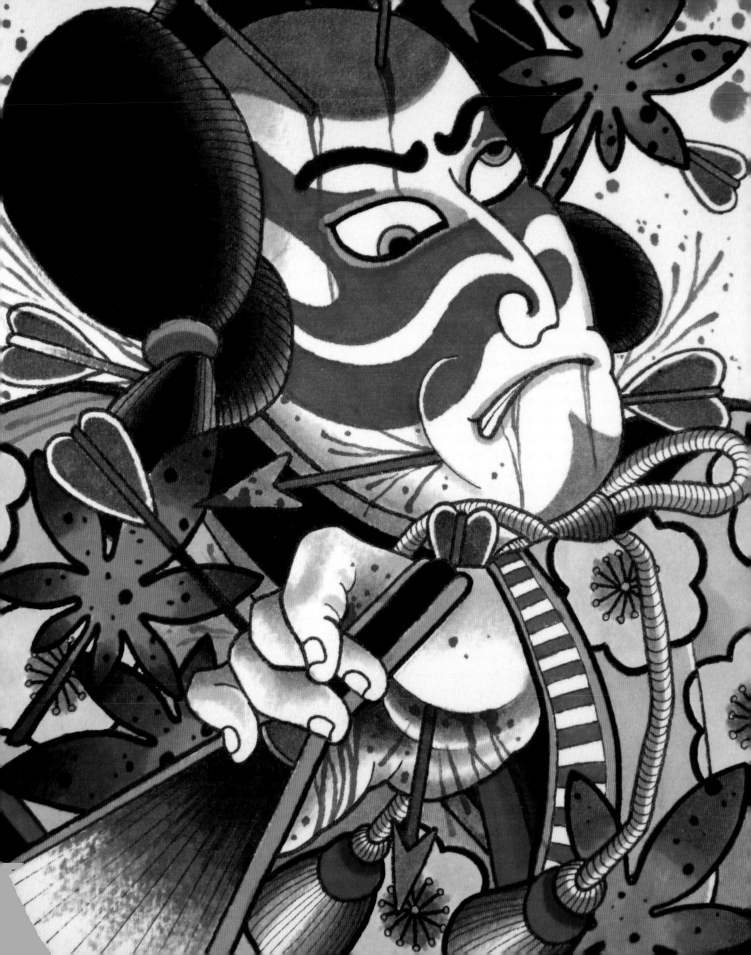

ALESSIA PEDROSA

"For me there was no defining moment," says Alessia."Tattoos fascinated me for as long as I can remember. Even as a child I used to draw with heavy lines and bright colours." Getting into tattoo, she says, isn't as hard as is sometimes made out. Getting the chance to learn from a talented tattoo artist, however, is. Her first break was in Shrewsbury, UK, and she then joined Colin Jones and the guys at Stained Class Tattoo. Alessia works mostly with acrylic ink and watercolour paint, although when she has the time and chance she loves to work with acrylics and oils on canvas. "Before I became a serious tattooist my techniques were more scatty and less technical. Now I get all the linework and shading done through one whole piece and then work through the colours." Her main influences are other neo-traditional tattoo artists – Justin Harris, Allan Graves, Neil Dransfield and Emily Rose Murray, to name a few. Outside tattooing it's street artist Miss Van and contemporary Japanese artists Junko Mizuno and Yoko d'Holbachie. "I'm also in love with the mixture of movement, geometry and timeless colour you get in art nouveau posters." Of the explosion of the scene in recent years she says: "It's critical to keep exploring outside influences and to build one's own unique portfolio, rather than replicating the popular artists out there."

RIGHT: *Death, Misery, Hate.*
Acrylic, ink and watercolour.

FAR RIGHT: *Faint Heart.*
Acrylic, ink and watercolour.

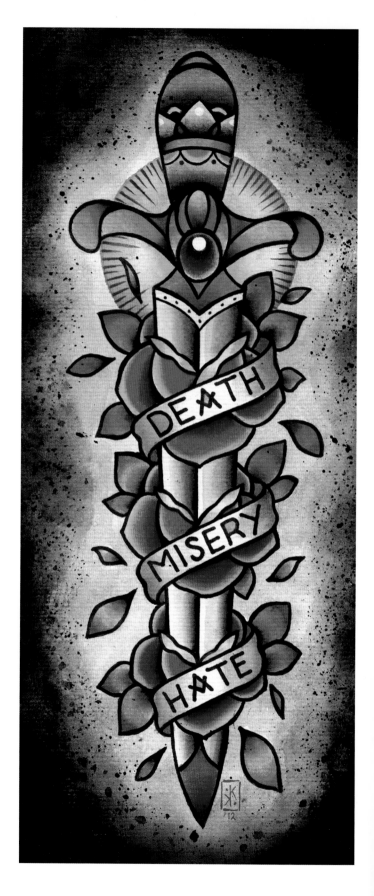

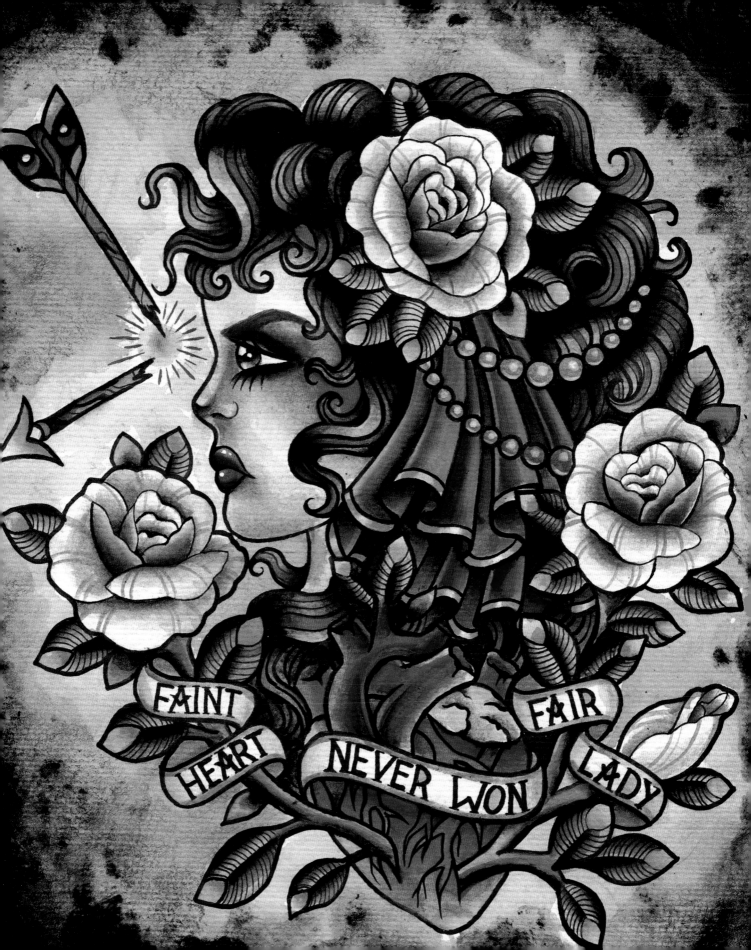

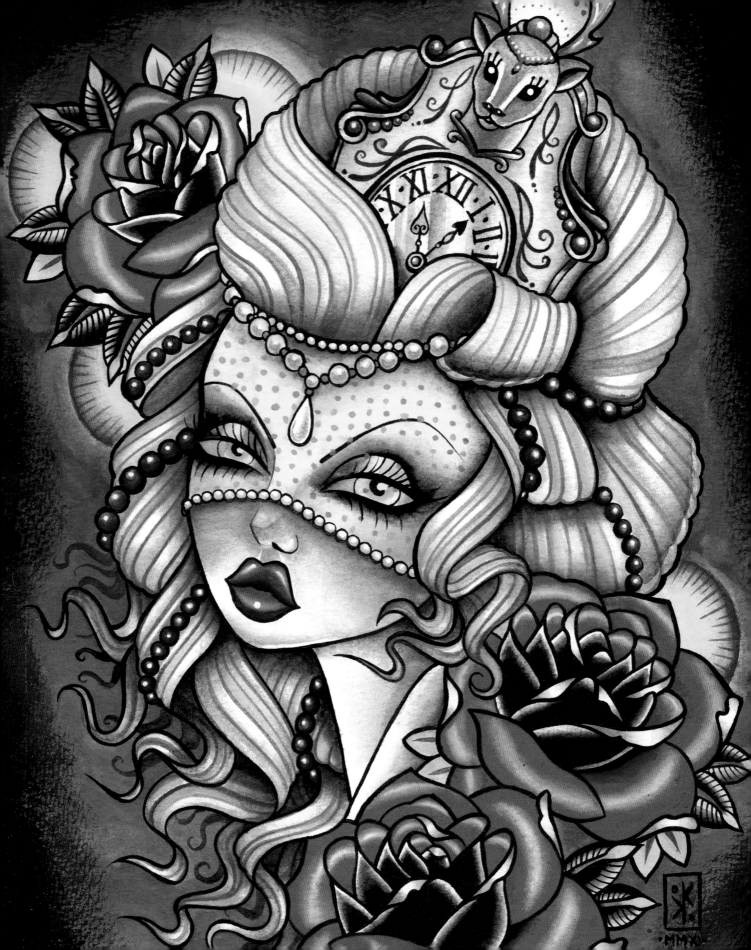

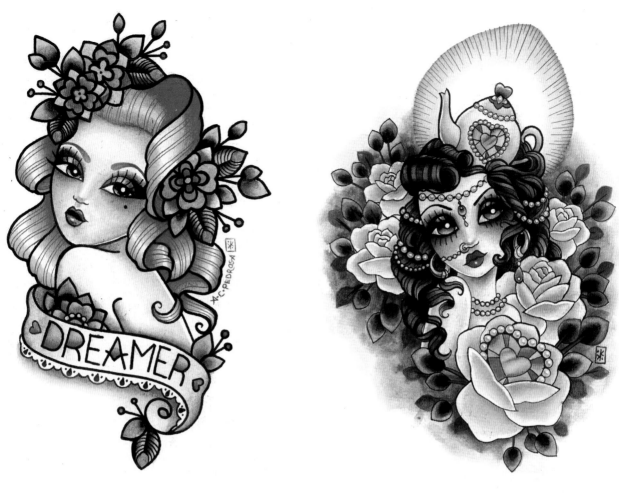

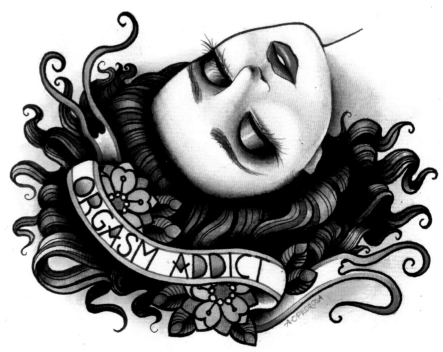

LEFT: *Life Won't Wait.*
Acrylic.

ABOVE: *Dreamer.*
Indian ink and
watercolour.

ABOVE RIGHT: *Tea Love.*
Indian ink and
watercolour.

RIGHT: *Orgasm Addict.*
Acrylic and ink.

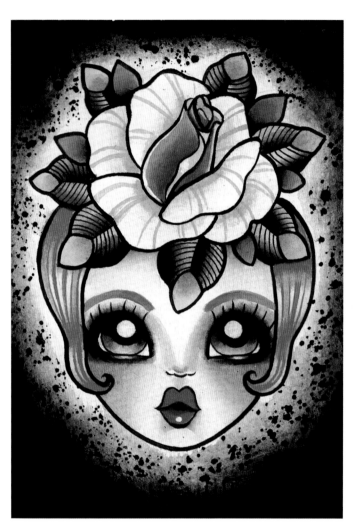

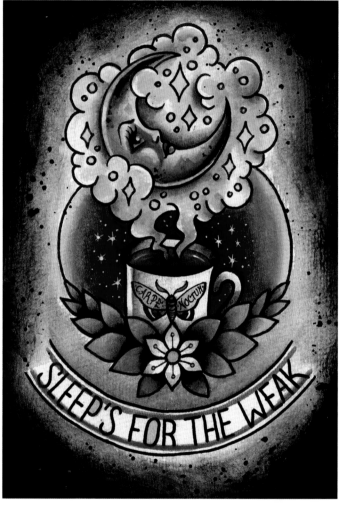

ABOVE: *One for Sorrow.*
Acrylic and watercolour.

ABOVE RIGHT: *Sleep's for the Weak.*
Acrylic and watercolour.

RIGHT: *Haunted.*
Acrylic, watercolour
and ink.

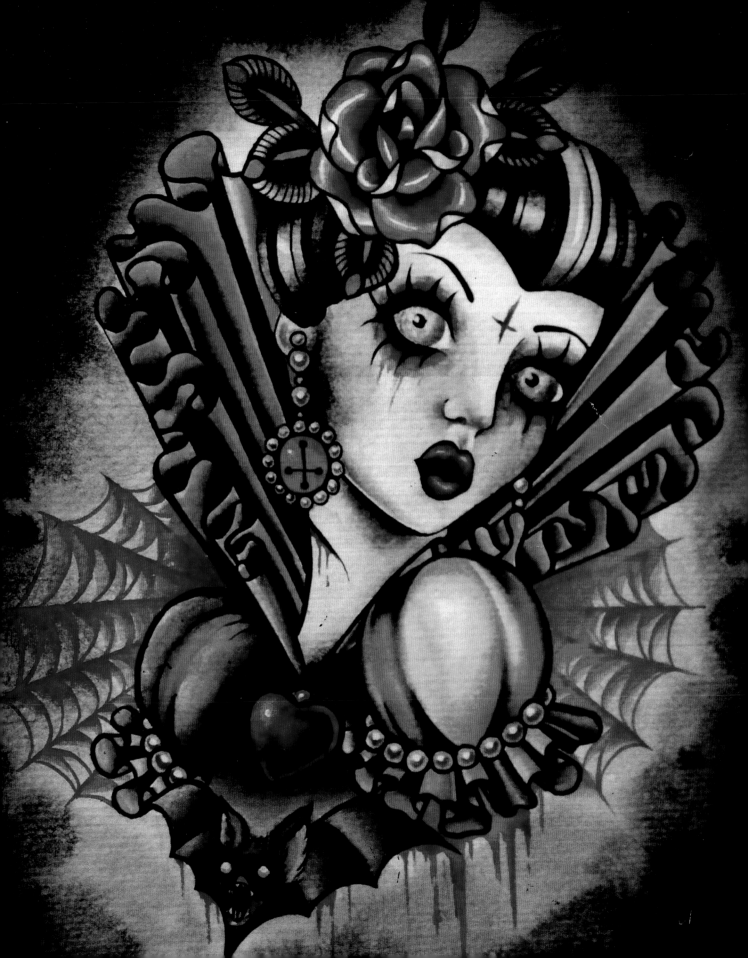

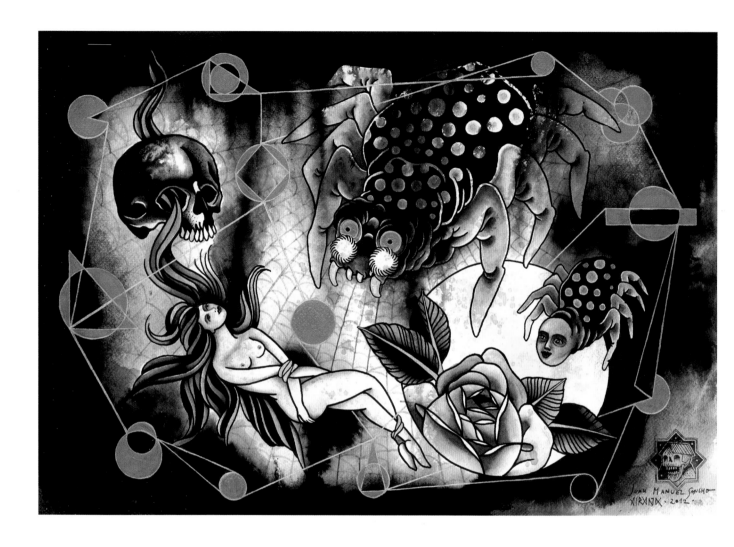

JUANMA PIRANHA

It took Piranha more than a year to overcome the stress and anxiety involved in creating his first tattoos as an apprentice. He had been working as a graphic designer for a Buenos Aires fashion brand when he started working at Welldone Tattoo: "I love the people, the place, the chemistry, which is why I'm still here." Piranha explores new ideas in ink and watercolour, but also likes to paint with acrylic on canvas. Tattooing influences everything he now creates. In terms of design specifics it also makes his art "more graphic, more organised." His influences are varied – surrealism, horror movies, Dada, hardcore punk, magic and nature. Largely self-taught (although his father was an artist, and he learnt a lot from him), the artists he admires include Robert Crumb, Max Ernst, Moebius, Magritte, Dann Highs, Audubon, Tomas Garcia, Mariano Castiglioni, Jair Dominguez Dumois, Freddy Leo, Percy Waters and Agustin Croxatto, "to name only a few." Piranha also holds that "tattooing makes you grow spiritually as a person, it's a culture that touches your whole life."

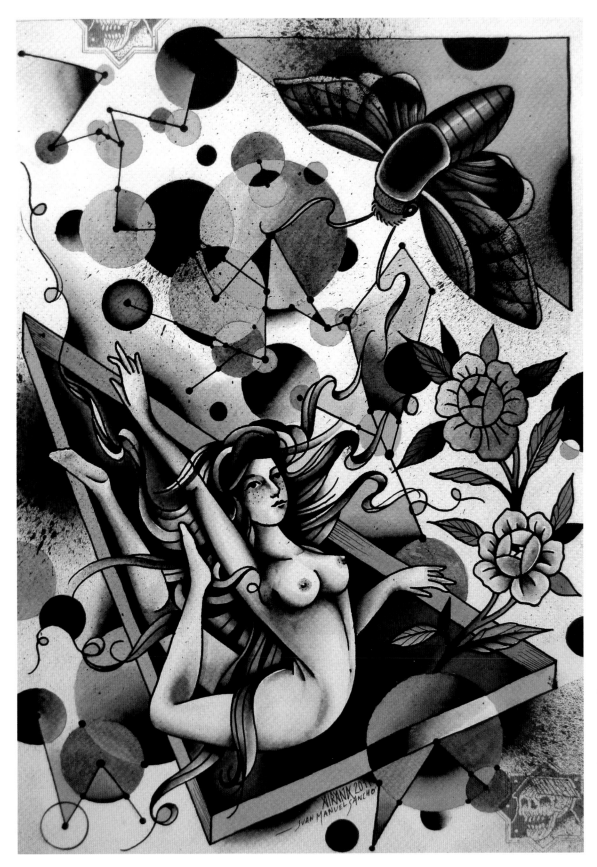

FAR LEFT: *La Red (The Network).* Ink and golden ink on paper.

LEFT: *Mutacion (Mutation).* Ink and watercolour on paper.

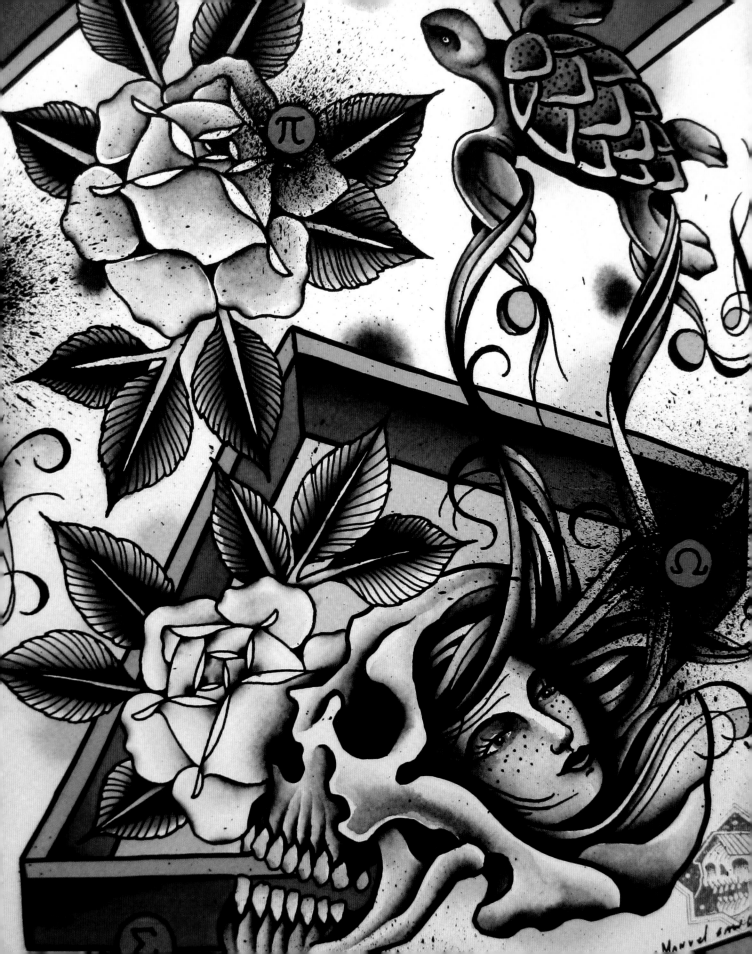

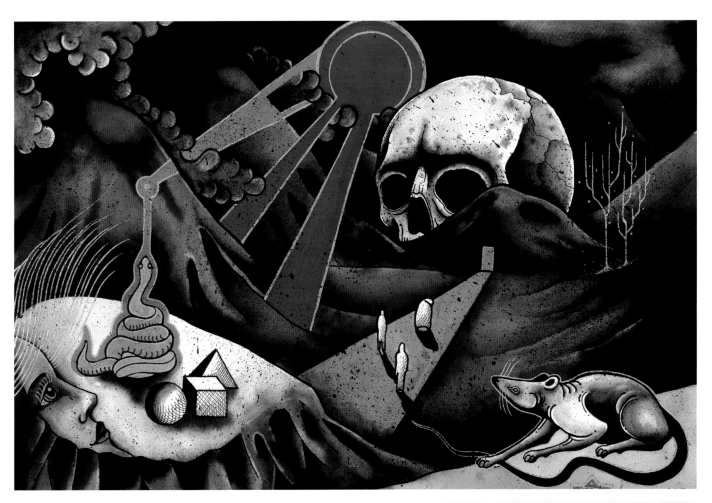

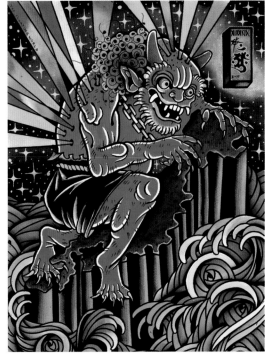

LEFT: *Se Escapo la Tortuga (The Tortoise Escaped).* Ink and watercolour on paper.

ABOVE: *La Procesion (The Procession).* Ink and watercolour on paper.

RIGHT: *The Floating World.* Ink and watercolour on paper.

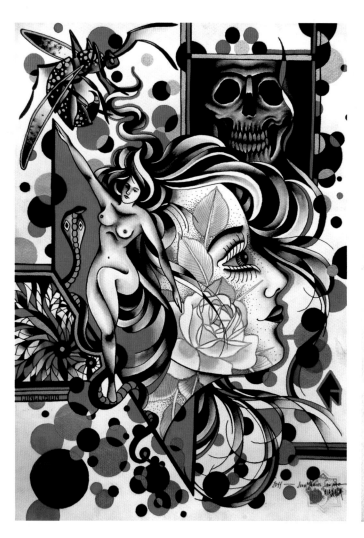

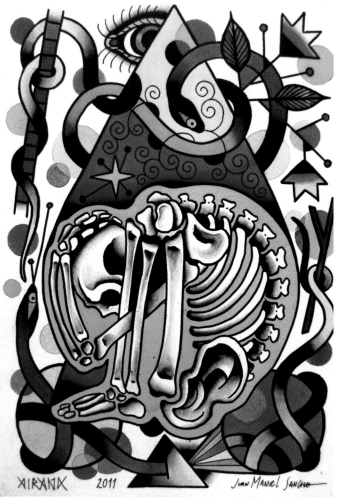

ABOVE LEFT: *Conclusion*.
Ink and watercolour
on paper.

ABOVE: *Saturno (Saturn)*.
Ink and watercolour
on paper.

RIGHT: *Silence*.
Acrylic on paper.

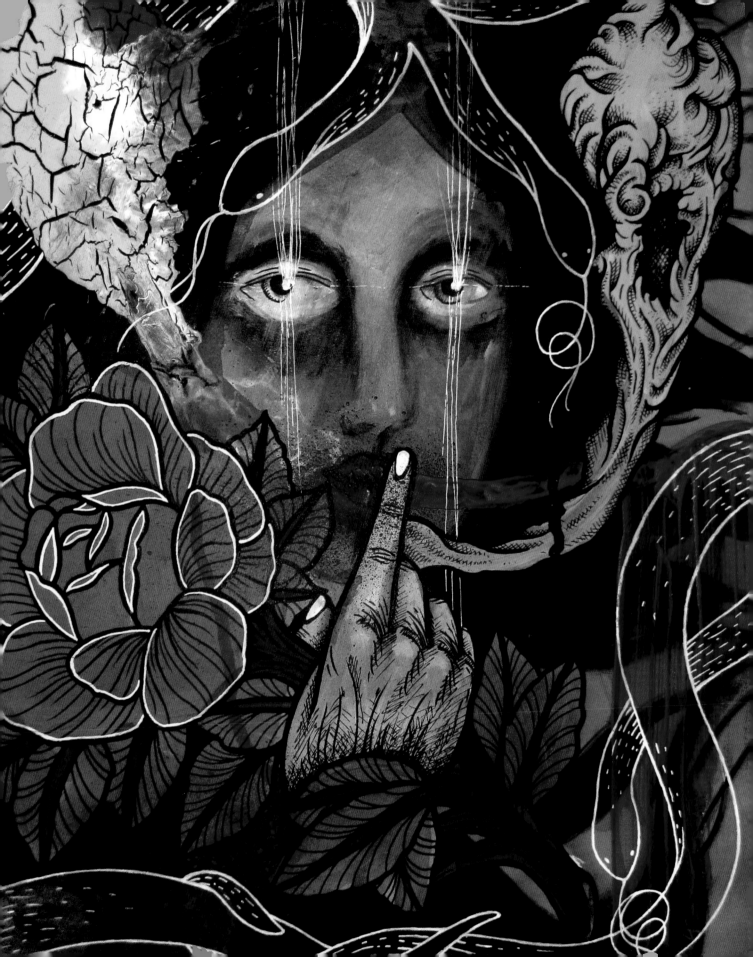

DAVID ROBINSON

"The trust that people give you to create art on their body, that felt like the biggest reward when I was starting out," says David Robinson. He was always drawing growing up and thought about going into architecture, drawing comic books, animation and tattoo. Getting tattooed himself also made the choice for him. His apprenticeship was at two small shops on the West Coast; "they weren't the best people." But David did learn his craft, including how to make needles. He remembers his first tattoo machine: "It was from the Huck Spaulding tattoo kit. I spent all my time taking the machine apart and putting it back together. I was fascinated by how it all worked." Today David is with Everlasting Tatto in San Francisco and Humble Beginnings in San Jose. For drawing, he favours ink and watercolours on 300-lb paper. His inspiration comes from "everything I look at. But I particularly love the baroque, roccoco and art nouveau movements. My clients come to me for the intricacy and delicate imagery that is part of those styles." David admires many artists, but particularly the work of Fuyuko Matsui, Vania Zouravliov, Arthur Rackham and J.C. Leyendecker.

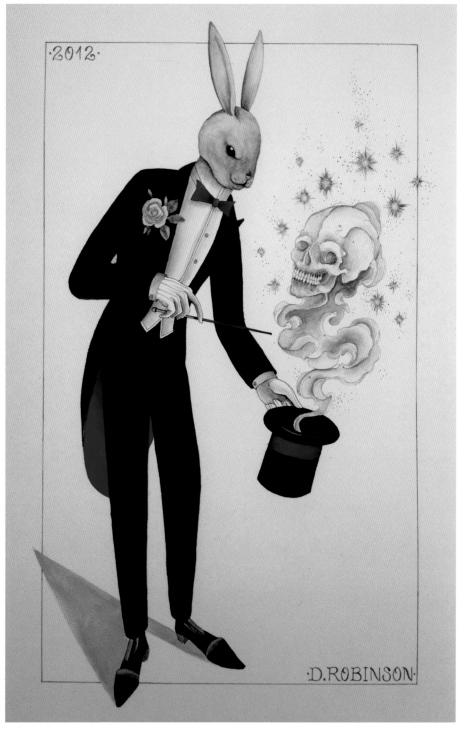

ABOVE: *Rabbit Conjuror.* Pen and ink.

RIGHT: *Shanghai Courtesan.* Pen, ink and watercolour.

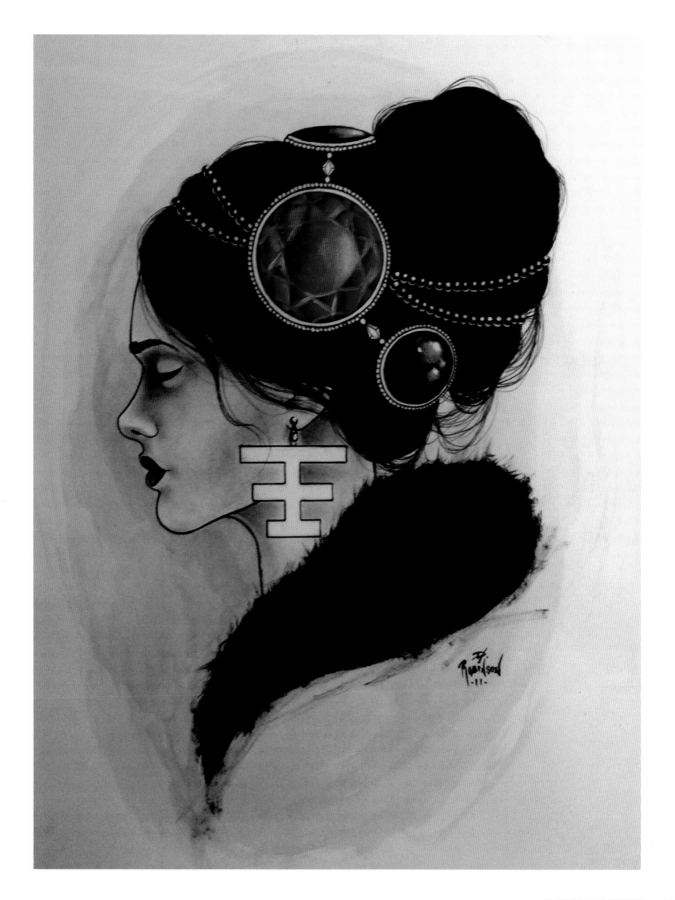

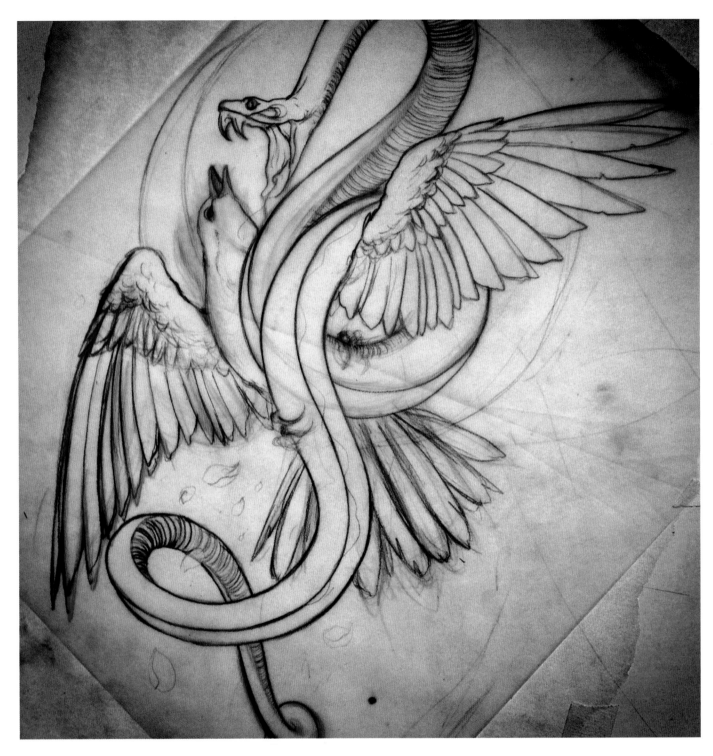

ABOVE: *Snake and Dove.*
Pen and tracing paper.

RIGHT: *Beetle Wings.*
Pen, ink and
watercolour.

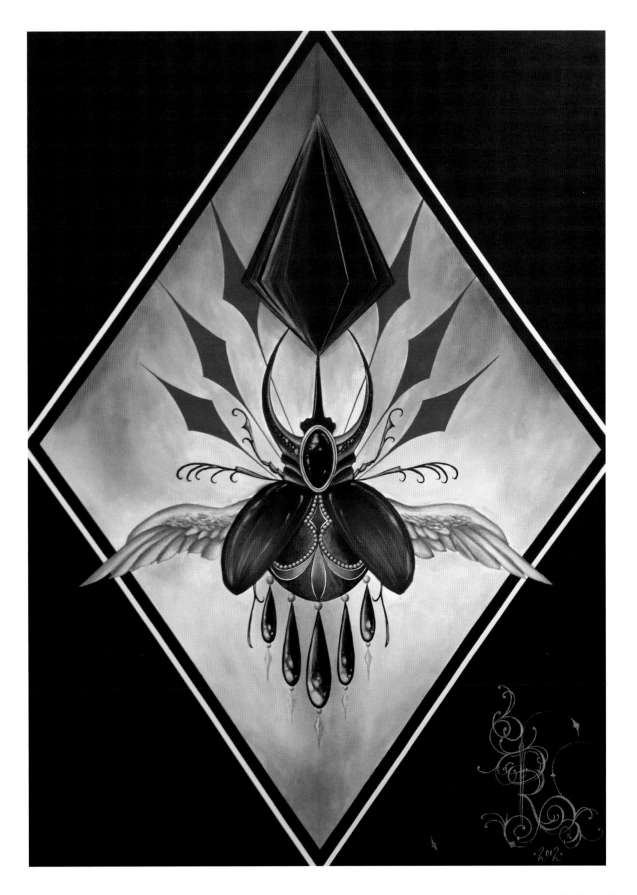

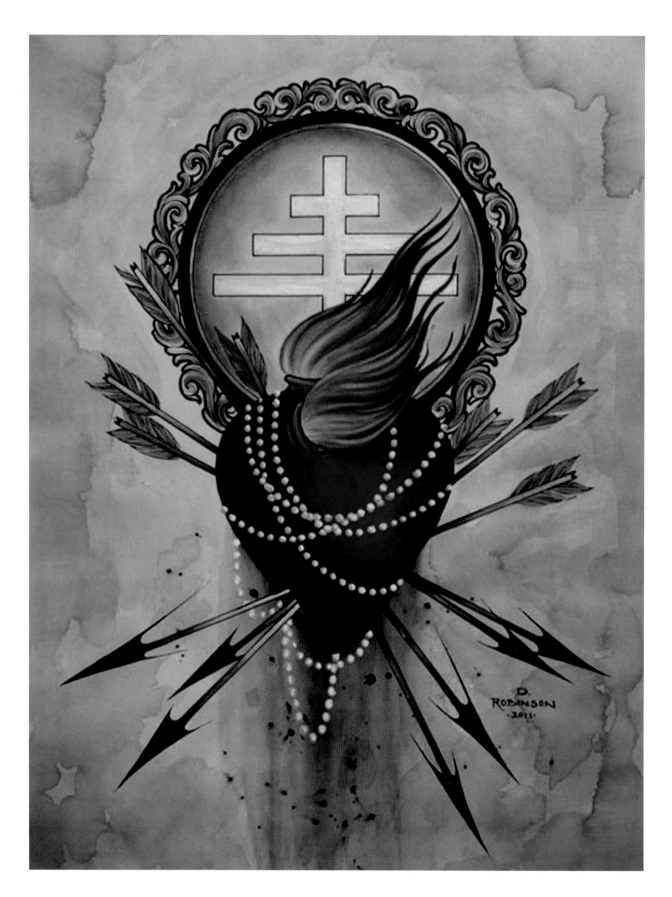

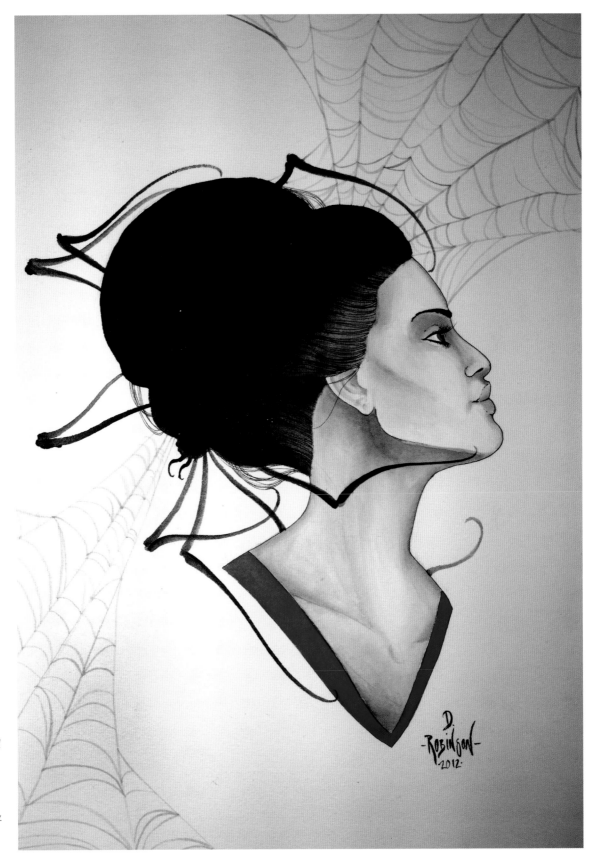

LEFT: *Flaming Pearl Heart.*
Pen, ink and watercolour.

RIGHT: *Black Widow.*
Pen and ink.

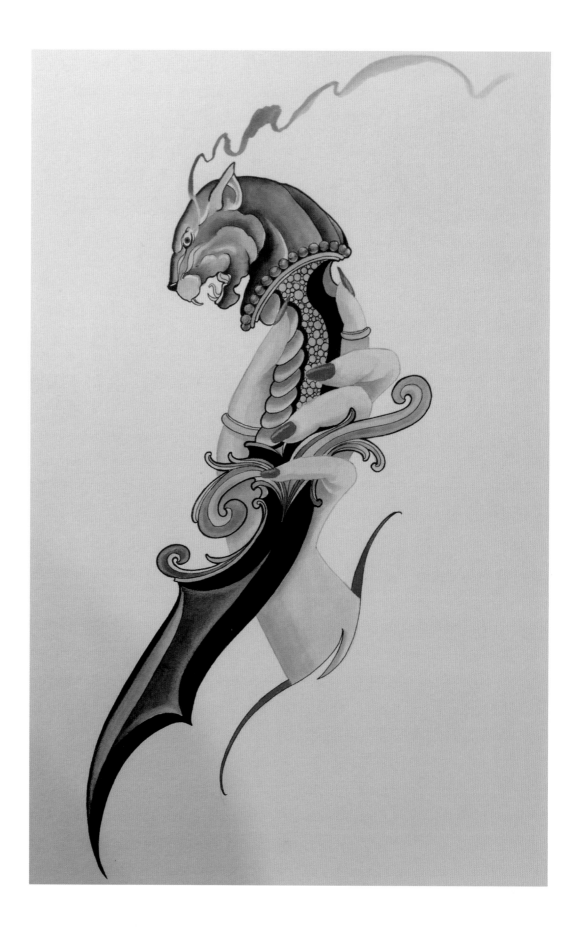

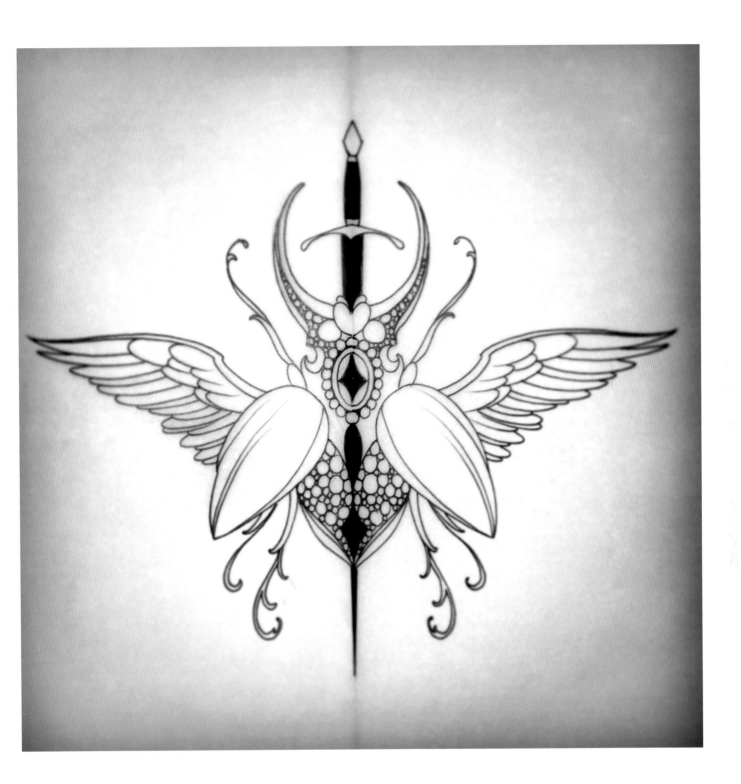

LEFT: *Opium Dagger.*
Pen, ink and
watercolour..

ABOVE: *Flying Scarab.*
Pencil, pen and ink on
tracing paper.

DAVID RUDZINSKI

David Rudzinski began tattooing in his native town of Elk, in north-eastern Poland. At the start it was all about "how sharp the guitar strings were and my machine then was essentially a pen attached to some Walkman machinery. Getting through that was a hell of a long journey. I'm just relieved my hands are more or less intact after that phase." Today he works in his own studio - Theatrum Symbolica - in Warsaw. "You can't find my studio unless you know where to look. It is not on the street and so none of my customers are 'walk-ins'. It's a word of mouth thing. They know of me and my work and so know what to expect. Many come back again and again – it's a question of building trust. And they like the environment – everything about the studio is as you would expect from the name." David works with watercolours, black ink, coloured pencils and fine line markers. He also likes to create "impossible to tattoo" images – exploring new techniques like using burnt wood. Inspiration comes from within: "All the ideas you need in order to create are already inside you. I don't look for inspiration from the world of tattoo. Inspiration comes from my imagination." Of the future he says "All I know is it will change. Everything is in flux – that's what the universe is about. I do know for sure, however, that tattoo will not end up in a museum. For me it's not 'art' – you don't need to justify it by giving it that label. Tattoo is itself."

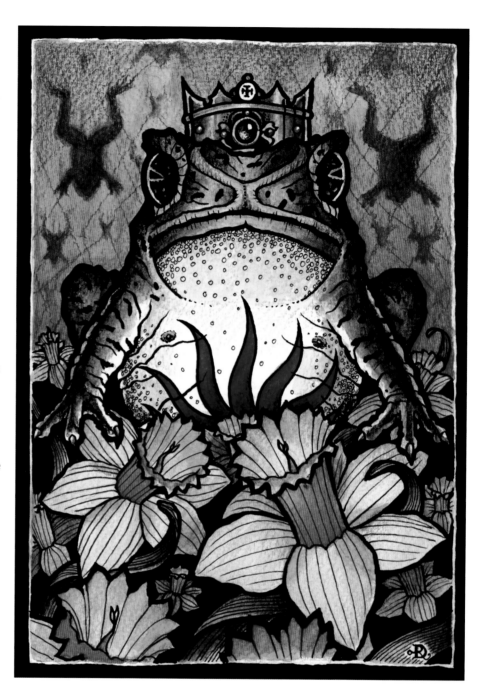

ABOVE: *Kaiser Krote.*
Watercolour pencils.

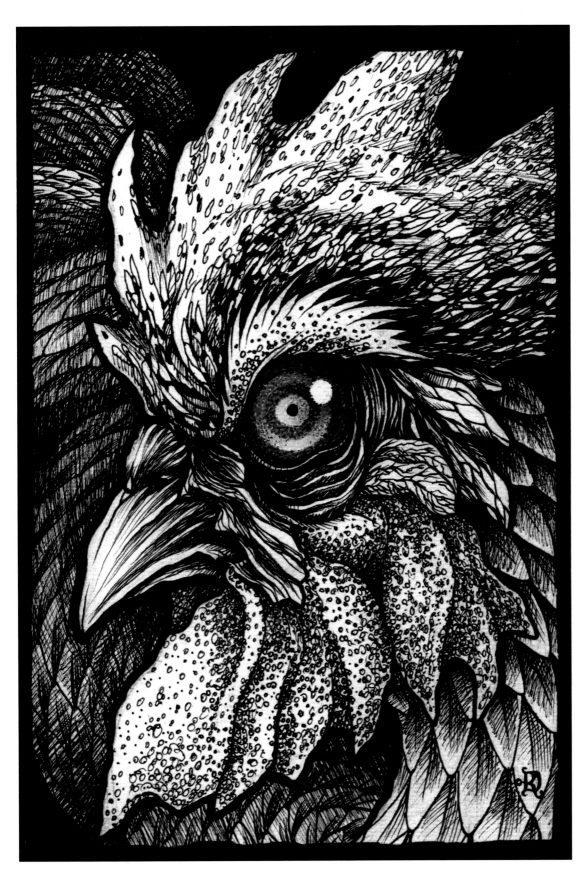

LEFT: *Bazyliszek.*
Fineliner and pencils.

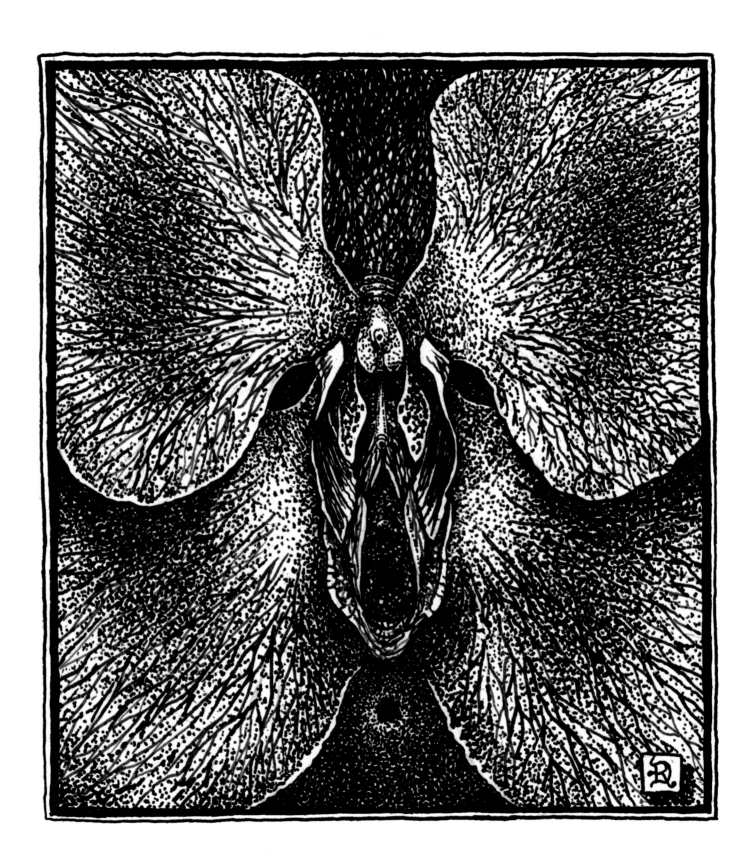

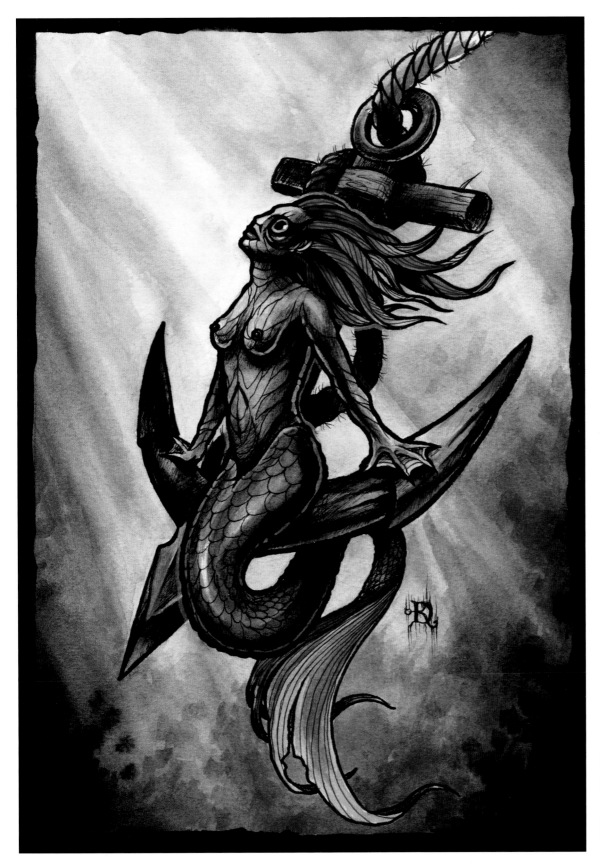

FAR LEFT: *Flower of Filthiness.* Fineliner.

LEFT: *Siren.* Watercolour.

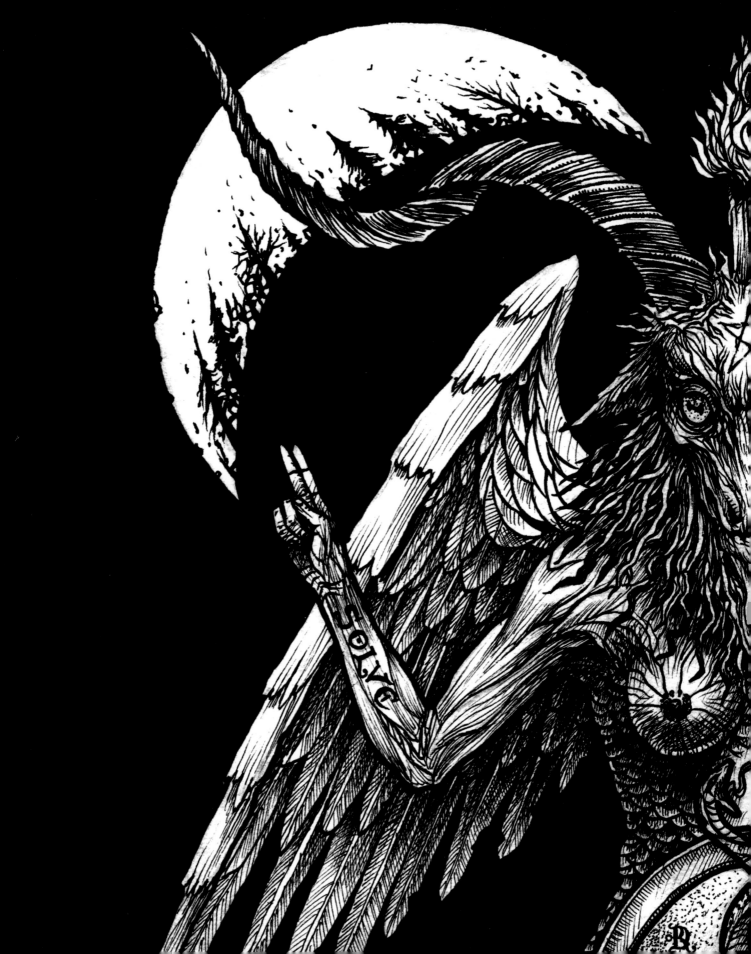

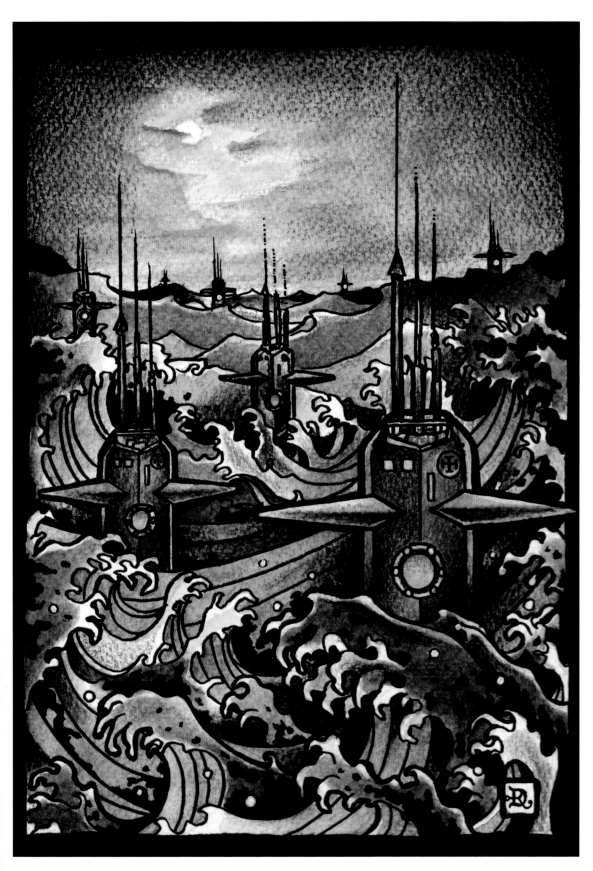

FAR LEFT: *Baphomet*.
Fineliner.

LEFT: *Submarines*.
Watercolour pencils.

JEFF SAUNDERS

"Becoming a tattoo artist? It never crossed my mind as a career move. I was always drawing as a kid... fast forward to age 23 and I'm unloading trucks for a living and hating it, when my dad suggested tattooing. A few weeks later I was starting my apprenticeship." Unlike many tattooists, getting taken on was the easy bit – it was Steve Rotondi, whom he knew, from Mean Street Tattoos who gave him his break after looking at his portfolio and sketches. "It was work, work, work. I did loads of watching, made a load of stencils and, of course, played shop bitch. It wasn't hard and it wasn't easy; it was *challenging*. Every day offered something new." Saunders has used every technique – pencils, ballpoints, sharpies, cross-hatching and smooth shading. Today he favours Prismacolor pencils. He did a few classes at high school, but often fought with his art teachers, and is essentially self-taught. "Those art teachers were always telling their students to do a project 'this way' or 'that way' – fact is there is no 'right way' in art." The early influences were *Batman* comics, Spawn, Todd McFarlane and Greg Capullo – "If it wasn't for comics, who knows where my art would be today." He admires the work of a host of artists, including Nikko Hurtado, Bob Tyrrell, Dmitriy Samohin, Denis Sivak and Victor Portugal. "But when it comes to a work ethic I've learnt the most from Jeff Davis (a.k.a. Stress the Whiteboy). He's taught me that hard work and dedication to your craft will earn you great things. Nothing is ever handed to you!"

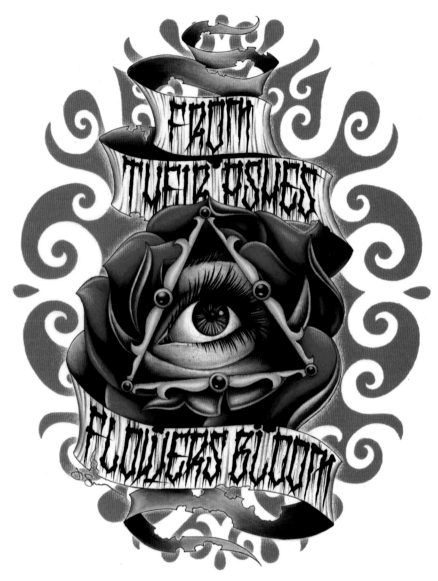

ABOVE: *From Their Ashes.* Ink on paper.

RIGHT: *Dream.* Ink and acrylic.

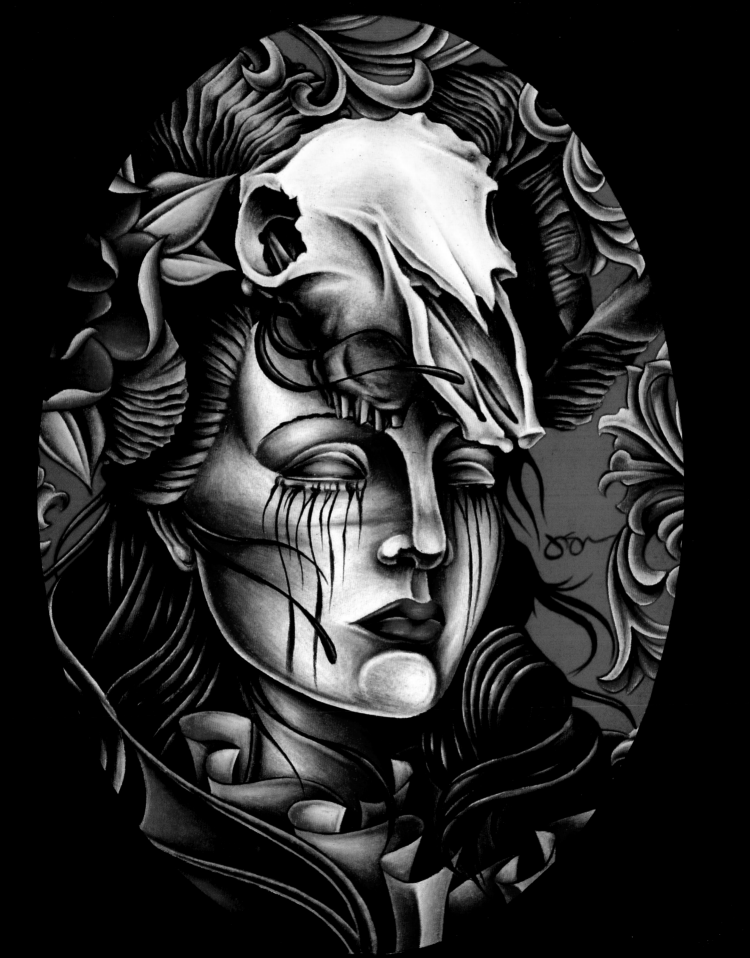

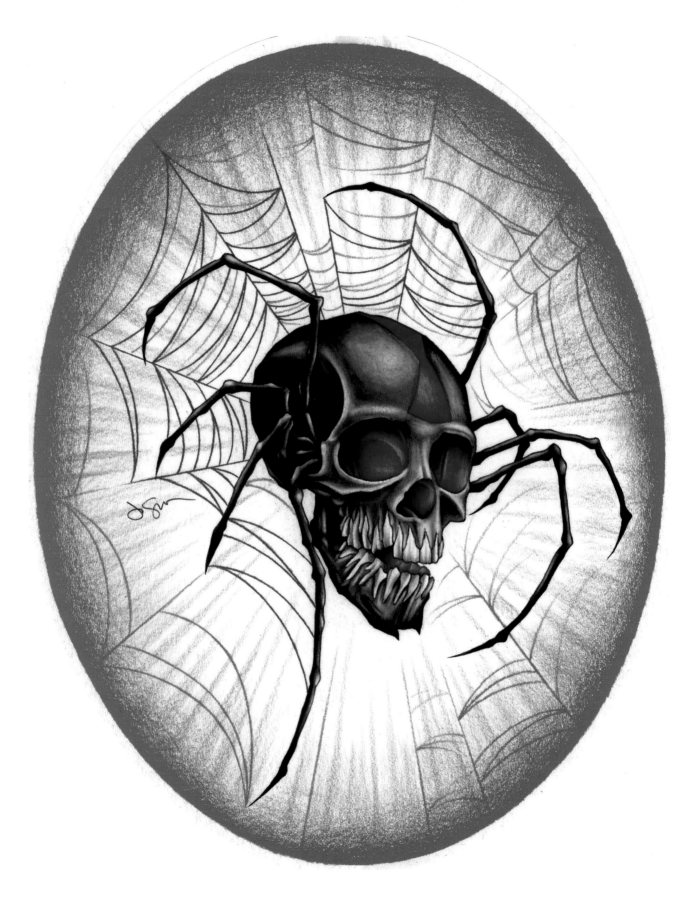

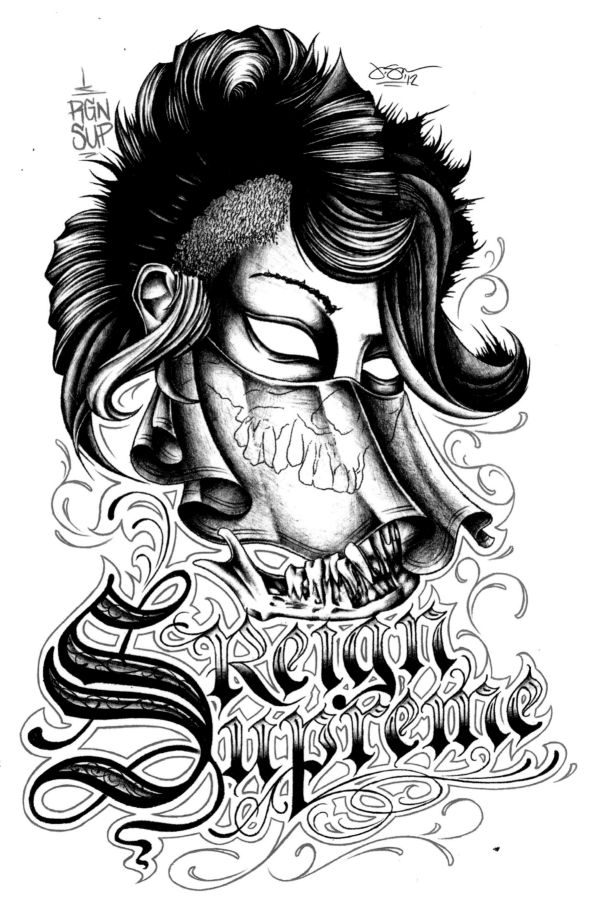

LEFT: *Black Widow.*
Ink on paper.

RIGHT: *Reign Supreme.*
Ink on paper.

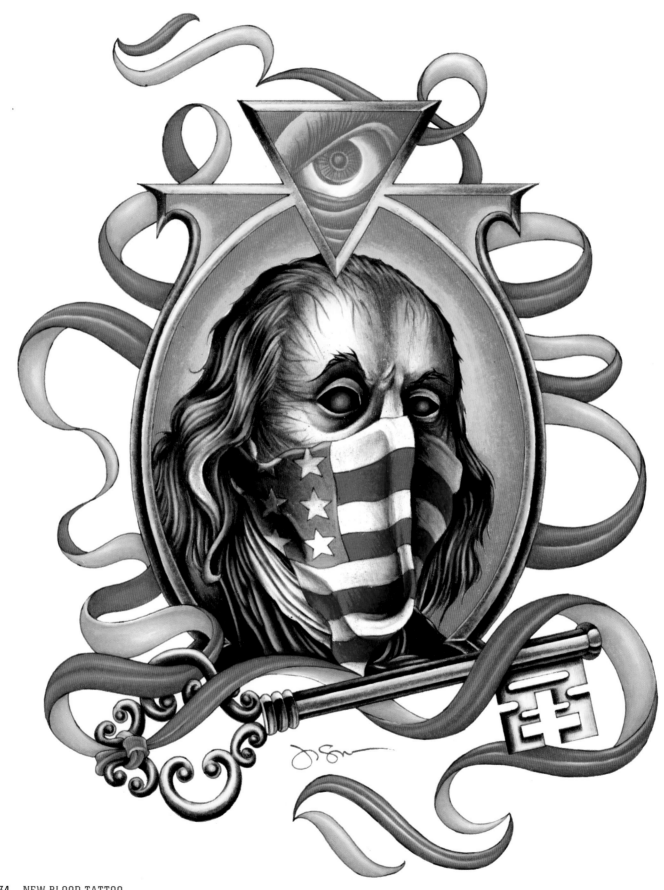

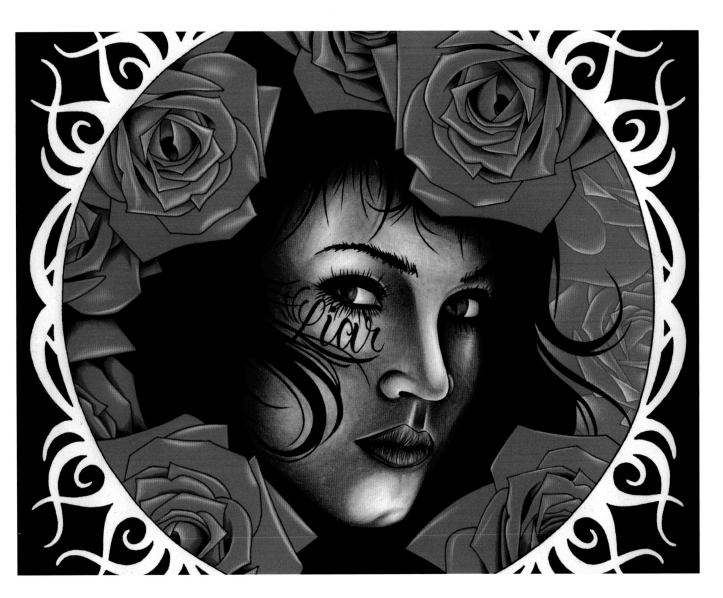

LEFT: *Franklin.*
Acrylic and ink.

ABOVE: *Liar.*
Acrylic and ink.

BELOW: *Untitled.*
Resin.

RIGHT: *Rose Skull.*
Ink on paper.

FAR RIGHT: *Pointless
Prayers.*
Ceramic with flowers.

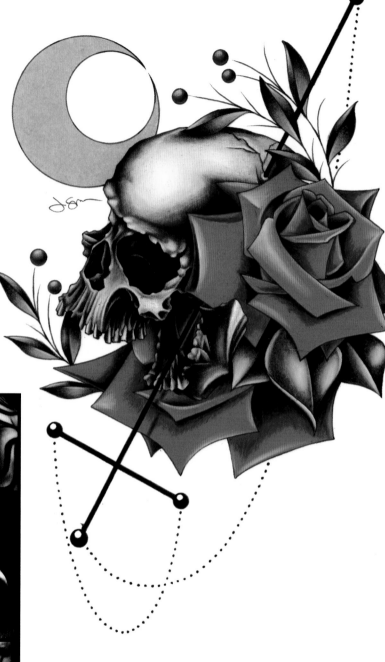

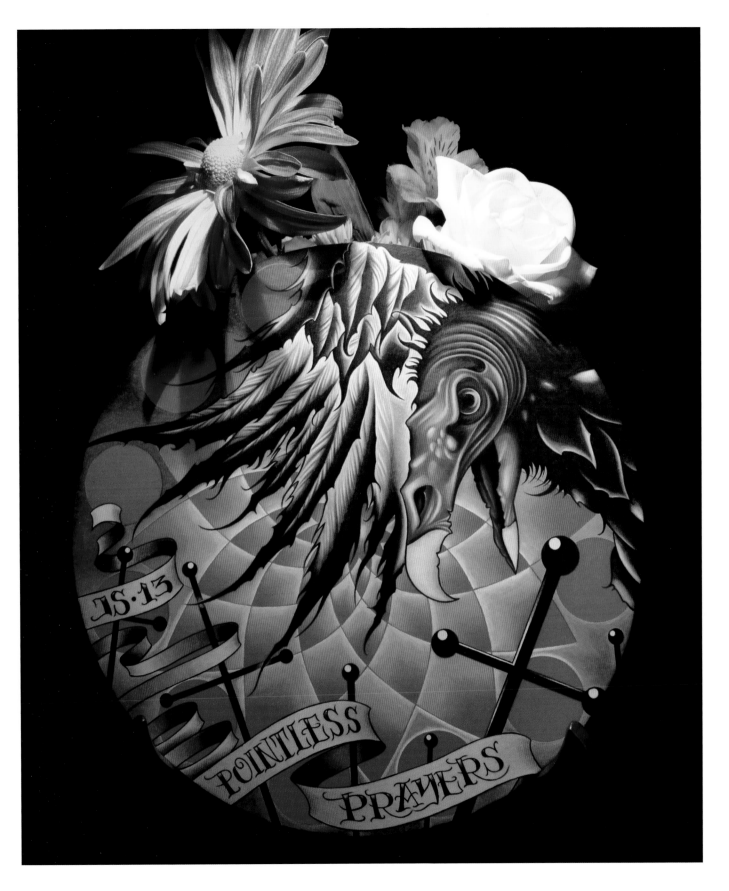

EVA SCHATZ

It was whilst getting a tattoo from Leo at Naked Trust Tattoo in Salzburg that Eva had her revelation. "I had a great job as a graphic designer in an advertising agency, but getting that tattoo made me realise I was in love with this whole new world. So I quit my job, sold my car, moved back to my parents' house and began an apprenticeship in that same Leo's shop. It was like love at first sight." At first she thought it was easy, that she could do everything, and then a few weeks later "I was like, oh my God, this is so hard, I'll never be able to draw a straight line. And I was working my ass off, with 12-14 hour days, with no days off." She was with Leo for "five great fun years" before opening her own space, in an atelier in Salzburg old town. "Because I want to create a work of art for each customer, it's a better environment than the shop." Eva loves to paint with ink, in greyscale with a few colour accents. When translated into a tattoo she then adds bright colours. For sketching she uses red and blue Prismacolour col-erase pencils. Inspiration comes from many other artists. "We have a huge library in the atelier. Between appointments I love to drink a cup of coffee and flip through art books looking for ideas. I love Renaissance art and Alphonse Mucha. It's funny and effective to combine different cultures and art styles." Social media is a mixed blessing, she says. "I love Instagram. For our art, telling the world something interesting with a picture is great. But then you can also see that a douche-bag on the other side of the world has made a screenshot and tattooed my design on someone else. Yeah, that bit sucks!"

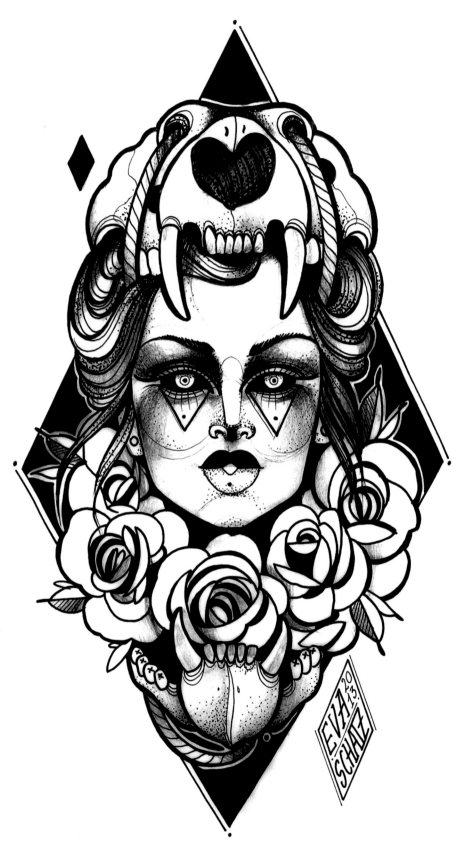

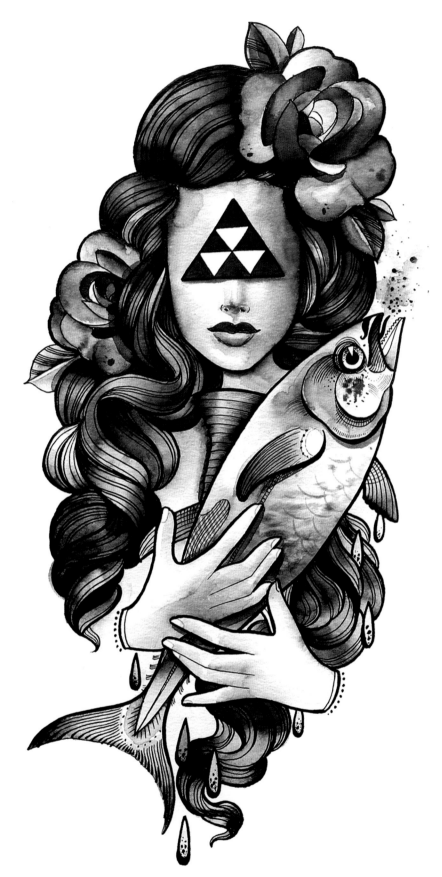

LEFT: *Lion Head.*
Ink on paper.

RIGHT: *Water Nymph.*
Ink on paper.

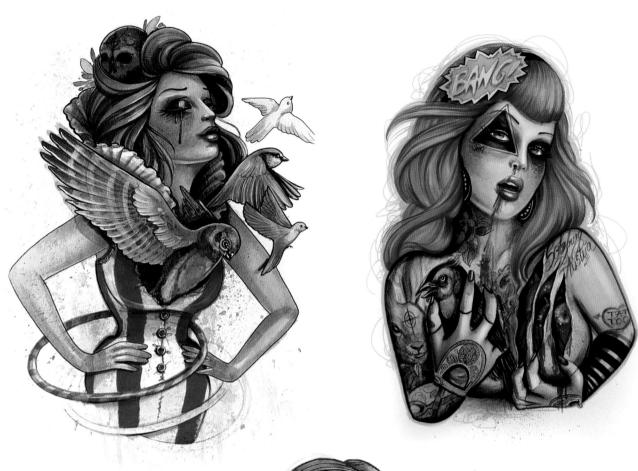

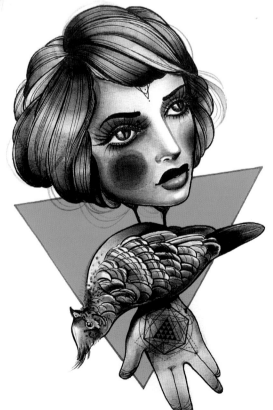

ABOVE: *Hula Girl.*
Ink on paper.

ABOVE RIGHT: *Bang.*
Ink on paper.

RIGHT: *Bird in the Hand.*
Ink on paper.

DREW SHALLIS

"The hardest thing about starting out was having to prove that you weren't just some anybody who wanted an apprenticeship because you'd seen tattooing on TV," says Australia-based Drew. "Luckily Shannon Richmond of STR Body Modifications saw something in me, and I'm still here." Seeing Jasmin Austin's work was the original spark which made Drew want to become a tattooist. "I guess you could label my work as being in a neo-traditional style, but I really just love bold lines and bright colours." He works hard at his flash designs and researches artists outside the tattoo field to keep his work original. "The thing is you can't help but be amazed by some of the work in the industry," adds Drew, and then cites the art and designs of Shannon Richmond, Dave Olteanu, Ebony Mellowship and Zane Donnellan as well as Jasmin Austin, Annie Frenzel and Peter Lagergren. Of the future he says "social media will determine what we are doing. It's a shame as new things spread very fast, but die very fast also. Those tattooers who survive will be those who are doing solid, clean tattoos and who don't worry whether their work is cool right this minute or not."

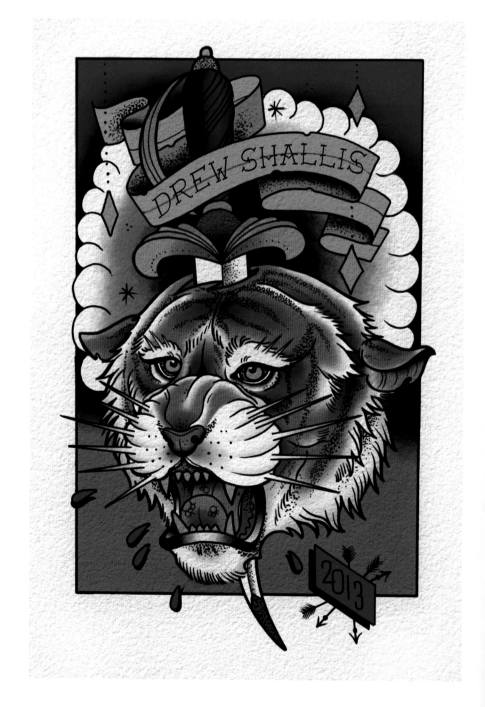

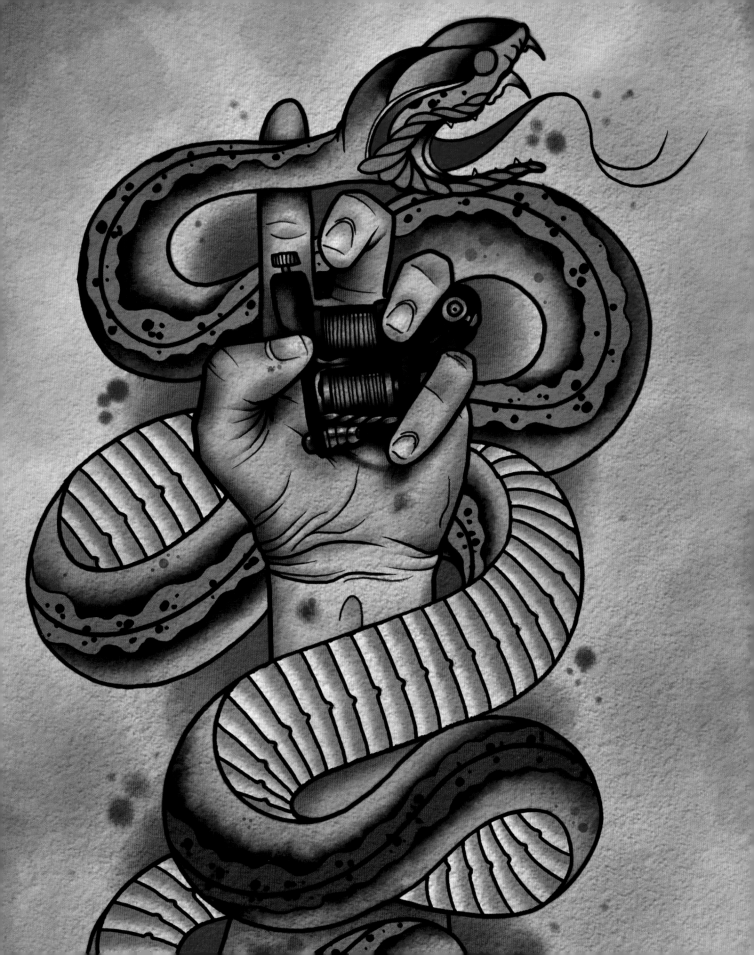

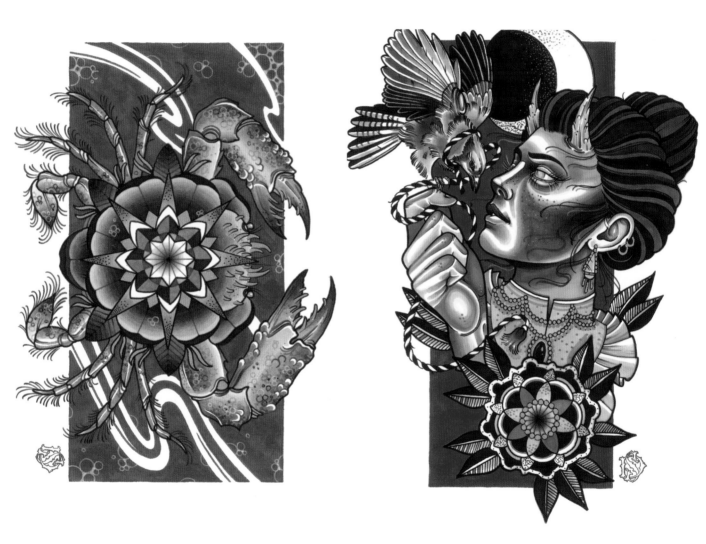

ABOVE: *Star Crab.*
Pen, ink and markers.

ABOVE RIGHT:
Collared Bird.
Pen, ink and markers.

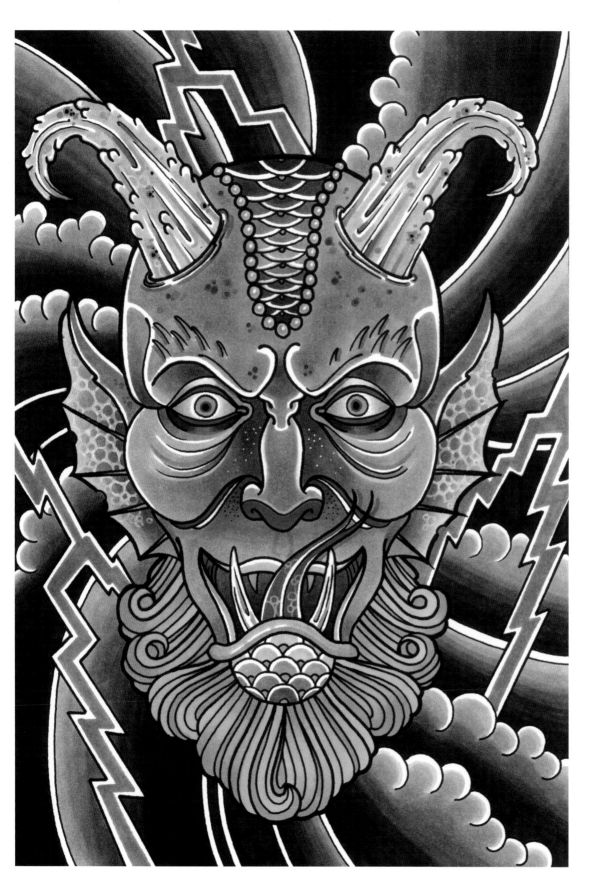

LEFT: *Horned Devil.*
Copic markers.

KODIE SMITH

From having tattoos to becoming a tattoo artist was a logical progression for Kodie: "I looked into it and just went for it." He got his apprenticeship at Edshead in Chelmsford, UK, where he is still based. "It was hard at the beginning as you're basically doing everything for nothing. But it was great in that I was learning loads and drawing 24/7." He works with pencil, pen and ink and Ph Martins watercolours – "probably always will; they are perfect for what I do." Kodie is always seeking to improve. "I look at artists like Dave Tevenal, Mitch Allenden and Rachi Brains and I say to myself 'you've gotta up your game'. That being really self-critical thing is just part of being an artist." Tim Burton's art and films are another big influence, together with video game artwork. He is largely self-taught. "I did some art at high school, but quit without finishing. I was never driven or inspired by any of the mainstream artists. It was rubbish: I hated having to justify why I did what I did, by inventing some kind of bullshit story or reason – 'enjoyment' was never enough." Of the tattoo scene he says "There are so many insanely good artists popping up everywhere, which is great as it keeps us all on our toes. As far as I can see the more popular tattoos are, the more work there is, the more crazy cool artwork will emerge."

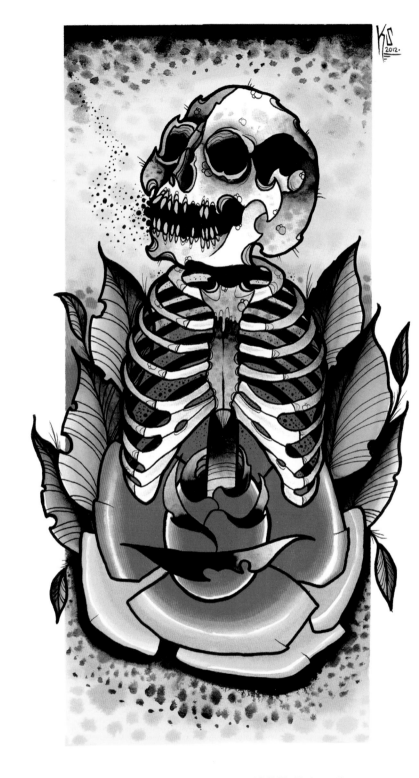

ABOVE: *Skeleton Rose.*
Watercolour on paper.

RIGHT: *Split with Lee.*
Watercolour on paper.

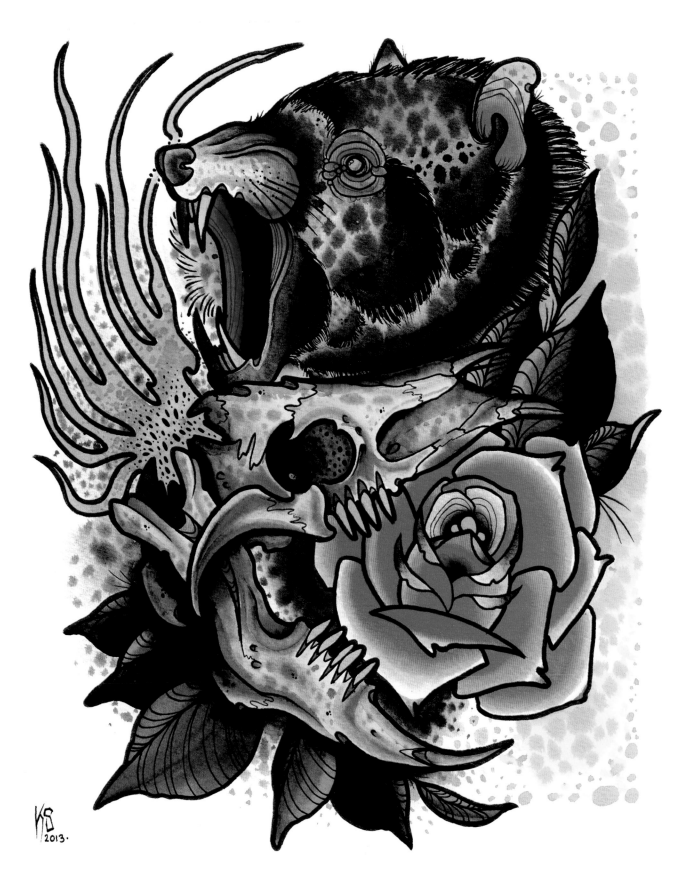

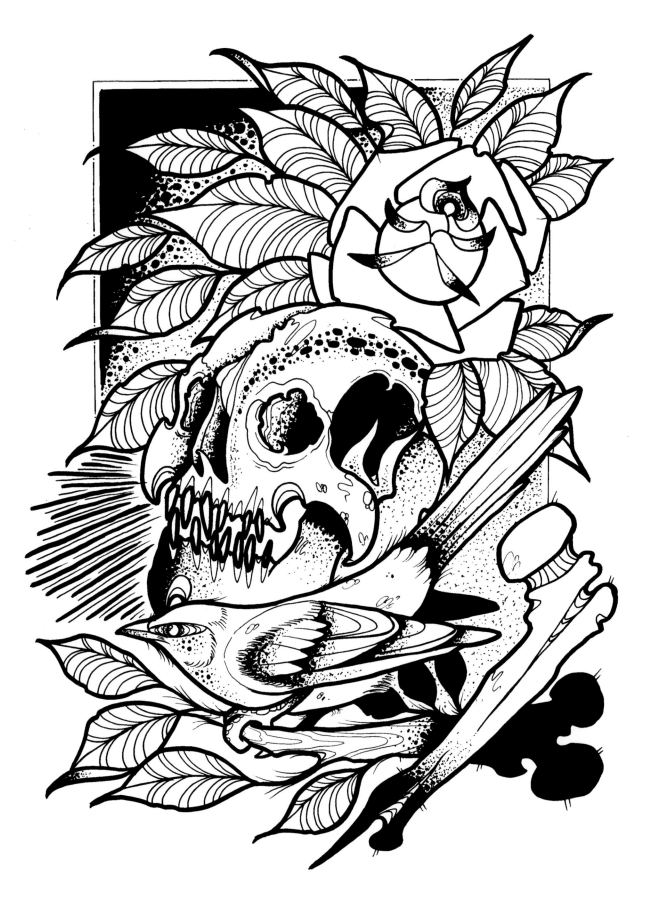

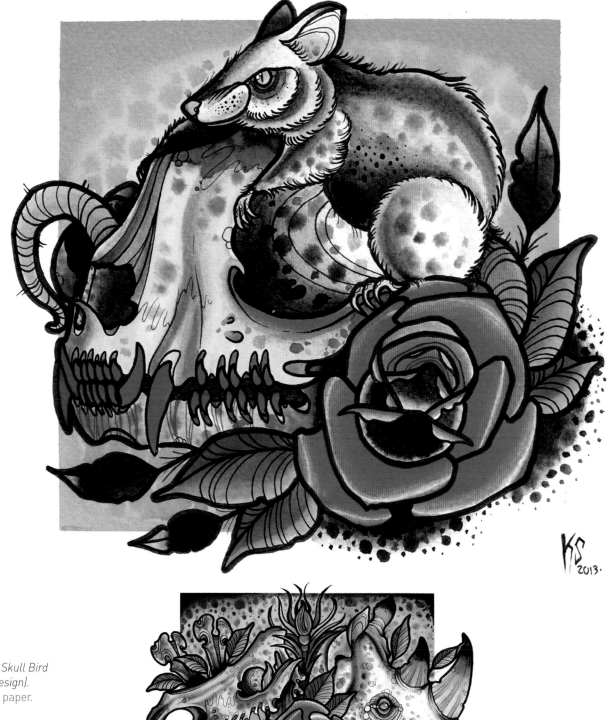

LEFT: *Skull Bird (Tee Design).*
Ink on paper.

ABOVE: *Rat and Cat.*
Watercolour on paper.

RIGHT: *Rhino.*
Watercolour on paper.

TOP LEFT: *My Part of the Split*. Watercolour on paper.

TOP RIGHT: *Skull Rose*. Watercolour on paper.

BOTTOM LEFT: *Foxy*. Watercolour on paper.

BOTTOM RIGHT: *Snake*. Watercolour on paper.

RIGHT: *Bear and Salmon*. Watercolour on paper.

ROSE WHITTAKER

Throughout high school, the only subject Rose put any effort into was art. She got into punk rock aged 13 – "everyone in the bands I loved had tattoos" – and used to copy band artwork and tattoos, redrawing spider webs, girls' faces, dice, sacred hearts and wings. "Then, seeing heavily tattooed women like Theo Kogan and Tairrie B just blew my mind." She got her first tattoo aged 14 ("to piss off my parents"), then started getting into the art, buying tattoo magazines and drawing more tattoo-related imagery. Going on to a foundation course in art and design, she realised that a career in graphic design or advertising wasn't for her. So, aged 19, she took off to Australia. " There I got tattooed by the wonderful Miss Alison Manners. Meeting her – she gave me great direction and advice – is the reason I'm tattooing today." On her return Rose started networking, getting tattoos from Steve Byrne in Leeds and from Cult Classic in Essex. Then in 2010 she moved to London and was taken on as an apprentice by "the fantastic" Steve Barron at A True Love Tattoo, before getting her full-time position at Haunted Tattoo. Rose's 'weapons of choice' are watercolour inks, fineliners, sharpies, markers and, occasionally, acrylic inks. She is influenced by many artists outside tattooing – Caravaggio, Beardsley, Raymond Pettibon, Jim Phillips, Ralf Steadman, Kozik, Coop, Robert Crumb and Eric Stanton. "I love anything smutty, or that involves punk or skateboarding." Other sources of inspiration include Victorian botanical illustrations, Russian icons, masonic imagery and Native American art. Of the future she says "I hope it brings more artists who care about tattooing. Despite the over-saturation of tattoos everywhere, there are still amazing artists from all over the world who keep pushing themselves, creating great art that makes me sick with envy."

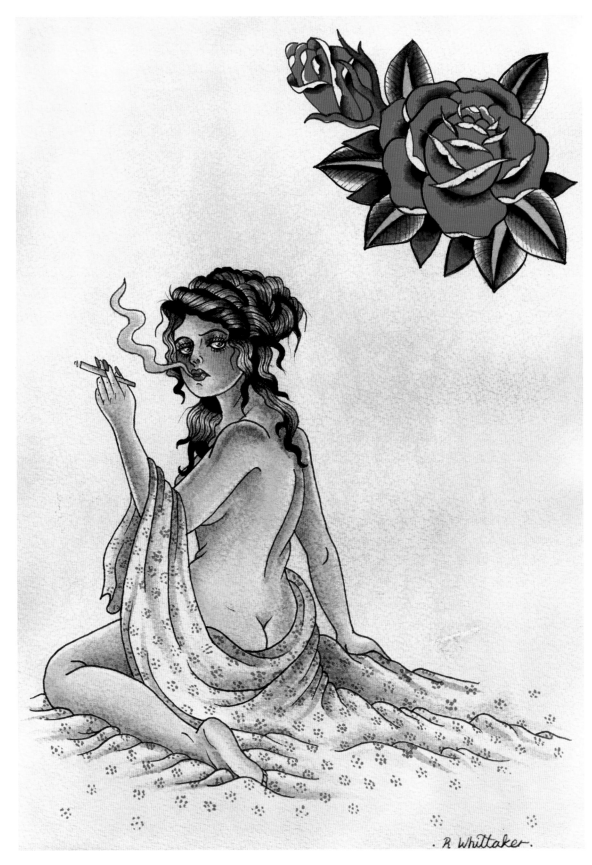

FAR LEFT: *Smoking Nude II.* Watercolour ink on paper.

LEFT: *Smoking Nude I.* Watercolour ink on paper.

. R. Whittaker.

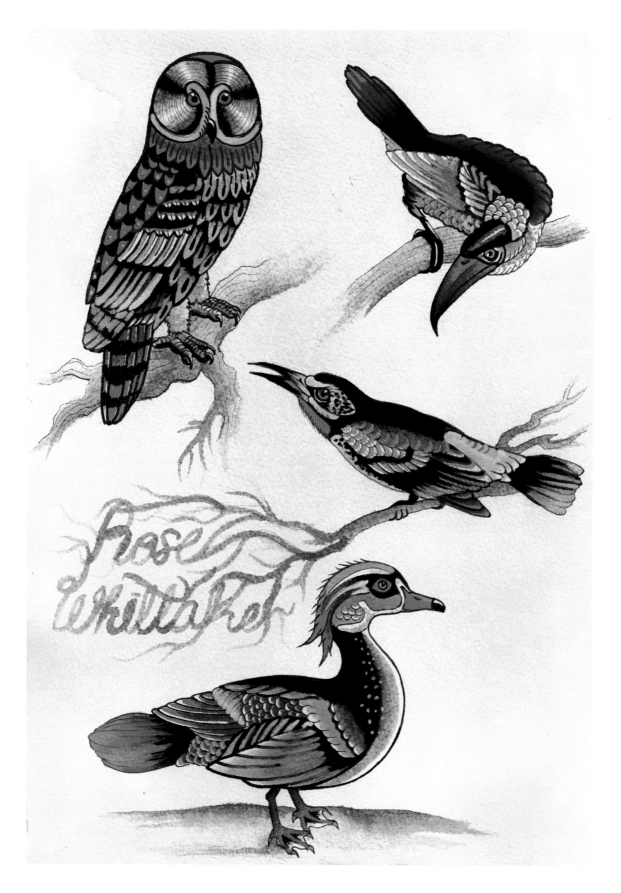

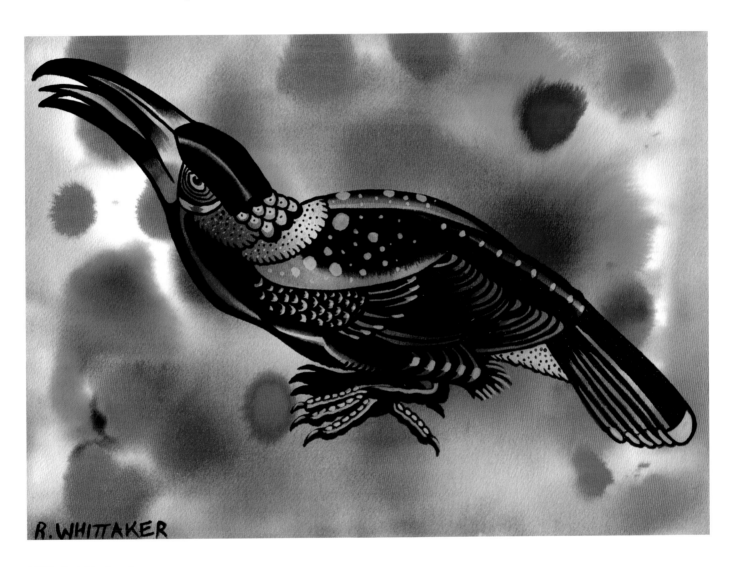

R. WHITTAKER

LEFT: *Red, Black and
Blue Birds.*
Watercolour ink
on paper.

ABOVE: *Bird.*
Watercolour ink
on paper.

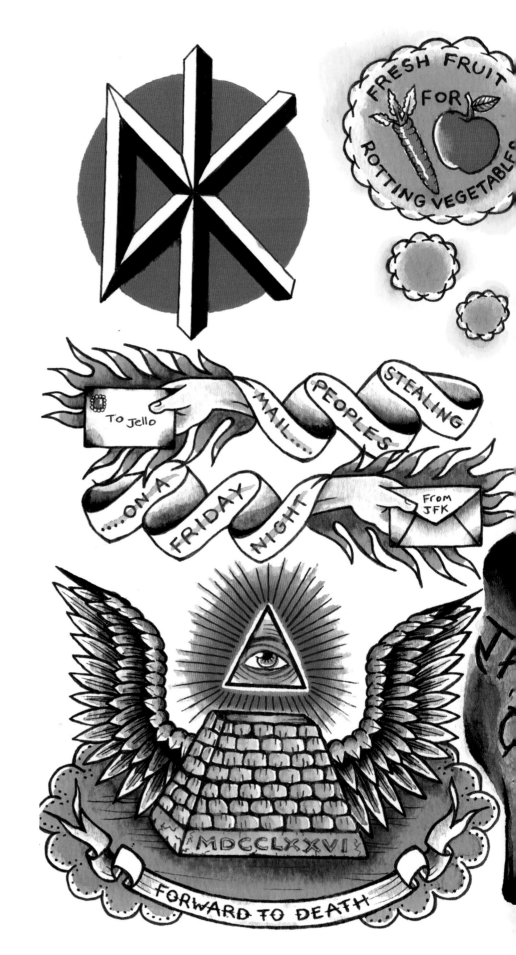

RIGHT: *Dead Kennedy Flash.*
Watercolour ink on paper.

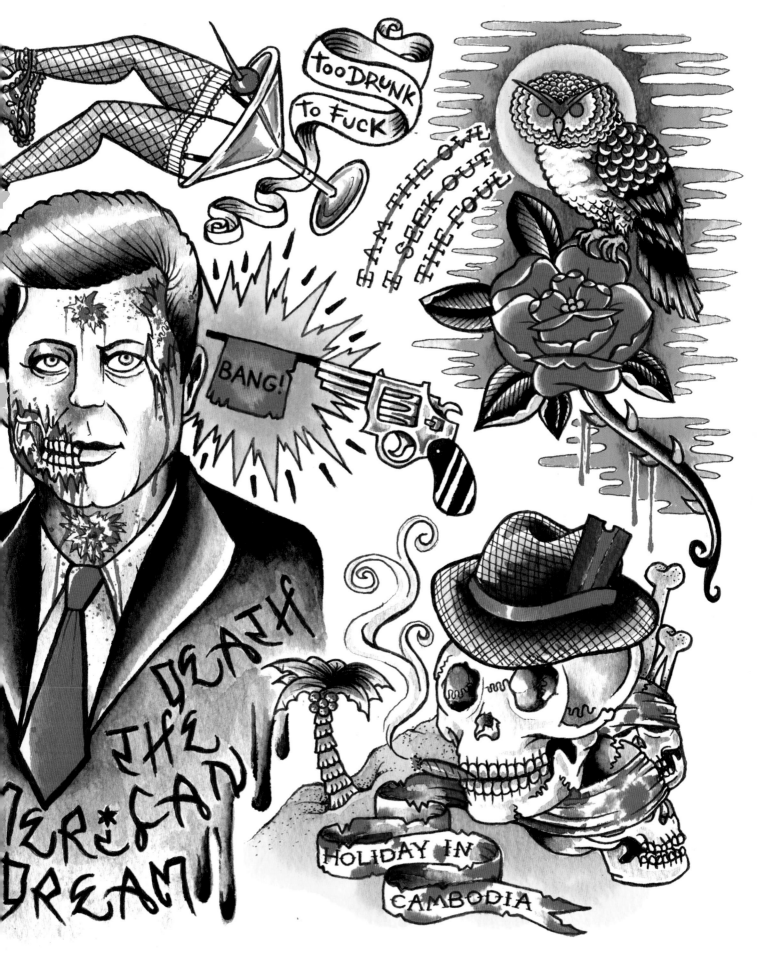

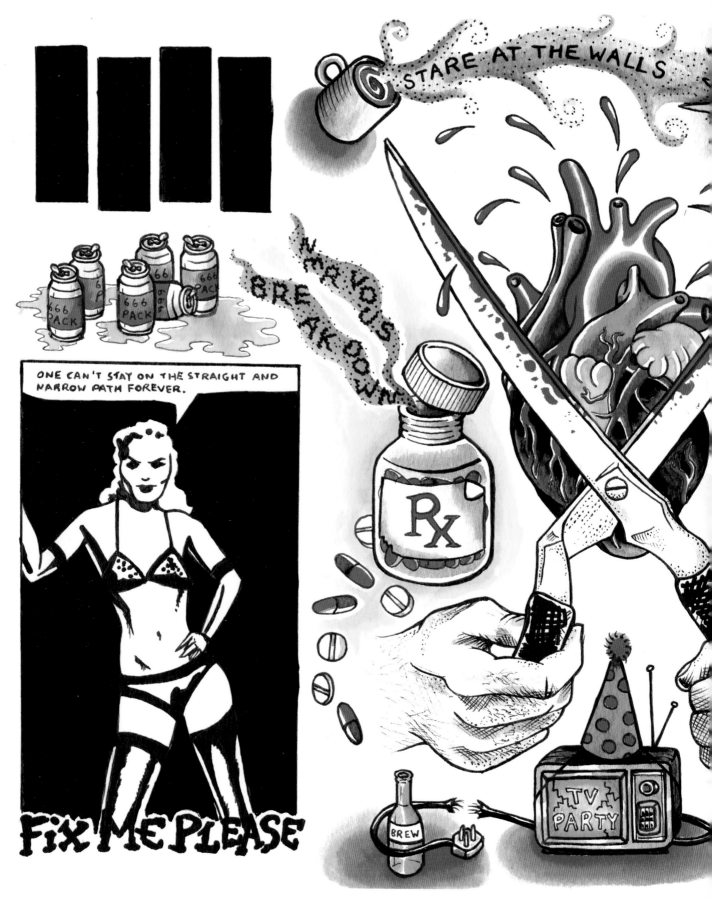

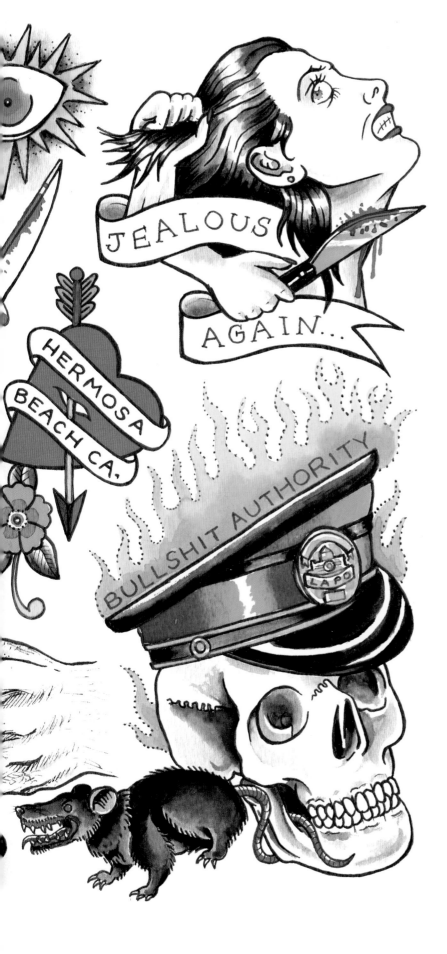

LEFT: *Black Flag Flash*.
Watercolour ink on paper.

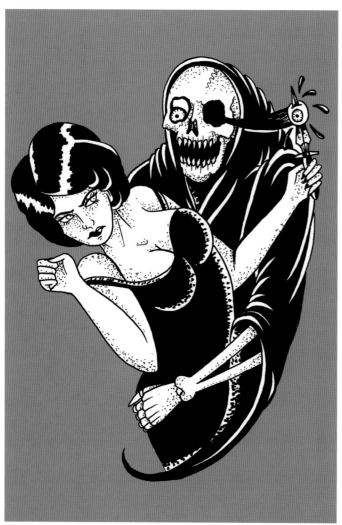

ABOVE: *Damsel in Distress.* Watercolour ink on paper.

ABOVE RIGHT: *Femdeath.* Watercolour ink on paper.

RIGHT: *Reaper Girl Blue.* Watercolour ink on paper.

ABOVE: *Leopard Snake.*
Watercolour ink
on paper.

RIGHT: *Eagle Scorpion.*
Watercolour ink
on paper.

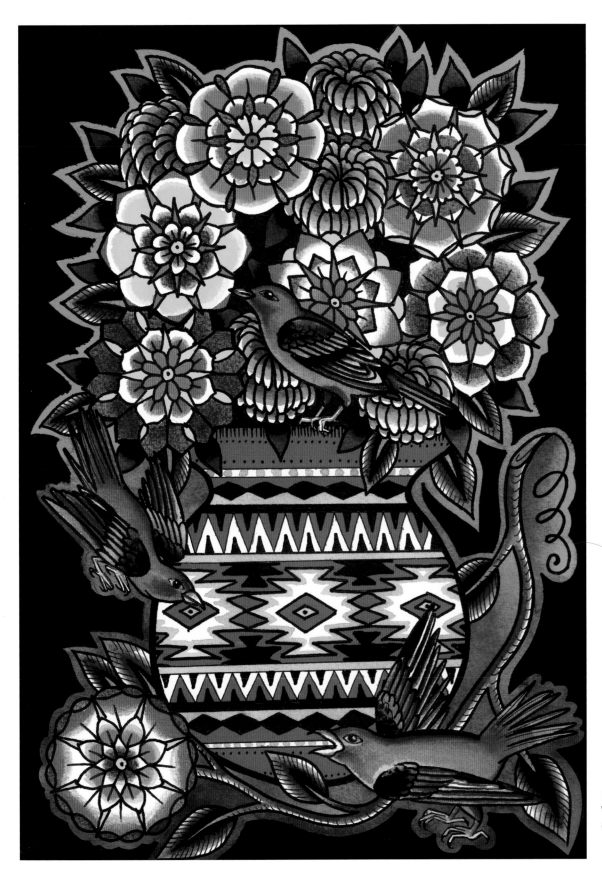

LEFT: *Yellow Birds.*
Watercolour ink
on paper.

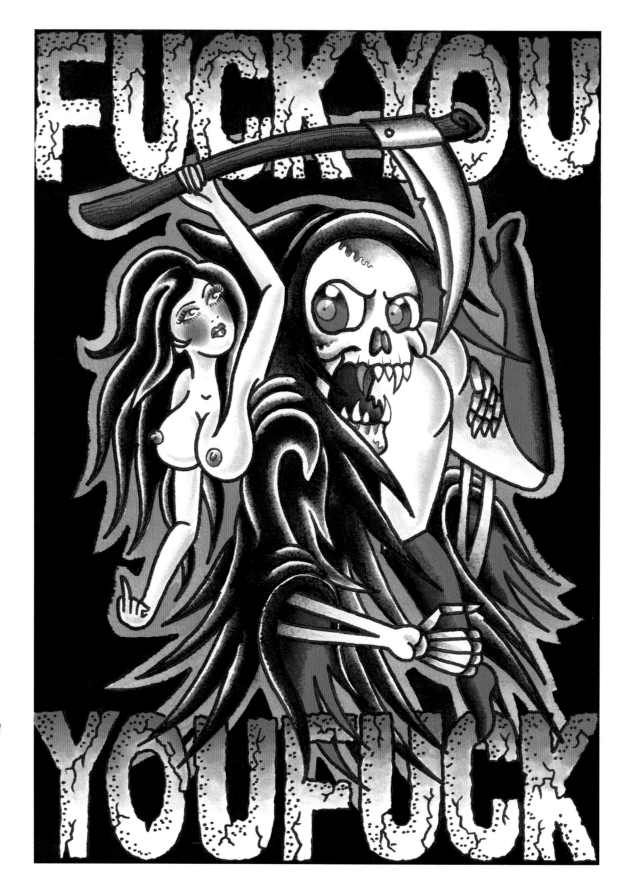

RIGHT: *Fuck You You Fuck.* Watercolour ink on paper.

FAR RIGHT: *Devil Flash.* Watercolour ink on paper.

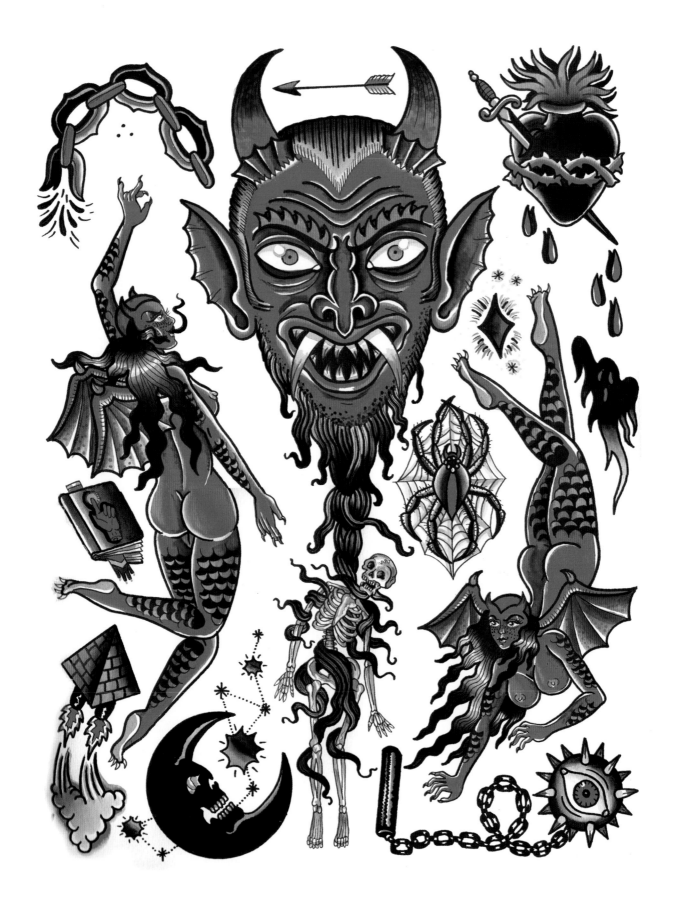

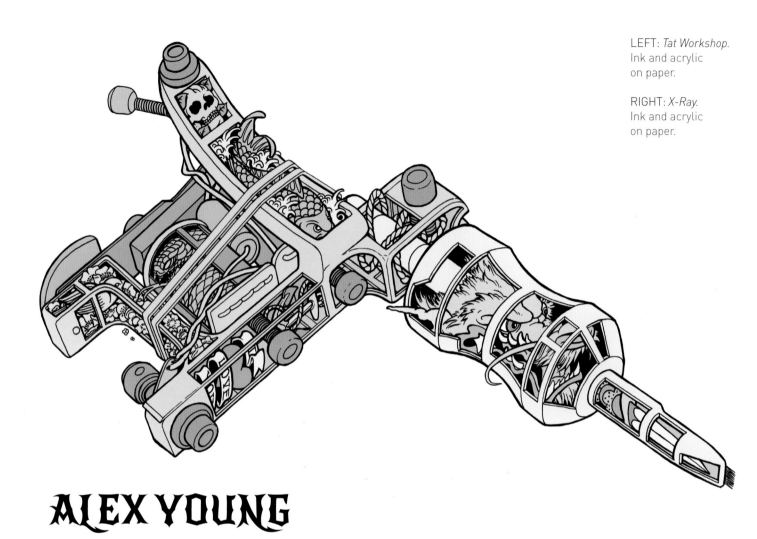

LEFT: *Tat Workshop.*
Ink and acrylic
on paper.

RIGHT: *X-Ray.*
Ink and acrylic
on paper.

ALEX YOUNG

"It was just a matter of time," says London-based Alex. After art school at Kent Institute of Art and Design
he established himself first as an illustrator. "There was no instant spark which made me a tattooist. I was
painting, illustrating, doing graffiti and getting tattooed. I hung around with a lot of tattoo artists, including
James 'Woody' Woodford. He showed me some stuff, encouraged me. That's how it happened." The hardest
thing for Alex was controlling expectations. Many clients who knew his illustration work instantly assumed that
he could reproduce the same, as though he had ten years' experience. "Even the pros just told me to get on with
it, assuming I'd be fine. I had to remind them of my novice tattoo status." Alex's drawing skill have, however,
translated successfully into his tattoo designs and many of his tattoo clients are people who know him as an
illustrator, as well as comic book fans. Artists who have been of influence include Chuck Close, Geof Darrow,
Marc McKee, Jim Phillips, Bill Sienkiewicz and Todd McFarlane. More generally it's skateboarding, comics and
graffiti. Of the scene he says: "There are many more art school pussies like me working as tattooists. It used to
be much more hard-core. Going into a tattoo shop used to be scary; not any more."

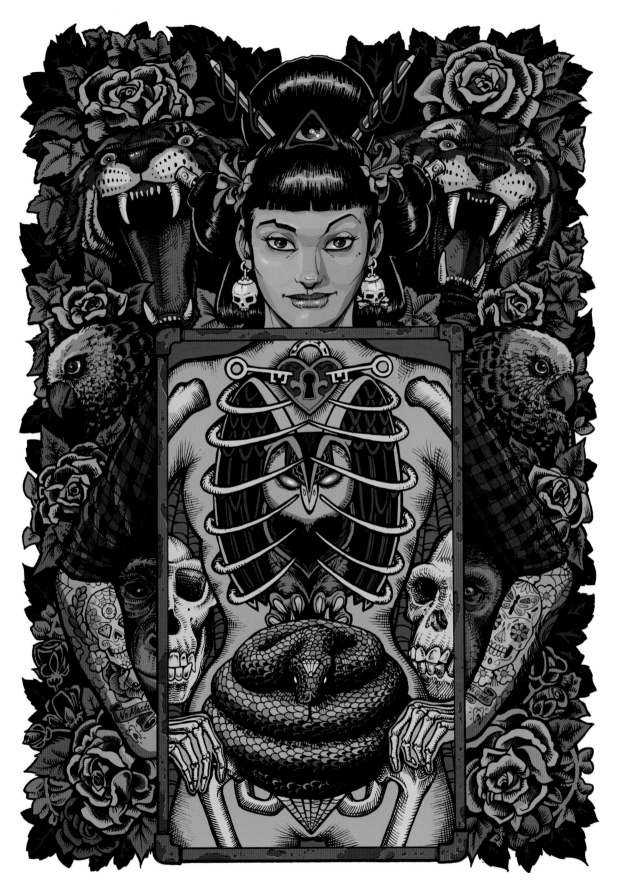

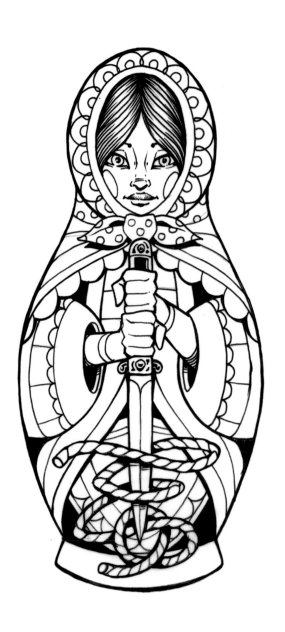

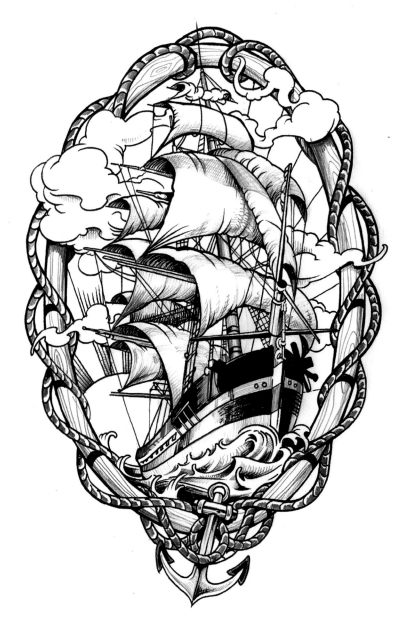

ABOVE: *Babushka*.
Ink on paper.

ABOVE RIGHT: *Ship*.
Ink on paper.

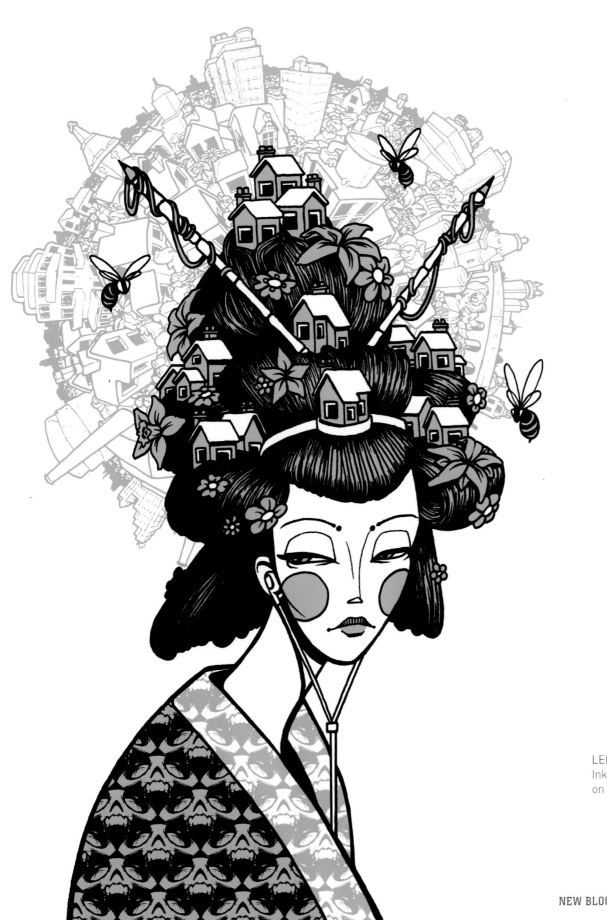

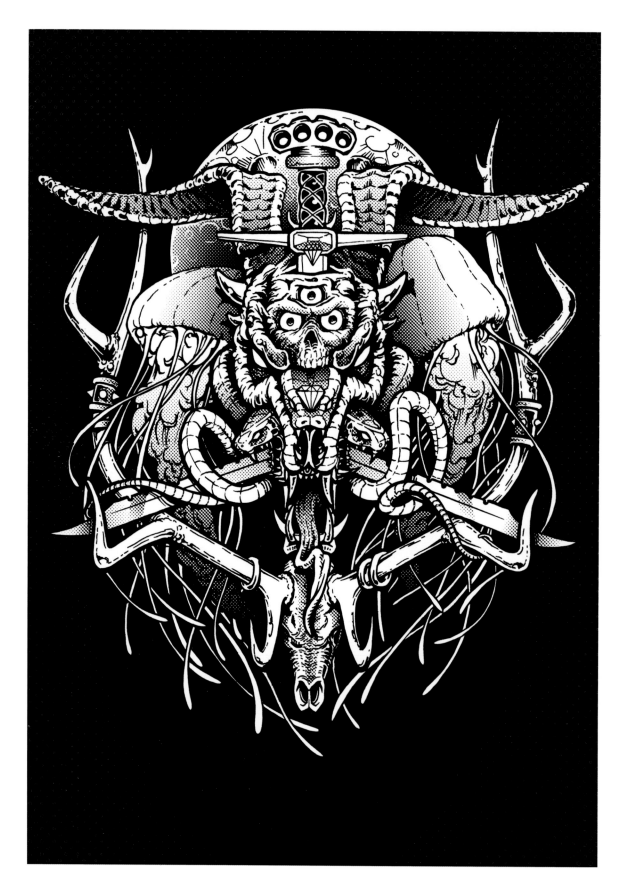

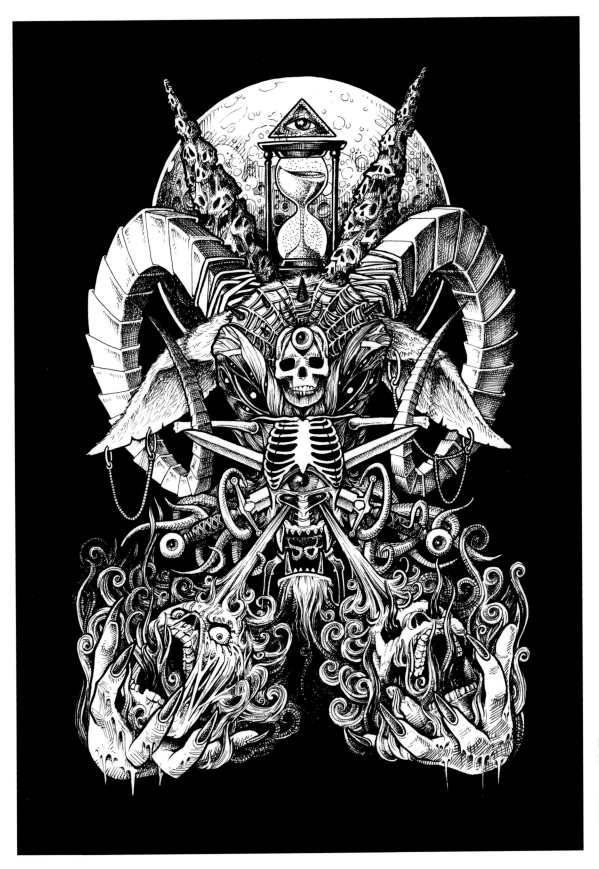

FAR LEFT: *Demonoid*.
Ink on paper.

LEFT: *Goat*.
Ink on paper.

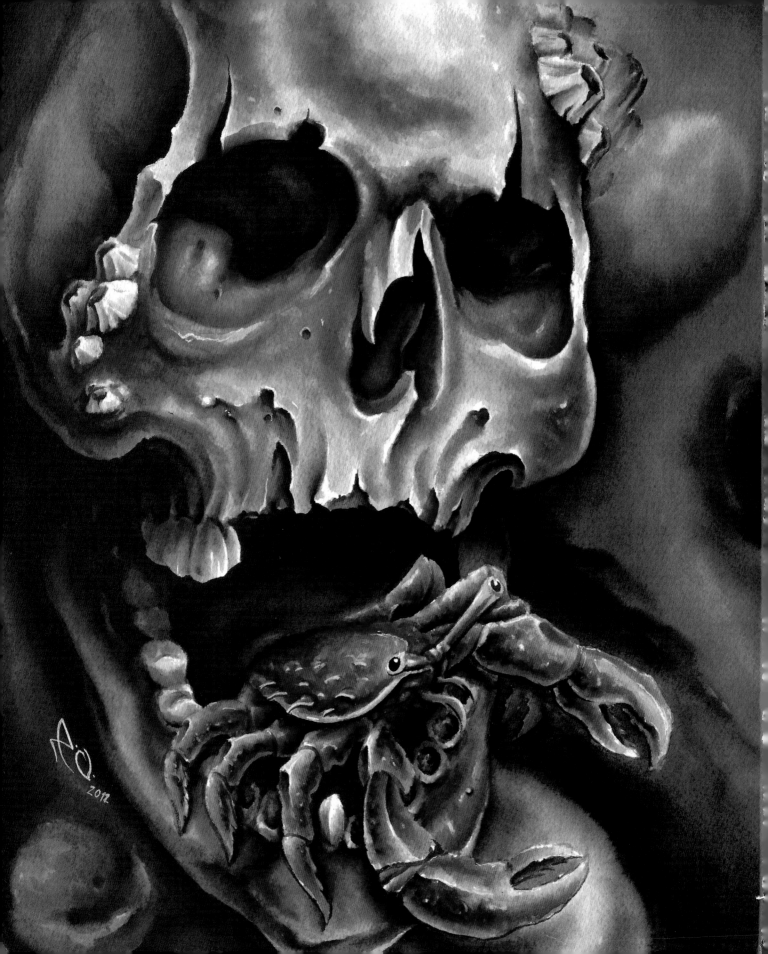

APPENDIX

ARTISTS

Fernando Amador
London, UK
forevermoretattoo.co.uk

Myra Brodsky
Berlin, Germany
myrabrodsky.com

Craig Chazen
Atlanta, GA, USA
livefreetattoo.com

Ben Cheese
San Francisco, CA, USA
everlastingtattoo.com

Dani DMT
London, UK
Facebook.com/tatuariadani

Luca Font
Bergamo, Italy
lucafont.wordpress.com

Sebastian Forsberg
Uppsala, Sweden
4-evertattoo.se

Dani Green
Edinburgh, UK
lovehatetattoo.co.uk

David Hale
Athens, GA, USA
Lovehawk.com

Valentin Hirsch
Berlin, Germany
valentinhirsch.com

Ramon Maiden
Barcelona, Spain and NYC, USA
ramonmaiden.com

Scott Move
London, UK
hauntedtattoos.com

Aaron Odell
Carmichael, CA, USA
cartelinkworks.com

Stuart Padgin
Barnsley, UK
padzlucky13.tumblr.com

Alessia Pedrosa
Shrewsbury, UK
facebook.com/alessia.pedrosa

Juanma Piranha
Buenos Aires, Argentina
xpiranhax.com.ar

David Robinson
Los Angeles, CA, USA
davidrobinsontattoo.com

David Rudzinski
Elk, Poland
facebook.com/david.rudzinksi

Jeff Saunders
Philadelphia, PA, USA
facebook.com/effjay.aundersay

Eva Schatz
Salzburg, Austria
evaschatz.tumblr.com

Drew Shallis
Sydney, Australia
facebook.com/drewshallis

Kodie Smith
Chelmsford, UK
kodieart.bigcartel.com

Rose Whittaker
London, UK
womenarewolves.tumblr.com

Alex Young
London, UK
facebook.com/alexyoungart

OVERLEAF:
Aaron Odell
Triptych Skull.
Ink and watercolour.

ACKNOWLEDGEMENTS

The Publisher wishes to thank Allan Graves for his clever
curatorship, Ramon Maiden and Miki Edge for their
art and great work on an inspired jacket design, Aaron
Odell for his striking back cover image and, most of all,
the brilliant artists who have shared some of their most
interesting work in this book.

Allan Graves wishes to thank:

Mum and my family and Mariana for putting up with my
endless emails. Julia (Ghoulia) Paoletty for being there
to fix all my mess. The crew at Haunted and Emily Power.
Enrique, Lorenzo, Francisco and Javi at Freaks. Sitch D,
Kate and the Defiled. Ash and Michelle Ghoulmore and the
Kreepsville crew. The Freac Chic Tattoo crew. Lal Hardy,
Woody BTC, Miki Vialetto and Gez Toxico. Graham at The
Cinema Store. Br1, Ramon Maiden And Miki Edge and all
the Zorriguella crew. Derick Montez and the Everlasting
Tattoo crew. The Forevermore Tattoo crew. Ben Estrada,
Raziel Quiroz, Manolo Cera, Stacie and Curt C and Mary
Clark. Max Doulat, Stef and Aaron at the Sate51 Co, David
HC, Sonia and Danielle, Ele and Co. Last, and definitely not
least, all my customers for their constant support.

Photo of Allan Graves on back jacket flap by Anuska Rujas.

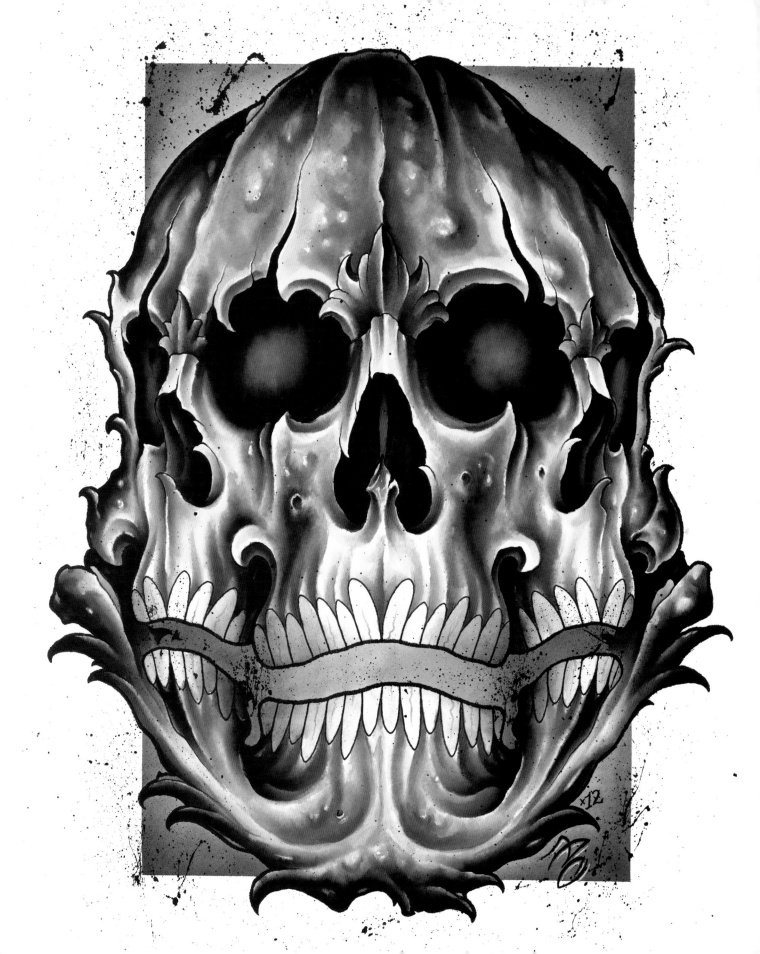